NIK(
D52

THE EXPANDED GUIDE

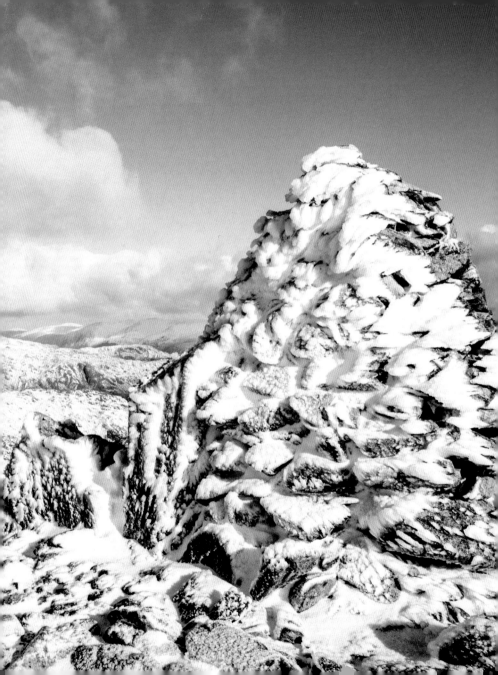

NIKON
D5200

THE EXPANDED GUIDE

Jon Sparks

AMMONITE
PRESS

First published 2013 by
Ammonite Press
an imprint of AE Publications Ltd
166 High Street, Lewes, East Sussex, BN7 1XU, UK

Text © AE Publications Ltd, 2013
Images © Jon Sparks, 2013
Cover images and product photography © Nikon, 2013
(except where indicated)
Copyright © in the Work AE Publications Ltd, 2013

ISBN 978-1-78145-046-8

British Library Cataloging in Publication Data: A catalog
record of this book is available from the British Library.

Editor: Rob Yarham
Series Editor: Richard Wiles
Design: Fineline Studios

Typefaces: Giacomo
Color reproduction by GMC Reprographics
Printed in China

‹‹ PAGE 2 PEAK PRACTICE
In demanding conditions,
such as here on Swirl How
in the Lake District, UK,
you need a camera you
can trust. *35mm, 1/640 sec.,
f/11, ISO 200.*

» CONTENTS

Chapter 1
OVERVIEW

1 OVERVIEW

The D5200 is Nikon's latest advanced "consumer" digital SLR (DSLR), slotting into the company's range between the entry-level D3200 and the semi-professional D7000. However, it stands apart from all other Nikon DSLRs in having an articulating LCD screen. This offers extra flexibility when shooting in Live View and can be of special benefit when shooting movies.

The D5200 can be used as a pure "point-and-shoot" camera and need not intimidate the novice, but it is ready to unleash much greater imaging power. Its range of exposure modes includes the traditional, highly controllable, standards of Aperture-priority, Shutter-priority, and Manual. Crucially, the image quality is excellent and with careful use can meet professional standards and satisfy the most discerning of enthusiasts.

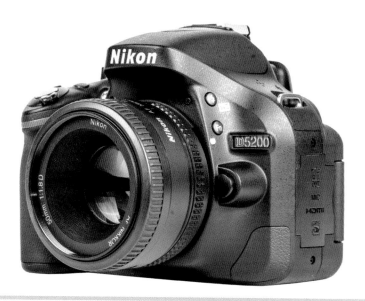

» EVOLUTION OF THE NIKON D5200

Nikon has always valued continuity as well as innovation. When the major manufacturers first introduced viable autofocus 35mm cameras in the 1980s, many ditched their existing lens mounts, but Nikon stayed true to its tried and tested F-mount (originally introduced in 1959). It's still possible to use many classic Nikon lenses with the latest DSLRs, like the D5200, though some camera functions (e.g. autofocus) may be lost.

Nikon's first DSLR was the E2s, with a 1.3-megapixel sensor. It had no rear screen and images could only be viewed by connecting it to an external device.

A more direct line of descent really begins with the 2.7-megapixel D1. Introduced in 1999, the D1 is the most influential digital camera ever made, and the first DSLR to match the flexibility and ease of handling of 35mm SLRs. Its sensor adopted the DX format (see next page), subsequently used in every Nikon DSLR until the "full-frame" D3 arrived in 2008.

In 2004, Nikon introduced the 6-megapixel D70, regarded as their first "enthusiast" DSLR. The D50 (2005) was essentially a simplified D70, but late in 2006 Nikon introduced the D40, designed from the ground up for ease of use. The D60

Nikon D1 (1999) ❅
The D1 was a revolutionary camera, making digital photography a practical, everyday proposition for thousands of professionals, not to mention amateur "early adopters".

Nikon D70 (2004) ❅
The D70 was the camera which persuaded a host of enthusiasts and not a few professionals (including the author) to take their first plunge into digital photography.

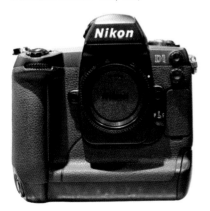

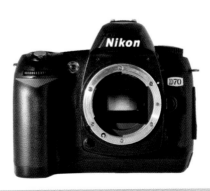

(2008) was essentially a D40 with a 10Mp sensor. Later the same year, the D90 took the megapixel count to 12, along with a raft of significant new features: Live View, dust removal, a new CMOS sensor, better low-light performance, and a headline-grabbing movie mode.

In 2009, the D5000 incorporated many of these innovations while adding a fold-out LCD screen. The D5100 of 2011 had more pixels, a smaller overall form factor, and a repositioned pivot for the screen. On the surface, the D5200 is very similar, but boasts many refinements, including a 24-megapixel sensor, enhanced image processing and an upgraded 39-point autofocus system (as seen on the D7000).

› Nikon DX-format sensors

The DX format sensor, measuring approximately 23.6 x 15.8mm (the D3200's is marginally smaller), was used in every Nikon DSLR from the D1 until the arrival of the "full-frame" (or "FX') format in the D3 (2007). The DX format is still used for the majority of cameras in the range, but the

Nikon D5000 (2009) ≈
The D5000's main talking-point was its articulating screen, although opinions were divided about the wisdom of placing the hinge at the base (the D5100 shifted it to the side).

Nikon D7000 (2010) ≈
The D7000 included many features (such as its 39-point autofocus system) which have since "trickled down" to the D5200.

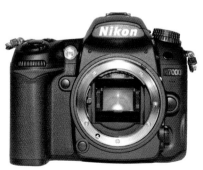

number of pixels squeezed into that tiny area has risen from 2.7 million to 24.2 million in the D3200. The format dictates a 1.5x magnification factor, relative to the same lenses used on 35mm or FX cameras. The D3200 uses a CMOS (Complementary Metal Oxide Semiconductor) sensor with 24.2 million effective pixels, producing images at a native size of 6016 x 4000 pixels, far more than enough for most purposes, and suitable for large prints and book and magazine reproduction.

Externally, the Nikon D5200 is extremely similar to the D5100, but major changes to the imaging system inside will still make it a worthwhile upgrade for many. In rear view it's almost identical to its predecessor, with the same control layout and fold-out 3in. rear LCD panel (Nikon calls it a "swivel monitor"), hinged at the left side. Internally, major features include a 24.1-megapixel CMOS sensor with self-cleaning function, Expeed 3 image processing, 39-point autofocus module, and a maximum shooting rate of 5 frames per second.

Like all Nikon SLRs the D5200 is part of a vast system of lenses, accessories, and software. The *Expanded Guide to the Nikon D5200* will guide you through all aspects of the camera's operation, and its relation to the system as a whole.

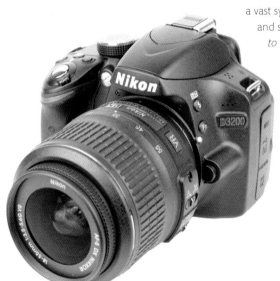

1 » MAIN FEATURES

Sensor

24.1 effective megapixel DX-format RGB CMOS sensor measuring 23.5 x 15.6mm and producing maximum image size of 6000 x 4000 pixels; self-cleaning function.

Image processor

EXPEED 3 image processing system featuring 14-bit analog-to-digital (A/D) conversion.

Focus

39-point autofocus system, supported by Nikon Scene Recognition System, tracks subjects by shape, position, and color. Three focus modes: (S) Single-servo AF; (C) Continuous-servo AF; and (M) Manual focus (AF-A automatically selects from AF-S and F-C). Four AF-area modes: Single-point AF; Dynamic-area AF (9, 21, or 39 points); 3D tracking AF; and Auto-area AF. Rapid focus point selection and focus lock.

Exposure

Three metering modes: matrix metering; center-weighted metering; spot metering. 3D Color Matrix Metering II uses a 2016-pixel color sensor to analyze data on brightness, color, contrast, and subject distance from all areas of the frame. With non-G/D Type lenses, standard Color Matrix Metering II is employed.
ISO range between 100 and 6400, with extension to 25,600; Auto ISO. Exposure compensation between −5 Ev and +5 Ev; exposure lock and bracketing facility.

Exposure modes

Two fully auto modes: auto; auto (flash off). 16 Scene modes: 🎭 Portrait; 🏞 Landscape; 👧 Child; 🏃 Sports; 🌷 Close up; 🌃 Night portrait; 🌆 Night landscape; 🎉 Party/indoor; 🏖 Beach/snow; 🌅 Sunset; 🌆 Dusk/dawn; 🐕 Pet portrait; 🕯 Candlelight; 🌸 Blossom; 🍂 Autumn colors; 🍴 Food. Seven Effects modes: 🌙 Night Vision; 🎨 Color Sketch; 📷 Miniature Effect; 🖌 Selective Color; 🎞 Silhouette; HI High key; LO Low key. Four user-controlled modes: (P) Programmed auto with flexible program; (A) Aperture-priority auto; (S) Shutter-priority auto; (M) Manual.

Shutter

Shutter speeds from 1/4000 sec. to 30 sec., plus B. Max frame advance 5 frames per second (fps).

Viewfinder

Pentamirror viewfinder with 95% coverage and 0.78x magnification.
LCD monitor Vari angle 3in./75mm, 921,000-dot TFT LCD display with 100% frame coverage.

Movie Mode

Movie capture in .MOV format (Motion-JPEG compression) with image size (pixels) of: 1920 x 1280; 1280 x 720; 640 x 424.

Buffer

Buffer capacity allows up to 100 frames (JPEG fine, large) to be captured in a continuous burst at 5fps, approximately 15 RAW files.

Built-in flash

Pop-up flash (manually activated) with Guide Number of 12 (m) or 39 (ft) at ISO 100 supports i-TTL balanced fill-flash for DSLR (when matrix or center-weighted metering is selected) and Standard i-TTL flash for DSLR (when spot metering is selected). Up to 10 flash-sync modes (dependent on exposure mode in use): Auto; auto + red-eye reduction; auto slow sync; auto slow sync + red-eye reduction; fill-flash; slow sync; rear-curtain sync; rear-curtain slow sync; red-eye reduction; slow sync + red-eye reduction. Flash compensation from −3 to +1 Ev.

Custom functions

22 parameters and elements of the camera's operations can be customized through the Custom Setting menu.

File formats

The D5200 supports NEF (RAW) (14-bit) and JPEG (Fine/Normal/Basic) file formats plus .MOV movie format.

System back-up

Compatible with around 60 current and many non-current Nikkor lenses (functionality varies with older lenses); SB-series flashguns; Wireless Remote Control ML-L3 and WR-R10; GPS Unit GP-1; ME-1 stereo microphone and many more Nikon system accessories.

Software

Supplied with Nikon Transfer and Nikon View NX2; compatible with Nikon Capture NX2 and many third-party imaging applications.

1 » FULL FEATURES AND CAMERA LAYOUT

FRONT OF CAMERA

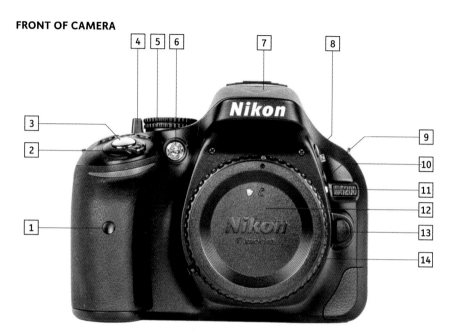

1	Infrared receiver (front)	**8**	Flash/Flash mode/Flash compensation button
2	Power switch	**9**	Camera strap mount
3	Shutter-release button	**10**	Fn button
4	Live View switch	**11**	Mounting mark
5	Mode Dial	**12**	Body cap
6	AF-assist illuminator/Self-timer/Red-eye reduction lamp	**13**	Lens-release button
7	Built-in flash	**14**	Lens mount

BACK OF CAMERA

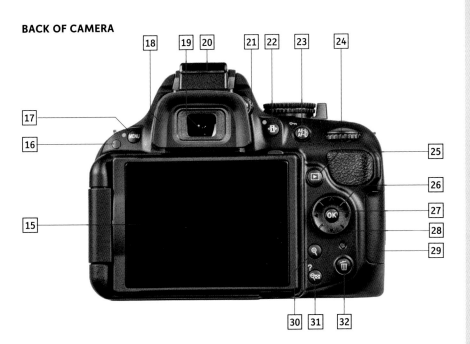

15 Monitor	**25** Playback button
16 Infrared receiver (rear)	**26** Multi-selector
17 MENU button	**27** OK button
18 Eyecup	**28** Memory card access lamp
19 Viewfinder eyepiece	**29** Memory card slot cover
20 Accessory hotshoe cover	**30** Playback zoom in button
21 Diopter adjustment dial	**31** Thumbnail/playback zoom out/Help button
22 Information edit button	**32** Delete button
23 AE-L/AF-L/Protect button	
24 Command Dial	

1 » FULL FEATURES AND CAMERA LAYOUT

TOP OF CAMERA

LEFT SIDE

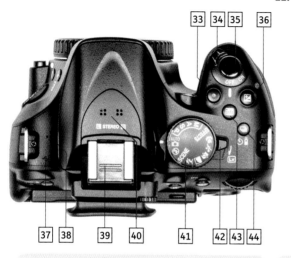

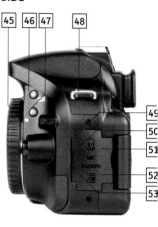

33	Movie-record button
34	Power switch
35	Shutter-release button
36	Exposure compensation/Aperture adjustment/ Flash compensation button
37	Focal plane mark
38	Speaker
39	Accessory hotshoe
40	Stereo microphone
41	Mode Dial
42	Live View switch
43	INFO button
44	Release Mode/Self-timer/Remote control

45	Mounting mark
46	Flash/Flash mode/Flash compensation button
47	Fn button
48	Camera strap mount
49	Connector cover
50	External microphone connector
51	USB and AV connector
52	HDMI mini-pin connector
53	Accessory terminal

BOTTOM OF CAMERA

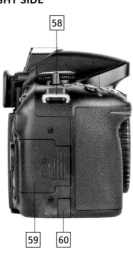

RIGHT SIDE

54	Tripod socket (¼in.)
55	Camera serial number
56	Battery compartment
57	Battery compartment release lever

58	Camera strap mount
59	Memory card slot cover
60	Power connector cover for optional power connector

1 ›› INFORMATION DISPLAY

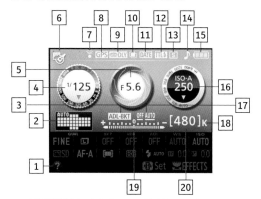 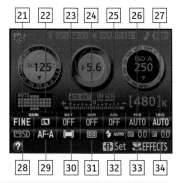

1	Help icon
2	Auto-area AF indicator
3	Bracketing indicator
4	Shutter speed
5	Aperture (f-number)
6	Shooting mode
7	Eye-Fi connection indicator
8	GPS connection indicator
9	Exposure delay mode
10	Multiple exposure indicator
11	Print date indicator
12	Flash control indicator
13	Release mode
14	"Beep" indicator
15	Battery indicator
16	ISO sensitivity
17	ADL bracketing amount
18	"K" (when over 1000 exposures remain)

19	Exposure/Exposure compensation/ Bracketing progress indicator
20	Number of exposures remaining/White balance recording/Capture mode indicator
21	Image quality
22	Image size
23	AF-area mode
24	Metering
25	Active D-Lighting
26	White balance
27	ISO sensitivity
28	Picture control
29	Focus mode
30	AF-area mode
31	Metering
32	Flash mode
33	Flash compensation
34	Exposure compensation

» VIEWFINDER DISPLAY

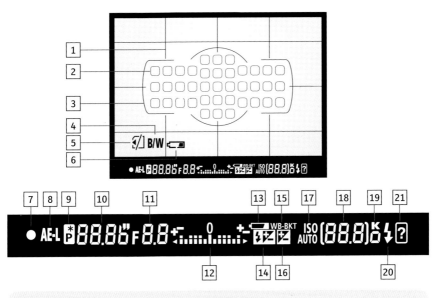

1	Framing grid	13	Battery indicator
2	Focus points	14	Flash compensation indicator
3	AF area brackets	15	Bracketing indicator
4	Monochrome indicator	16	Exposure compensation indicator
5	No memory card warning	17	Auto ISO sensitivity indicator
6	Low battery warning	18	Number of exposures remaining/ Number of exposures remaining in buffer/white balance recording indicator/exposure compensation value/flash compensation value/ ISO sensitivity/Capture mode indicator
7	Focus indicator		
8	AE lock indicator		
9	Flexible program indicator		
10	Shutter speed		
11	Aperture	19	K (when over 1000 exposures remain)
12	Exposure indicator/exposure compensation display/electronic rangefinder	20	Flash-ready indicator
		21	Warning indicator

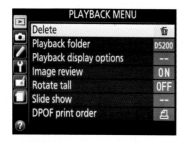

Playback menu
> Delete
> Playback folder
> Playback display options
> Image review
> Rotate tall
> Slide show
> DPOF Print order

Shooting menu
> Reset shooting menu
> Storage folder
> Image quality
> Image size
> White balance
> Set Picture Control
> Manage Picture Control
> Auto distortion control
> Color space
> Active D-Lighting
> HDR (high dynamic range)
> Long exposure NR
> High ISO NR
> ISO sensitivity settings
> Release mode
> Multiple exposure
> Interval timer shooting
> Movie settings

Custom Setting menu
Reset custom settings
a: Autofocus
> a1 AF-C priority selection
> a2 Number of focus points
> a3 Built-in AF-assist illuminator
> a4 Rangefinder
b: Exposure
> b1 Ev steps for exposure control
c: Timers/AE Lock

> c1 Shutter-release button AE-L
> c2 Auto off timers
> c3 Self-timer
> c4 Remote on duration (ML-L3)
d: Shooting/display
> d1 Beep
> d2 Viewfinder grid display
> d3 ISO display
> d4 File number sequence
> d5 Exposure delay mode
> d6 Print date
e: Bracketing/flash
> e1 Flash cntrl for built-in flash
> e2 Auto bracketing set
f: Controls
> f1 Assign <[number]> /Fn button
> f2 Assign **AE-L/AF-L** button
> f3 Reverse dial rotation
> f4 Slot empty release lock
> f5 Reverse indicators

Setup menu
> Format memory card
> Monitor brightness
> Info display format
> Auto info display

> Clean image sensor
> Lock mirror up for cleaning
> Image Dust Off ref photo
> Video mode
> HDMI
> Flicker reduction
> Time zone and date
> Language
> Image comment
> Auto image rotation
> Accessory terminal
> Eye-Fi upload
> Wireless mobile adapter
> Firmware version

Chapter 2
FUNCTIONS

Nikon

D5200

2 FUNCTIONS

The Nikon D5200 sports over a dozen control buttons, a Mode Dial, a Command Dial, and a Multi-selector, so it may appear complex and daunting to users familiar with digital compacts—or even 35mm SLRs. However, it can be operated as simply as any "point-and-shoot" camera. It will be ready for such use when you first unpack it, and at any time you can quickly reset it to full auto operation by holding down **MENU** and ✦**▣**▸ for at least 2 seconds.

However, the D5200 offers much greater flexibility than the average point-and-shoot camera, not to mention far superior image quality. Its layout and interface encourage a progressive transition from leaving everything to the camera to taking full control of its key functions.

Leaving the camera at default settings misses out on much of its imaging power, and the intention of this chapter is to provide a step-by-step introduction to its most important features and functions. Even in a much longer book it would be impossible to fully explore every last detail, so we'll concentrate on these aspects which will be relevant to the majority of photographers.

Tips

For on-screen Help during shooting and when using menus, press ⊞ to bring up information relating to the item currently selected. You can't access Help during playback as the button then has a different function.

? Flash compensation

Adjust flash level.
Control the brightness of the subject relative to the background.
Choose positive values to increase lighting for the main subject. Choose negative values to decrease lighting for the main subject.

On-screen help

GETTING FAMILIAR «
When you unpack a new camera, it's tempting to start shooting right away—and taking pictures is the best way to learn. However, it still makes sense to peruse this book first, to ensure you don't miss out on new features and functions.

» CAMERA PREPARATION

Some basic operations, like charging the battery and inserting a memory card, are essential before the camera can be used. These operations, and others like changing lenses, may seem trivial, but it can be important to be able to perform them quickly and smoothly in awkward situations or when time is short.

Setting the time, date, and time zone is also a good idea, and the camera will prompt you to do this when first switched on: see under Setup menu on *page 111.*

› Attaching the strap

To attach the supplied strap, ensure the padded side will face inwards (so the maker's name faces out). Attach either end first to the appropriate eyelet, located at the top left and right sides of the camera. Loosen the strap where it runs through the buckle, then pass the end of the strap through the eyelet and back through the buckle. Bring the end of the strap back through the buckle, under the first length of strap already threaded (see photo).

> Note:
> This method is not the same as that shown in the Nikon User's Manual, but is both more secure and neater.

ATTACHING THE STRAP　　　　⌃
The strap is shown fully tightened on the left, threaded but not yet tightened on the right.

Repeat the operation on the other side. Adjust the length as required, but ensure a good length (minimum 5cm) of strap extends beyond the buckle on each side to avoid any risk of it pulling through. When satisfied with the length, pull it firmly to seat it securely within the buckle.

› Adjusting for eyesight

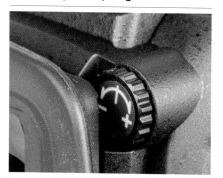

DIOPTER ADJUSTMENT �
The diopter adjustment dial enables you to correct the viewfinder readouts and focus points for your eyesight.

The D5200 offers dioptric adjustment, between −1.7 and +0.5m^{-1}, to allow for individual variations in eyesight. Make sure this is optimized for your eyesight (with glasses or contact lenses if you normally use them). The diopter adjustment dial is immediately right of the viewfinder. With the camera switched on, rotate the dial until the viewfinder readouts and focus points appear sharpest. Unless your eyesight changes, you should only need to do this once. Supplementary viewfinder lenses are available if this adjustment proves insufficient.

› Mounting lenses

MOUNTING LENSES ✯
The ability to use a wide range of lenses *(see Chapter 7, page 200)* is one of the great advantages of a DSLR.

Switch the camera off before changing lenses. Remove the rear lens cap and the camera body cap (or the lens if already mounted). To remove a lens, press the lens-release button and turn the lens clockwise (as you face the front of the camera). Align the index mark on the lens with the one on the camera body (white dot), insert the lens gently into the camera and turn it anti-clockwise until it clicks home. Do not use force; if the lens is correctly aligned it will mount smoothly.

Warning!

Avoid touching the electrical contacts on lens and camera body, as dirty contacts can cause malfunctions. Replace lens or body caps as soon as possible. Most Nikon F-mount lenses can be used on the D5200; however, with older lenses many functions are lost, notably autofocus. When using older lenses with an aperture ring, rotate this to minimum aperture. See Chapter 7, Lenses *(page 200)*; the maker's manual also has detailed information on compatible lenses.

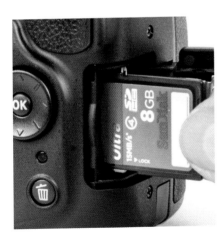

INSERTING A MEMORY CARD ⌃
The D5200 stores images on Secure Digital (SD) cards, including SDHC and SDXC cards.

› Inserting and removing memory cards

1) Switch OFF the camera and check that the green access lamp on the back of the camera (below the Multi-selector) is not lit.

2) Slide the card slot cover on the right side of the camera towards the rear. It will spring open.

3) To remove a memory card, press the card gently into its slot, it will then spring out slightly. Pull the card gently from its slot.

4) Insert a card with its label side towards you and the rows of terminals along the card edge facing into the slot. The "cut-off" corner of the card will be at top left. Push the memory card into the slot, without excessive force, until it clicks home. The green access lamp will light up briefly.

5) Close the card slot cover.

Tip

Cards are tiny and easily lost; handle with care, especially when they are loaded with irreplaceable images.

› Formatting a memory card

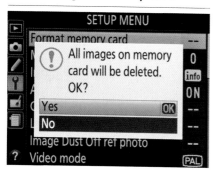

› Inserting the battery

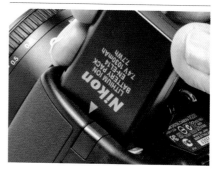

It's advisable to format a new memory card, or one that has been used in another camera, before using it with the D5200. Formatting is also the most efficient way to erase existing images on the card, so take care—make sure images have been saved elsewhere before formatting.

To format a memory card

1) Press **MENU** and then select the Setup menu from the symbols at left of the screen.

2) Select **Format memory card** and press **OK**.

3) Select **Yes** and press **OK**.

The Nikon D5200 is supplied with an EN-EL14 li-ion rechargeable battery. This needs to be fully charged before first use *(see Battery charging, below)*.

Turn the camera upside down and locate the battery compartment below the handgrip. Release the latch to open the compartment. Insert the battery, contacts first, with the side that says "Nikon" facing away from the lens. Use the battery to nudge the gold-colored battery latch aside, then slide the battery gently in until the latch locks into position. The green access lamp on the camera back illuminates briefly. Shut the battery compartment cover, ensuring it clicks home.

To remove the battery, switch OFF the camera, and open the compartment cover as above. Press the gold latch to release the battery and pull it gently out of the compartment.

› Battery charging

Use the supplied MH-24 Charger to charge the battery. Remove the terminal cover (if present) from the battery and insert the battery into the charger with the maker's name uppermost and terminals facing the contacts on the charger. Press the battery gently but firmly into position. Plug the charger into a mains outlet. The Charge lamp will blink while the battery is charging, then shine steadily when charging is complete. A completely discharged battery will take around 90 minutes to recharge fully.

› Battery life

Under standard test conditions (CIPA) the D5200 should deliver around 500 shots before the battery needs recharging. This is fairly realistic, but a great deal depends on how you use the camera. If you make minimal use of the LCD screen, i.e. rarely changing settings and not reviewing your shots, you may achieve several times this number. On the other hand, heavy screen use, such as extensive Live View shooting, can drastically reduce it. Heavy use of the built-in flash also depletes the battery.

Battery life may also be significantly shorter if you're shooting in temperatures outside the recommended range (0°C–40°C, see Chapter 8, *page 233*).

The Information Display and viewfinder give an approximate indication of how much charge remains. These icons blink when the battery is exhausted.

For information on alternative power sources (see Accessories and care, Chapter 8, *page 227*).

› Switching the camera on

Power switch and shutter-release button

The power switch, which surrounds the shutter-release button, has two self-explanatory settings, **OFF** and **ON**.

> ### *Tips*
>
> *The battery charger can be used abroad (100–240 V AC 50/60 Hz) with a commercially available travel plug adapter. Do not attach a voltage transformer as this may damage the battery charger.*

2 » BASIC CAMERA FUNCTIONS

With strap, lens, battery, and memory card on board, the D5200 is ready to shoot. The camera arrives set to Auto mode and with its LCD screen stowed away. The D5200 is perfectly happy to shoot indefinitely like this, but as soon as you want to change any settings, review, or playback your shots, use Live View or shoot movies, you'll need to use the screen (see below).

In beginning to explore a wider range of options, the key controls are the Mode Dial, Command Dial and Multi-selector, along with the release mode button.

Settings which are affected by these controls are seen in the Information Display *(see page 32)* on the rear LCD screen, and some are also displayed in the viewfinder. However, in Auto and Scene modes it is perfectly possible (though not necessarily recommended) to shoot without reference to any of these displays or controls.

positions but is more vulnerable to damage when opened out. For normal use, open the screen out, rotate it 180° (push the top away from you), then fold it back against the camera body until it clicks into place. It's obviously convenient to leave the screen in this position, but this makes it vulnerable to scratches and other damage. It's better to get in the habit of stowing the screen away when transporting or storing the camera; if you set a suitable shooting mode before stowing, you can grab shots quickly without needing to open out the screen first.

> ### Tip
>
> *The screen can be hard to see clearly in bright sunlight. Screen shades are available which help to get around this problem (see page 228).*

› Using the LCD screen

To use the screen, grasp the tabs at top right and bottom right and ease it away from the camera. The screen can be angled and rotated to a wide range of

MULTI-SCREEN »
The posable screen is useful when the camera is in an awkward position (e.g. for close-up photography) or to avoid glare.

› Operating the shutter

The shutter-release button operates in two stages. Pressing it lightly, until you feel initial resistance, activates the metering and focus functions. Half-pressure also clears the Information Display, menus, or image playback, making the D5200 instantly ready to shoot. Press the button more firmly (but still smoothly) to take the picture.

› Mode Dial

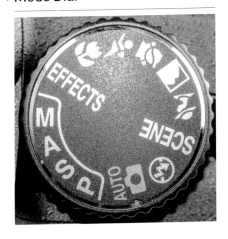

The mode setting, chosen from this dial, determines whether the camera operates entirely automatically or requires some level of input from you. It has 13 positions, split into four groups: Full Auto modes, User-control modes, Scene modes and Effects. For a full run-down of these see under Exposure modes, *page 36*.

› Command Dial

The Command Dial falls naturally under the right thumb when the camera is in shooting position. It is fundamental to the operation of the Nikon D5200, especially in the user-control modes.

Operating the Command Dial

The dial's function is flexible, varying according to the operating mode at the time. In Shutter-priority (S) or Manual (M) mode, rotating the Command Dial selects the shutter speed. In Aperture-priority (A) mode it selects the aperture. In Program (P) mode it engages flexible program, changing the combination of shutter speed and aperture. For descriptions of these modes *see page 52.*

Warning!

The Mode Dial does not have a lock. It is firmly click-stopped, so accidental shifts are rare, but they can occur.

2

The Command Dial is also used to select from among the more specialized Scene or Effects modes when the Mode Dial is set to SCENE or EFFECTS. Apart from this, when shooting in Auto, Scene, and Effects modes, the Command Dial has no direct effect.

› Multi-selector

The other principal control is the Multi-selector. Its main use when shooting pictures is to select and change settings in the Active Information Display. The **OK** button at its center is used to confirm settings. The Multi-selector is also used for navigating through the menus, and through images on playback: these will be covered in the relevant sections.

› Information Display

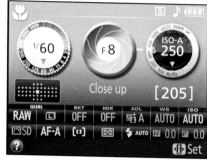

The Information Display—Graphic format

The Information Display is central to using the Nikon D5200. If you're familiar with traditional camera control using buttons and dials it may seem a little strange at first, but soon proves to be a straightforward, though arguably slower, way of accessing camera functions.

To activate the Information Display, do any of these:

- Half-press and release the shutter-release button (if you maintain pressure the Information Display will not appear);
- Press **INFO** on top of the camera;
- Press **⚏** on the rear of the camera.

This brings up a display showing the selected exposure mode, the aperture, and shutter speed, and a range of other detail. This screen can be displayed in a choice of two formats. **Graphic** format, active by

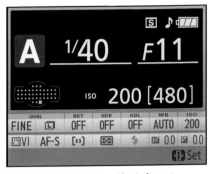

The Information Display—Classic format

default, uses icons and pictures to illustrate the effect of various settings. **Classic** format presents the information more traditionally, using text and numbers. The color scheme can also be changed. These options are exercized through the Setup menu *(see page 111)*.

> ## Active Information Display

The Active Information Display with ISO setting highlighted

Note:
We've coined the term "Active Information Display". It is not used in Nikon's own manual, which instead refers clunkily to "placing the cursor in the Information Display".

The initial Information Display is passive, i.e. it displays many settings but does not allow you to change them. To make changes possible, press ⓘ while the initial display is visible (if the screen is blank, press the button twice). The lower panel on the screen is highlighted and the Multi-selector can now be used to move quickly through the various settings. To make changes, press **OK**, and the range of options for that setting appears. Use the Multi-selector to move through these options; when the one you want is highlighted, press **OK** again to select it.

2 › Release mode

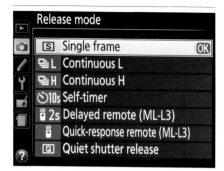

Setting Release mode ⌃

"Release mode" may seem an obscure term. It determines whether the camera takes a single picture or shoots continuously. It can also allow you to delay the shot or trigger the camera remotely.

Selecting Release mode

1) Press ⏶ to bring up the menu of options (see table opposite). (This screen can also be reached from the Active Information Display: Release mode is halfway down the right-hand side.)

2) Highlight the desired option and press **OK** to make it active. The chosen release mode is shown in the Information Display.

Seven possible release modes can be selected in this way.

› Buffer

Images are initially stored in the camera's internal memory ("buffer") before being written to the memory card. The maximum number of images that can be recorded in a continuous burst depends upon file quality, release mode, memory card capacity, and how much buffer space is available. The figure for the number of burst frames possible at current settings is shown in the viewfinder at bottom right when the shutter-release button is half-depressed. e.g. **[r05]**.

If **(0)** appears, the buffer is full, and no more shots will be taken until enough data has been transferred to the memory card to free up space in the buffer. This normally happens very quickly, but if you're shooting in ⏶ or ⏶ Continuous modes you may notice a slowdown or break in the rhythm of the shutter.

> **Note:**
> In theory you can shoot up to 100 shots continuously at 5fps, but this is probably only possible when image quality is set to Basic. When it's Fine, I've never managed more than about 20 shots without some signs of slowdown; in RAW, about 8 shots.

RELEASE MODE OPTIONS

Setting	Description
⑤ Single frame	The camera takes one shot each time the shutter release is fully depressed.
🖳 Continuous L	The camera fires continuously as long as the shutter release is fully depressed. The maximum frame rate is 3 frames per second (fps).
🖳 Continuous H	The camera fires continuously as long as the shutter release is fully depressed. The maximum frame rate is 5 frames per second (fps).
♻ Self-timer	The shutter is released a set interval after the release button is depressed. Can be used to minimize camera shake and for self-portraits. The default interval is 10 sec. but 2 sec., 5 sec., or 20 sec. can be set using Custom Setting c3. Up to 9 shots can be taken for each release.
📷♻ Delayed remote	Requires the optional ML-L3 remote control; shutter fires approximately 2 sec. after remote is tripped.
📷 Quick response remote	Requires the optional ML-L3 remote control; shutter fires immediately when remote is tripped.
Q Quiet shutter release	Similar to Single Frame, but mirror remains up and shutter does not re-cock until shutter-release button is released, making operation almost silent.

There's also an Exposure Delay mode, which can only be activated through the Custom Setting menu *(see page 107)*.

2 » EXPOSURE MODES

The choice of exposure mode makes a significant difference to the amount of control you can—or can't—exercise. Exposure modes are selected from the Mode Dial, with the addition of the Command Dial for some more specialized modes. The D5200 has a very wide choice of Exposure modes, but they fall conveniently into three main groups: Full Auto modes, Scene modes and User-control modes. There's also an EFFECTS position on the Mode Dial for more extreme or wacky results.

In Auto modes and Scene modes the majority of settings are controlled by the camera. These go beyond basic shooting settings (shutter speed and aperture) to include options such as release mode, whether or not flash can be used, and how the camera processes the shot. The difference is that Full Auto modes use compromise settings to cover most eventualities while SCENE mode settings are tailored to particular shooting situations.

User-control modes, by contrast, give you complete freedom to control virtually everything on the camera.

FLOAT YOUR BOAT ⨯
Exposure modes help you capture the image in a way that's appropriate for the subject and conditions. *200mm, 1/250 sec., f/5.6, ISO 400.*

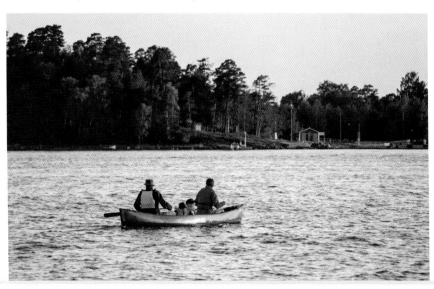

Mode group	Exposure mode	
Full Auto modes	📷 Auto 🚫 Auto (flash off)	Leave all decisions about settings to the camera.
Scene modes (directly selectable on Mode Dial)	Portrait Landscape Child Sports Close-up	Choose the appropriate mode to suit the subject, and the camera then employs appropriate settings.
Scene modes (set Mode Dial to SCENE and use Information Display)	Night portrait Night landscape Party/indoor Beach/snow Sunset Dusk/dawn Pet portrait Candlelight Blossom Autumn colors Food	
Special Effects (set Mode Dial to EFFECTS and use Information Display)	Night Vision Color Sketch Miniature Effect Selective Color Silhouette High key Low key	Use for more extreme pictorial effects.
User-control modes	**P** Program **S** Shutter-priority **A** Aperture-priority **M** Manual	Allow much greater control over the full range of camera settings.

2 » FULL AUTO MODES

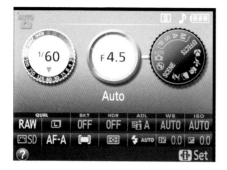

whenever use of flash is prohibited or would be intrusive, or when you just want to discover what the D5200 can do in low light.

Nikon calls these "point-and-shoot" modes, which is probably a fair reflection of the kind of photography for which they're likely to be used. It works pretty well, most of the time; you'll hardly ever get a shot that doesn't "come out" at all, but you may find that the results aren't always exactly what you were aiming for. After all, it's the camera, not you, which is deciding what kind of picture you are taking and how it should look.

There's only one difference between these two modes. In 📷 Auto mode the built-in flash will pop up automatically if the camera determines light levels are too low, and can only be turned off via the Active Information Display *(see page 33)*. (If a separate accessory flashgun is attached and switched on, this overrides the built-in unit.)

In 🚫 Auto (flash off) mode the flash stays off no matter what. This is useful

SENTRY DUTY ⏬
Full auto mode is ideal when shots need to be grabbed quickly, but can diminish your sense of control and creativity. *112mm, 1/400 sec., f/5.6, ISO 250.*

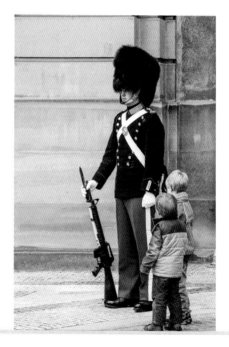

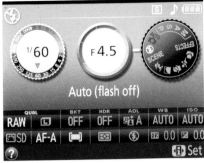

› Exposure warnings

In all modes, if the camera detects that light levels are too low or, more rarely, too high for an acceptable exposure, warnings will be displayed. The viewfinder display blinks, and in the Information Display you'll see a flashing question mark and a warning message.

The camera will still take pictures, but results may be unsatisfactory; for instance, if it's too dark, shots may be underexposed or subject to camera shake. However, the warning will still appear even if the camera is on a tripod, when camera shake should not be an issue.

FLASH OFF ⚡
This mode is suitable when flash is banned or would be intrusive, or just when the picture would be better without it (which it frequently is). *135mm, 1/20 sec., f/4.5, ISO 1600.*

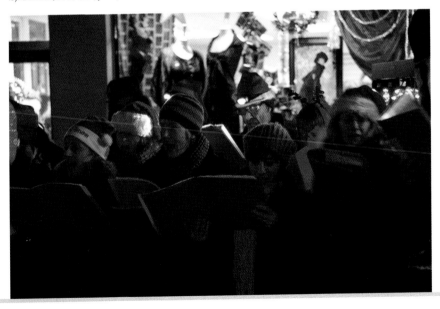

2 » SCENE MODES

The Nikon manual calls these Creative Photography modes—a debatable tag, as they still take many decisions out of your hands. However, even the most experienced may find them handy on occasion, as a quick way to set the camera for shooting a particular kind of image. DSLR newcomers will find Scene modes a good way to discover how differently the camera can interpret the same scene. This makes them a great stepping stone to the full range of options offered by the D5200. The first step is to understand how the various Scene modes work and to be aware of the difference they can make in your images. An obvious way to do this is to shoot the same subject using different modes.

Scene modes control basic shooting parameters such as how the camera focuses and how it sets shutter speed and aperture. They also determine how the image is processed by the camera (assuming you are shooting JPEG images, *see page 68*). For instance, Nikon Picture Controls *(see page 88)* are predetermined. In 🙎 Portrait mode, for example, the camera applies a Portrait Picture Control, which gives natural color rendition and is particularly kind to skin tones. Most Scene modes also employ Auto White Balance *(see page 70)*, but in a few cases the White Balance setting is predetermined to suit specific subjects.

Five Scene modes are directly selectable using the Mode Dial; eleven more are selected by first setting the Mode Dial to **SCENE**, then rotating the Command Dial. The Information Display activates, showing a "virtual mode dial", with the current mode's icon highlighted and its name also shown. A thumbnail image gives an example of an appropriate subject and the way it should turn out when this mode is used. The "virtual mode dial" disappears after a few seconds; rotate the Command Dial again when you need to reactivate it.

› 🙎 Portrait

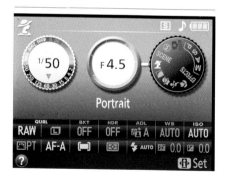

In Portrait mode the camera sets a relatively wide aperture to reduce depth of field *(see page 129)*, helping subjects stand out from their background. The camera also selects the focus point automatically,

› Landscape

PORTRAIT ⌃
Portrait mode works pretty well for candid shots, especially when the light is good and the flash stays off. *200mm, 1/320 sec., f/7.1, ISO 800.*

using Face Detection. You can't override this selection, except by focusing manually. The flash automatically pops up if the camera determines light levels are too low, but can (and often should) be turned off via the Active Information Display. Attaching a separate flashgun will override the built in-flash—and usually improves results dramatically *(see page 168).*

LANDSCAPE MODE »
This mode aims to keep foreground and background sharp, and give vibrant colors. *18mm, 1/40 sec., f/11, ISO 400.*

In Landscape mode, the camera sets a small aperture, aiming to maximize depth of field *(see page 129)*. Small apertures mean that shutter speeds can be on the slow side, so a tripod is often advisable. The camera also selects the focus point automatically, though this can be overridden. A Landscape Picture Control is applied to give vibrant colors. The built-in flash remains off, even in low light, and you can't activate it manually. However, you can use a separate flashgun.

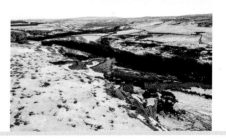

› 🐾 Child

› 🏃 Sports

Child mode is broadly similar to Portrait mode, but one obvious difference is that the camera tends to set higher shutter speeds, no doubt because children are less likely than adults to sit still when required. JPEG processing is based on a Standard Picture Control rather than Portrait, which should give results that are more vivid overall but still give pleasing skin tones. The flash activates automatically, but of course its limitations are just as noticeable as in 🐾 Portrait. It can be turned off via the Active Information Display.

Sports mode is intended for shooting not just sports but other fast-moving subjects, including wildlife. The camera will set a fast shutter speed to freeze the action. This usually implies a wide aperture and therefore shallow depth of field. The camera initially selects the central focus point and if it detects subject movement will track it using all 39 focus points. (You can change the autofocus options via the Active Information Display.) The flash remains off, so if you'd like some fill-in flash (see page 159) you'll have to use a different mode (try 🐾, or one of the user-control modes). Alternatively, fit a separate flashgun. JPEG processing is based on a Standard Picture Control.

CHILD MODE »
Child mode is slanted towards active subjects rather than static poses. *70mm, 1/160th sec., f/6.3, ISO 200.*

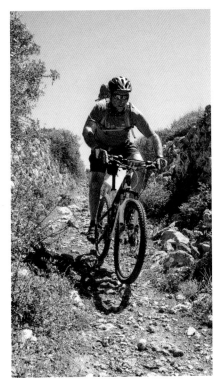

› 🌷 Close-up

SPORTS MODE ⌃
This mode aims to freeze the action. (The author in Menorca, photographed by Bernie Carter.)
27mm, 1/500th sec., f/7.1, ISO 200.

Close-up mode is of course intended for shooting at really close range. The camera sets a medium to small aperture to improve depth of field, so a tripod is often useful to avoid camera shake. The built-in flash will activate automatically in low light, but fortunately it can be turned off via the Active Information Display; built-in flash is often a poor choice for close-up shots *(see page 183).* A separate accessory flashgun, attached and switched on, will override the built-in unit. The camera automatically selects the central focus

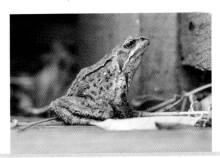

CLOSE-UP MODE »
This mode often benefits from turning off the flash, as with this shot of a common toad.
105mm, 1/100 sec., f/8, ISO 200.

point, but this can be overridden, using
the Multi-selector *(see page 66)*, and you
can also change the AF options or focus
manually. JPEG processing is based on
a Standard Picture Control.

For much more on close-up
photography, see Chapter 5 *(page 174)*.

› Night portrait

In most respects Night portrait mode is
similar to regular Portrait mode, but when
the ambient light is low it allows the
camera to set a long shutter speed to allow
an image of the background to register.
For this reason, it's recommended to use
a tripod or other solid camera support.
The built-in flash operates automatically;
results may be less harsh than regular
Portrait mode but an accessory flashgun
will still improve results. JPEG processing is
based on a Portrait Picture Control.

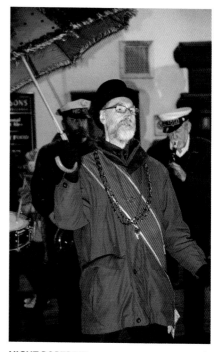

NIGHT PORTRAIT ⌃
Night portrait balances flash and background
lighting. *55mm, 1/60 sec., f/4, ISO 1600.*

› ▦ Night landscape

used. Images are processed to reduce noise and preserve colors, including the varied colors of artificial light. When exposures exceed 1 sec., Long exposure noise reduction applies, which means there is a delay before another shot can be taken *(see page 101)*. The maximum exposure time is 30 sec.; if a longer time is required, use Manual (M) mode and set exposure to Bulb *(see page 56)*. JPEG processing is based on a Standard Picture Control.

Night landscape mode allows long exposures to be used and therefore a tripod is strongly recommended. The built-in flash remains off but an accessory flash can be

NIGHT LANDSCAPE ⌄
This mode allows long exposure times. *24mm, 1/8 sec., f/11, ISO 1600.*

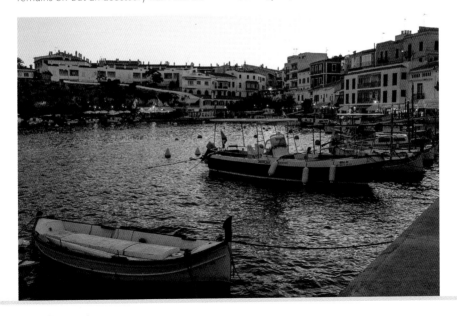

› 🎉 Party/indoor

This mode is broadly similar to 🌃 Night Portrait in seeking to record both people and their background, but does not allow such long exposures to be set. Again, Red-eye reduction flash is employed by default, complete with enforced shutter delay.

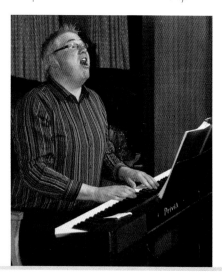

Fortunately, Flash mode can be changed via the Active Information Display *(see page 164)*. JPEG processing is based on a Standard Picture Control.

› 🏖 Beach/snow

Beach and snow scenes are notorious for disappointing results; the subject is full of bright tones and yet pictures all too often turn out relatively dark. The D5200 aims to counteract this, partly by applying exposure compensation *(see page 59)* and partly through image processing. The built-in flash remains off, despite the fact that strong lighting conditions often suggest the use of fill-in flash; however, you can use an accessory flashgun. JPEG processing is based on a Landscape Picture Control.

PARTY/INDOOR «
Flash mode was changed to avoid the agonizing delay created by red-eye reduction flash. *58mm, 1/50 sec., f/11, ISO 1600.*

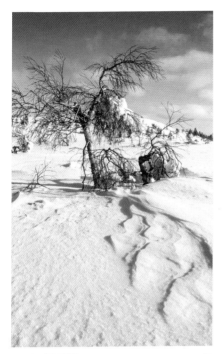

› ☀ Sunset

Sunset mode is similar in most respects to Night landscape. The built-in flash remains off, though an accessory flash can be used to light the foreground; long exposure times are possible and a tripod is recommended. Unlike Night landscape, however, white balance is predetermined, in order to preserve the vivid tones of the sky. JPEG processing is based on a Landscape Picture Control.

BEACH/SNOW ⚞
This mode preserves overall lightness. *18mm, 1/250 sec., f/11, ISO 200.*

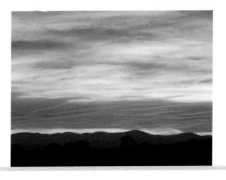

SUNSET »
This mode would be an obvious choice for this shot of a landscape at dusk. *85mm, 1/50 sec., f/11, ISO 1250.*

› Dusk/dawn

› Pet portrait

Dusk/dawn mode is also similar, but allows for the more muted colors and lower contrast usually experienced before sunrise and after sunset; again white balance is predetermined rather than automatic. Flash remains off (though, as ever, an external flashgun can be used) and a tripod is recommended. JPEG processing is based on a Landscape Picture Control.

DUSK/DAWN
This mode suits the softer light of dusk and dawn. *55mm, 1/40 sec., f/11, ISO 200.*

Recommended for portraits of active pets. The built-in flash will fire automatically in low light but the AF-assist illuminator turns off, presumably to avoid disturbing the animal before the shot. The flash can be

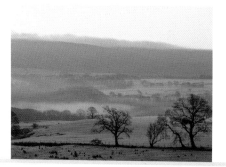

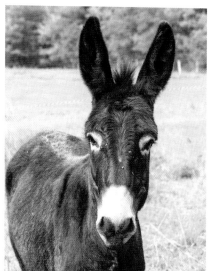

turned off via the Active Information Display. In other respects this mode is very similar to 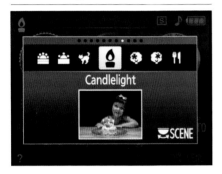 Child, including the use of a Standard Picture Control.

› ♨ Candlelight

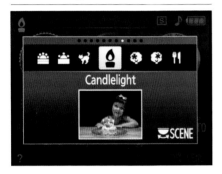

Recommended for portraits and other subjects illuminated by candlelight. Because this light is quite weak, exposure times are usually long, a tripod is recommended, and the subject will need to keep still. The built-in flash does not fire; it's possible to use an external flash but this generally defeats the object of shooting by candlelight. White balance is predetermined to allow for the very red hue of the candlelight. This mode could be used with other dim light sources but

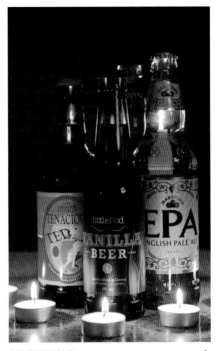

CANDLELIGHT ⌃
This mode does not completely neutralize the warm glow of the candlelight. *65mm, 1/30 sec., f/5, ISO 2500.*

because the camera expects the light to be red, colors with other light sources may appear excessively cool. JPEG processing is based on a Standard Picture Control.

PET PORTRAIT «
Not exactly a pet, but the effect is the same. *85mm, 1/40 sec., f/10, ISO 400.*

› ✿ Blossom

› ✿ Autumn colors

Use this mode for trees in blossom, fields of flowers, and similar subjects. Because the colors are intense, and blooms reflect a lot of light, detail is often lost in images of these subjects. The D5200 employs Active D-Lighting *(see page 87)* to retain detail in these highlight areas. JPEG processing (based on a Landscape Picture Control) aims to keep colors vivid but not garish. The built-in flash remains off.

This mode tackles similar issues, aiming to preserve the colors in autumn foliage, but processing favors the red and yellow parts of the spectrum. You could try it with

BLOSSOM　　　　　　　　　　　　　⌄⌄
These lupins made a vivid display at the roadside. *50mm, 1/60 sec., f/10, ISO 200.*

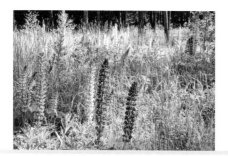

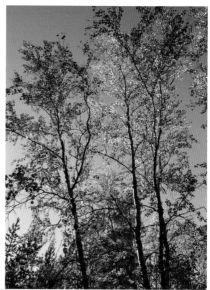

other subjects where these colors are paramount. Again, the built-in flash remains off and a tripod may be needed. JPEG processing is based on a Vivid Picture Control.

› ¶¶ Food

Recommended for detailed and vivid photos of food, this mode is unique among the D5200's Scene modes in that the built-in flash does not operate automatically but can be activated manually with the ⚡ button. However, because food photos are naturally taken at close range, the built-in flash may produce unwanted shadows *(see page 183)*. If the lighting is too dim for a handheld shot, it is usually better to use a separate flash or to

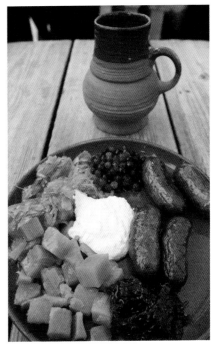

BLOSSOM ⌃
This mode is a good choice for close-up subjects when flash is not required. *18mm, 1/30 sec., f/4, ISO 400.*

employ a tripod. This mode can be handy for shooting other close-up subjects without flash. JPEG processing is based on a Standard Picture Control.

AUTUMN COLORS «
Autumn leaves show up particularly well against a blue sky. *18mm, 1/125 sec., f/11, ISO 200.*

Basic picture taking is essentially the same in all Full Auto and Scene modes.

1) Select the desired mode as described above.

2) Frame the picture.

3) Half-depress the release button to activate focusing and exposure. The focus point(s) will be displayed in the viewfinder image, and shutter speed and aperture settings will appear at the bottom of the viewfinder.

4) Fully depress the shutter release to take the picture.

› Special Effects

It's hard to avoid words like "gimmicky" when discussing Special Effects modes; most photographers will use them sparingly, if at all. For this reason we'll deal with them fairly briefly, starting on *page 93*.

» USER CONTROL MODES

The remaining four modes are traditional standards, which will be familiar to any experienced photographer. As well as allowing direct control over the basic settings of aperture and shutter speed (even in **P** mode through flexible program), these modes give full access to controls like White Balance *(page 70)*, Active D-Lighting *(page 87)* and to Nikon Picture Controls *(page 88)*. These extra controls give you great control over the look and feel of the image.

› (P) Programmed auto

In **P** mode the camera sets a combination of shutter speed and aperture that will give correctly exposed results in most situations. Of course, this much is also true of the Full Auto modes and Scene modes, but **P** mode allows you to adjust other parameters to suit your own creative ideas,

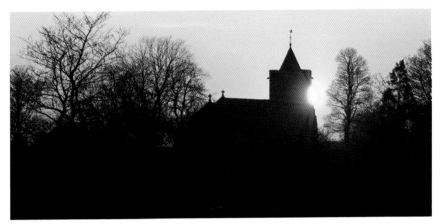

including White Balance *(page 70)*, Active D-Lighting *(page 87)*, and Nikon Picture Controls *(page 88)*. It also allows manual selection of ISO rating *(page 75)*. You can change things even more in **P** mode through options like flexible program (see below), exposure lock *(page 60)*, and exposure compensation *(page 59)*, and you have freedom to use flash, if you wish.

1) Rotate the Mode Dial to position P.

2) Frame the picture.

3) Half-depress the release button to activate focusing and exposure. The focus point(s) are displayed in the viewfinder image and shutter speed and aperture settings appear at the bottom of the viewfinder.

4) Fully depress the shutter release to take the picture.

PROGRAMMED AUTO ⌃
This mode allows you to tailor camera settings to suit your own creative ideas; this shot required +1 exposure compensation. (This is the same church as seen on *page 57*.) *170mm, 1/125 sec. (tripod), f/14, ISO 250.*

Flexible program

Without leaving **P** mode you can change the combination of shutter speed and aperture by rotating the Command Dial. While flexible program is in effect the **P** indication in the Information display changes to **P***. The shutter speed/aperture combination in the viewfinder can be seen to change.

This does not change the overall exposure, but allows you to choose a faster shutter speed to freeze action, or a smaller aperture to increase depth of field *(page 129)*, quickly giving you much of the control that **S** or **A** modes offer.

› (S) Shutter-priority auto

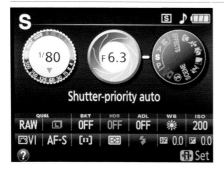

In Shutter-priority (**S**) mode, you control the shutter speed while the camera sets an appropriate aperture to give correctly exposed results in most situations. Control of shutter speed is key for moving subjects *(see page 133)*. You can set speeds between 30 sec. and 1/4000 sec. Fine-tuning of exposure is possible through exposure lock *(page 60)*, exposure compensation *(page 59)*, and possibly auto bracketing *(page 61)*.

› Scene modes and shutter speed

Sports mode, in particular, aims to set a fast shutter speed. This is fine as far as it goes, but does not give the direct, precise control that you get in **S** mode. **S** mode also allows you to shift quickly to a much slower shutter speed, which can be a great way to get a more impressionistic view of action.

See *page 133* for more about shutter speeds.

1) Rotate the Mode Dial to position **S**.

2) Frame the picture.

3) Half-depress the release button to activate focusing and exposure. The focus point(s) will be displayed in the viewfinder image and shutter speed and aperture settings appear at the bottom of the viewfinder. Rotate the Command Dial to alter the shutter speed; the aperture will adjust automatically.

4) Fully depress the shutter release to take the picture.

SHUTTER-PRIORITY ⌄
A slow shutter speed smoothed the falling water. *34mm, 4 sec.(bean bag) f/22, ISO 160.*

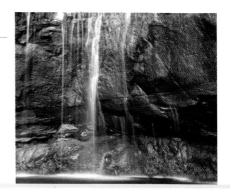

› (A) Aperture-priority auto

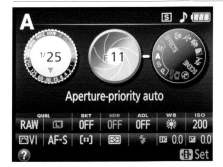

In Aperture-priority (**A**) mode, you control the aperture while the camera sets an appropriate shutter speed to give correctly exposed results in most situations. Control of aperture is particularly useful for regulating depth of field *(see page 129)*. The range of apertures available is limited by the lens that's fitted, not by the camera.

Fine-tuning of exposure is possible through exposure lock *(page 60)*, exposure compensation *(page 59)*, and possibly auto bracketing *(page 61)*.

1) Rotate the Mode Dial to position **A**.

2) Frame the picture.

3) Half-depress the release button to activate focusing and exposure. The focus point(s) will be displayed in the viewfinder, and shutter speed and aperture settings will appear below the viewfinder image.

4) Rotate the Command Dial to alter the aperture; the shutter speed will adjust automatically. The Information Display (in Graphic mode) also shows a graphic representation of the aperture.

5) Fully depress the shutter release to take the picture.

APERTURE-PRIORITY　　　　　**»**
This mode is ideal for controlling depth of field; here I kept it quite shallow. *50mm, 1/1250 sec., f/4, ISO 200.*

› (M) Manual mode

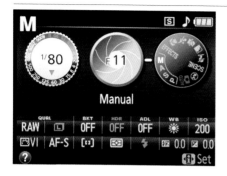

In **M** mode, you control both shutter speed and aperture for maximum creative flexibility. Manual mode is probably best employed when shooting without pressure of time or in fairly constant light conditions. Some experienced photographers use it habitually, enjoying the feeling of complete control.

The range of apertures available is determined by the lens in use, while you can set shutter speeds to any value between 30 sec. and 1/4000 sec. There's also **B** (or "Bulb"), in which the shutter remains open as long as you keep the shutter release depressed; this is not available in any other mode. To avoid camera shake in Bulb, use a wireless remote or remote cord *(see page 227)*.

1) Rotate the Mode Dial to position **M**.

2) Frame the picture.

3) Half-depress the release button to activate focusing and exposure. Check the analog exposure display in the center of the viewfinder readouts; if necessary adjust shutter speed and/or aperture for correct exposure.

4) Rotate the Command Dial to alter the shutter speed.

5) Hold ⊞ and rotate the Command Dial to alter the aperture.

6) Fully depress the shutter release to take the picture.

› Using analog exposure displays

In Manual Mode, an analog exposure display appears in the viewfinder readouts, and in the Information Display if it's active. This shows whether the photograph would be under- or overexposed at the current settings. Adjust shutter speed and/or aperture until the indicator is aligned with the **0** mark in the center of the display.

Tip

In any User-control mode, not just Manual, it is always helpful—time permitting—to review the image and check the histogram display (see Playback, page 84) after taking the shot (a process now known as "chimping"). If necessary you can then make further adjustments for creative effect or if the camera's recommended exposure does not achieve the desired result.

MANUAL MODE ⌄

Faced with a delicate balance of light, I used manual mode and "chimped" the histogram and highlights displays to make sure I wasn't losing too much detail, with special attention to those backlit clouds on the right. *50mm, 1/30 sec. (tripod), f/16, ISO 100.*

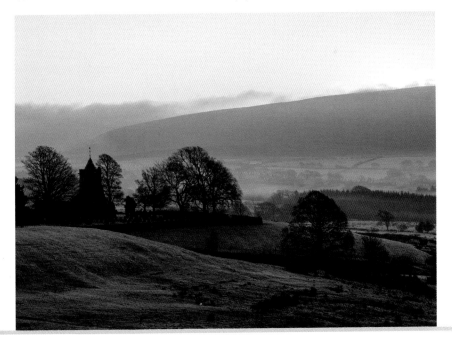

» METERING MODES

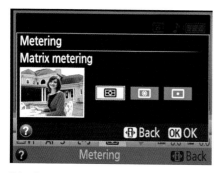

Selecting metering mode

To ensure that images are correctly exposed, the camera must measure the light levels; this is known as exposure metering. The D5200 provides three different metering modes, which should cover any eventuality. Switch between them using the Metering item in the Active Information Display (this is only possible in the User-control modes: in other modes matrix metering is automatically selected).

› 3D Color Matrix Metering II

Using a 2016-pixel color sensor, 3D Color Matrix Metering II analyzes data on the brightness, color, and contrast of the scene. When a Type G or D Nikkor lens is fitted, the system also analyzes distance information based on where the camera focuses—that's why it's called 3D. With other CPU lenses, this distance information is not used and metering automatically reverts to Color Matrix Metering II. Matrix metering is recommended for the vast majority of shooting situations and will nearly always produce excellent results.

› Center-weighted metering

This very traditional form of metering will be familiar to most photographers with experience of 35mm SLR cameras. While the camera meters from the entire frame, it gives greater weight (75%) to a central 8mm circle. Center-weighted metering is useful in areas like portraiture, where the key subject often occupies the central portion of the frame (although the D5200 uses matrix metering in Portrait mode).

› Spot metering

Here the camera meters solely from a small (3.5mm) circular area. This circle is centered on the current focus point, allowing you to meter from an off-center subject. This does not apply if Auto-area AF (AF-A) is in use, when the metering point is the center of the frame. Spot metering is useful when a subject is much darker or lighter than the background and you want to ensure it is correctly exposed (matrix metering is more likely to compromise between subject and background).

» EXPOSURE COMPENSATION

The D5200 will produce accurate exposures under most conditions, but no camera is infallible. It certainly can't read your mind or anticipate your creative ideas.

All metering systems still work partly on the assumption that key subject areas have a middling tonal value (like the "gray card" inside the cover of this book), and should appear as a mid-tone in the images. With subjects a long way from mid-tone, this can give inaccurate results. We've all seen brilliant white snow turn out gray: normal metering has tried to reproduce it as mid-tones, making it darker than it should be. Where very dark tones predominate, the converse is true. In the days of film, considerable experience was needed to accurately anticipate the need for exposure compensation. With instant feedback on exposure, digital cameras smooth the learning curve. It's always helpful to check the image, and the histogram, after shooting (see page 84). This makes it much easier to see when exposure compensation is needed.

The basic principle for exposure compensation is very simple: to make the subject look lighter, give more exposure or apply positive compensation. Conversely, to make the subject darker (to keep dark tones looking dark), give less exposure or apply negative compensation.

Tip

Exposure compensation is only available in P, S, and A modes. In M mode ☒ controls the aperture, but you can "compensate" simply by setting exposure so that the meter readout shows a + or – value. In Auto, Scene and Effects modes exposure control is fully automatic.

› Using exposure compensation

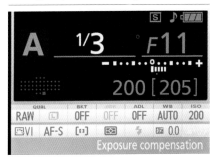

Setting exposure compensation

1) Press ☒ and rotate the Command Dial to set the negative or positive compensation required (between –5 Ev and +5 Ev). The setting is shown in both the viewfinder and Information Display. You can also set exposure compensation in the Active Information Display.

2

2) Release ⊞. The chosen exposure compensation value continues to be indicated in the Information Display. In the viewfinder, the **0** at the center of the analog exposure display flashes while compensation is in effect.

3) Take the picture as normal. If time allows, check that the result is satisfactory.

4) To restore normal exposure settings, repeat step 2 until the displayed value returns to **0.0**.

> ### Resetting exposure compensation

Remember to reset exposure compensation (Step 4 above) when you no longer need it. Exposure compensation is cancelled when you switch to Full Auto or Scene modes, but the camera remembers the compensation setting and restores it when you revert to the User-control modes. It does not reset automatically even when the camera is switched off. However, like many other settings, it will be restored to zero by a two-button reset (*page 76*).

Tip

Exposure compensation can be applied in steps of ⅓ Ev (default) or ½ Ev (use Custom setting b1). The best way to get a sense of how much difference this makes—how big the steps are—is to take a few shots and see: start with a difference of -1 and +1. See page 62 for an example.

» EXPOSURE LOCK

Exposure lock is another way to fine-tune the camera's exposure setting; in fact, many users find this the quickest and most intuitive method. It's useful, for instance, in situations where very dark or light areas (especially light sources) within the frame can overinfluence exposure. Exposure lock allows you to meter from a more average area, by pointing the camera in a different direction or stepping closer to the subject, then hold that exposure while reframing the shot you want. Unlike exposure compensation, it can be used in Scene modes.

Note:
Nikon does not recommend using Exposure lock when you're using Matrix metering, but if Matrix metering does not produce the desired result, why not?

› Using exposure lock

1) Aim the camera in a different direction, or zoom the lens to avoid the potentially problematic dark or light areas. If you're using center-weighted or spot metering, look for areas of middling tone (but which are receiving the same sort of light as the main subject).

2) Half-press the shutter-release button to take a meter reading, then keep it pressed as you press **AE-L/AF-L** to lock the exposure value.

3) Keep **AE-L/AF-L** pressed as you reframe the image and shoot in the normal way.

By default, **AE-L/AF-L** locks focus as well as exposure. This can be changed using Custom setting f2. There are several options, but the most relevant for using exposure lock is AE Lock only. You can also opt for AE Lock (hold). In this case you can release **AE-L/AF-L** after step 2, and exposure will remain locked until you press the button again or the meters turn off.

› Exposure bracketing

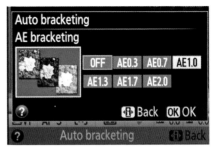

Bracketing in the Active Information Display

A time-honored way to ensure that you capture a correctly exposed image is to take several frames at differing exposures, and select the best one later; this is known as exposure bracketing. The D5200 allows you to bracket three exposures automatically, with up to 2 Ev between each.

1) Ensure that Custom setting e2 is set to AE bracketing (this is the default setting).

2) In the Active Information Display, highlight **BKT** and press **OK**, then use the

> ### Tip
>
> *Avoid exposure bracketing while shooting moving subjects: it's unlikely that the best exposure will coincide with the subject being in the best position. Use other means to get the exposure right beforehand.*

2

Multi-selector to select the exposure differential between shots in the sequence (from 0.3 Ev to 2 Ev). Press **OK** again. The chosen differential is shown in the Information Display. In the viewfinder, the **0** at the center of the Exposure Display flashes.

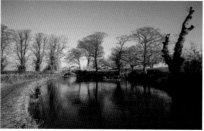

-1 Ev

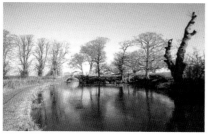

0 Ev

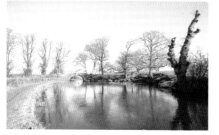

1 Ev

3) Frame, focus, and shoot normally. The camera will vary the exposure with each frame. Continuous release mode *(page 34)* is useful for this; the camera will pause at the end of the three-shot sequence.

4) To cancel bracketing and return to normal shooting, repeat step 2 and select **OFF**.

If the memory card becomes full before the sequence is complete, the camera will stop shooting. Replace the card or delete images to make space; the camera will then resume where it left off. If you turn the camera off in mid-sequence, when next you switch it on it will resume the sequence from where it left off.

ON REFLECTION **«**
Exposure bracketing: –1 Ev; 0 Ev; +1 Ev. *14mm, 1/200 sec., 1/100 sec., 1/50 sec. (tripod), f/11, ISO 200.*

Tip

The D5200 offers other forms of bracketing: choose between them using Custom setting e2 (page 108). Instead of AE bracketing (as described here), you can bracket White Balance or Active D-Lighting.

› FOCUSING

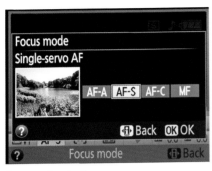

Focus mode selection

Note:
This section deals only with focusing in normal shooting. Focusing in Live View works differently *(see page 79)*. It's also different when shooting movies *(see page 192)*.

Focusing is not simply about ensuring that "the picture" is in focus. It's actually quite difficult, and sometimes impossible, to ensure that everything in an image appears sharp. The first essential is making sure that the camera focuses on the desired subject, or sometimes—especially in close-up photography—the right part of the subject. Control of depth of field *(page 129)* helps to determine how much of the rest of the image will also be sharp.

To secure focus on the desired subject, the D5200 has flexible and powerful focusing capabilities, offering manual focus as well as a range of autofocus modes. To select the focus mode, use the Active Information Display and select the focusing item (by default this reads **AF-A**). Press **OK** and then select from the available options; press **OK** again to confirm the selection and return to shooting mode.

If the camera is in an Auto or Scene mode, only two options are offered. Manual focus can always be selected, but the only autofocus option is AF-A. In P, S, A, or M mode four options are available.

› AF-A (Auto-servo AF)

By default the camera is set to AF-A in all exposure modes. AF-A means that the camera automatically switches between two autofocus modes: single-servo AF and continuous-servo AF (see below).

› AF-S (Single-servo AF)

The camera focuses when the shutter release is pressed halfway. Focus remains locked on this point as long as you maintain half-pressure. The shutter cannot release to take a picture unless focus has been acquired (focus priority). This mode is recommended for accurate focusing on static subjects.

› AF-C (Continuous-servo AF)

› (M) Manual focus

AF-C
AF-C is recommended for moving subjects. *38mm, 1/125 sec., f/11, ISO 200.*

MANUAL FOCUS
I wanted to focus very precisely on the upper edge of the leaf. *100mm macro, 1/25 sec. (tripod), f/16, ISO 200.*

In this mode, recommended for moving subjects, the camera continues to seek focus as long as the shutter release is depressed: if the subject moves, the camera will refocus. The camera is able to take a picture even if perfect focus has not been acquired (release priority).

The D5200 employs predictive focus tracking; if the subject moves while continuous servo AF is active, the camera analyzes the movement and attempts to predict where the subject will be when the shutter is released.

When a camera has sophisticated AF capabilities, manual focus might appear redundant, but many photographers still value the extra control and involvement. There are also certain subjects and circumstances which can bamboozle even the best AF systems. Manual focusing is a straightforward process, which hardly requires description: set the focus mode to MF and use the focusing ring on the lens to bring the subject into focus.

> ### Tip
>
> *Many lenses have an A/M switch: setting this to M will automatically set the camera's mode to MF.*

› Focus confirmation

When using a lens which does not focus automatically with the D5200, you can still take advantage of the camera's focusing technology with focus confirmation. This requires a focus area to be selected, as if you were using autofocus. When the subject in that area is in focus a green dot appears at far left of the viewfinder display. You can obtain further assistance with manual focus by choosing **ON** in Custom Setting a4 (Rangefinder). This enables the exposure display in the viewfinder to show whether the focus point is in front of or behind the subject, and by how much. This is not available in Manual exposure mode, when the exposure indicator is needed for its primary purpose.

› AF-area modes

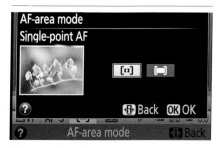

AF-area mode selection

The D5200 has 39 focus points covering much of the frame. When you half-press the shutter release, the currently active

focus point(s) are highlighted in red. The overall area which they cover is shown by a faint outline. To focus on the desired subject, it's vital that the camera uses appropriate focus point(s); this is the what AF-area mode is for. Select AF-area mode in the Active Information Display.

By default, the camera selects the focus point automatically (Auto-area), but you can always change to manual selection in any shooting mode. However, the camera only "remembers" this selection in P, S, A, or M modes. If you change the default setting in any of the Auto or Scene modes it will remain in effect only as long as you remain in that Exposure mode. For instance, if you switch from Portrait to Landscape and then back again, you'll find that the camera has reverted to default.

› Auto-area [■]

In Auto-area, the camera selects the focus point automatically. In effect, the camera is deciding what the intended subject is. When Type G or D lenses are used, Face Recognition allows the D5200 to distinguish a human subject from the background. Many photographers prefer to make their own selection; determining what the subject is seems a pretty basic decision—and the other AF-area modes let you do just that.

› Single-point [⁛]

In this mode, you select the focus area, using the Multi-selector to move quickly through the 11 focus points. The chosen focus point is illuminated in the viewfinder. This mode is best suited to relatively static subjects and as such marries naturally with AF-S autofocus mode.

› Dynamic-area AF [⁛]

This mode is more complicated, as it has several sub-modes. These can only be selected when the AF mode is AF-A or AF-C (see pages 63 and 64).

In all dynamic-area AF modes, the initial focus point is still selected by the user, as in Single-area AF, but if the subject moves, the camera will then employ other focus points to maintain focus. It's still trying to track the subject you selected, rather than making its own decision on what the subject is (as it does in [■] Auto-area).

The sub-mode options determine the number of focus points that will be employed for this: 9, 21, or the full 39 points. The final option is 3D tracking, which uses a wide range of information, including subject colors, to track subjects that may be moving erratically.

› Focus point selection

FOCUS POINT SELECTION ⌃
I selected the focus point manually; left to itself the camera would have focused on a closer twig. *105mm, 1/125 sec., f/6.3, ISO 400.*

1) Ensure the camera is set to an AF-area mode other than [■] Auto-area.

2) Half-depress the shutter release to activate autofocus.

3) Using the Multi-selector, move the focus point to the desired position (pressing **OK** jumps directly to the central focus point). The chosen focus point is briefly illuminated in red in the viewfinder and then remains outlined in black. If the AF-area mode is Dynamic, the focus point may move.

4) Press the shutter-release button halfway to focus at the selected point; depress it fully to take the shot.

› Focus lock

Though the D5200's focus points cover a wide area, they do not extend to the edges of the frame, and sometimes you may need to focus on a subject that does not naturally coincide with any of the focus points. The simplest way to do this is as follows:

1) Adjust framing so that the subject falls within the available focus area.

2) Select an appropriate focus point and focus on the subject in the normal way.

3) Lock focus. In Single-Servo AF mode, this can be done either by keeping half-pressure on the shutter-release button, or by pressing **AE-L/AF-L**. An **AE-L** icon appears in the viewfinder. In Continuous-Servo AF, only **AE-L/AF-L** can be used to lock focus.

4) Reframe the image as desired and press the shutter-release button fully to take the picture. If half-pressure is maintained on the shutter-release button (in Single-Servo AF), or **AE-L/AF-L** is kept under pressure (in either AF mode), focus will remain locked for further shots.

> **Note:**
> By default, **AE-L/AF-L** also locks exposure as well as focus, but this behavior can be changed using Custom setting f2.

The viewfinder displays available focus areas and an in-focus indicator at the left of the menu bar

› AF-assist illuminator

The AF-assist illuminator

An AF-assist illuminator, a small lamp, helps the camera focus in dim light. The camera needs to be in Single-Servo AF, and either the central focus point must be selected or Auto-area AF engaged. It does not apply in Live View or Movie mode and is disabled in a few Scene modes. For effective operation, the lens should be in the range 18–200mm and the subject no more than 9ft (3m) away. The AF-assist illuminator can be turned off using Custom setting a3.

2 » IMAGE QUALITY

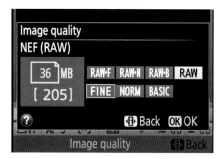

Setting image quality in the Active Information Display

The Image quality settings are not a shortcut to great pictures; that is still—thank goodness—the photographer's responsibility. "Image quality" refers to the file format, i.e. the way in which image data are recorded. The D5200 offers a choice of two file types: NEF (RAW) and JPEG.

The essential difference is that JPEG images are extensively processed in the camera to produce photos that should be usable right away (for instance, for direct printing from the memory card), needing little or no further processing on computer.

NEF (RAW) files, on the other hand, record image data from the sensor complete and unadulterated, without onboard processing. This leaves much greater scope for processing later to achieve exactly the pictorial result you desire. This requires sophisticated software

such as Nikon Capture NX2 or Adobe Lightroom. The generic term for files which preserve the raw data is RAW or Camera RAW; NEF is a Nikon-specific RAW file format.

The D5200 allows you to capture two versions of the same image simultaneously, one RAW and one JPEG. The JPEG can serve for immediate needs while the RAW version can be processed later for the ultimate result.

There are three options for JPEG quality (the compression applied when the file is saved). More compression produces smaller files but can degrade image quality. Fine produces the largest files but highest quality; Basic produces smaller files but lower quality; Normal is in-between.

› Setting image quality

1) In the Active Information Display, select the Image quality item.

2) Press **OK** to bring up the list of options. Using the Multi-selector, highlight the required setting then press **OK** again to make it effective.

Image quality options

RAW	14-bit NEF (RAW) files are recorded for the ultimate quality and flexibility.
FINE	8-bit JPEG files are recorded with a compression ratio of approximately 1:4; should be suitable for prints of A3 size or even larger.
NORM	8-bit JPEG files are recorded with a compression ratio of approximately 1:8; should be suitable for modest-sized prints.
BASIC	8-bit JPEG files are recorded with a compression ratio of approximately 1:16; suitable for transmission by email or website use but not recommended for printing.
RAW + F **RAW + N** **RAW + B**	Two copies of the same image are recorded simultaneously, one NEF (RAW) and one JPEG (Fine, Normal or Basic).

» IMAGE SIZE

For JPEG files, the D5200 offers three options for image size. **Large** is the maximum available size from the D5200's sensor, i.e. 6000 x 4000 pixels. **Medium** is 4496 x 3000 pixels, roughly equivalent to a 13.5-megapixel camera. **Small** is 2992 x 2000 pixels, roughly equivalent to a 6-megapixel camera. Even Small size images exceed the maximum resolution of an HD TV, or almost any computer monitor, and can yield reasonable prints up to around 12 x 8 inches (at 300 dpi). RAW files are always recorded at the maximum size.

> ### Tip
>
> *It's often assumed that RAW is the "real" photographer's choice and JPEG is for the casual snapper. It ain't necessarily so. You can get great results shooting JPEG (especially at Fine quality setting). However, there's less room to "fix" images later, so if you're serious about great results, shooting JPEG demands more, not less, care.*

› Setting image size

1) In the Active Information Display, select **Image size**. (If Image quality is set to **RAW** you will not be able to select this item.)

2) Press **OK** to bring up the list of options. Using the Multi-selector, highlight the required setting then press **OK** again to make it effective.

2 » WHITE BALANCE

Light sources, natural and artificial, vary enormously in color. The human eye and brain are very good (though not perfect) at compensating for this and seeing people and objects in their "true" colors, so that we nearly always see grass as green, and so on. Digital cameras also have a capacity to compensate for the varying colors of light and, used correctly, the D5200 can produce natural-looking colors under almost any conditions you'll ever encounter.

The D5200 has a sophisticated system for determining white balance automatically, which produces good results most of the time. For finer control, or for creative effect, the D5200 also offers a range of user-controlled settings, but these are only accessible when using P, S, A, or M modes.

› Setting white balance

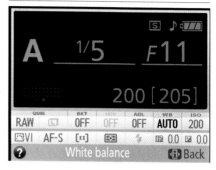

Setting white balance in the Active Information Display

There are two ways to set white balance:

Using the Active Information Display

1) In the Active Information Display, select the **WB** item near top right and press **OK** to reveal a list of options.

2) Use the Multi-selector to highlight the required setting, then press **OK** to accept it.

Tip

When shooting RAW images, the in-camera WB setting is not crucial, as white balance can be adjusted in later processing. However, it shouldn't be ignored, as it affects how images look on playback and review.

Incandescent

Flash

Cool-white fluorescent

Cloudy

Direct sunlight

Shade

EFFECTS OF WHITE BALANCE SETTINGS

Six otherwise identical shots, taken seconds apart, demonstrate how radically white balance settings can change the overall effect.

Using the Shooting menu

This is a slower method but makes extra options available.

1) Press **MENU**, select **Shooting menu**, and navigate to **White Balance**.

2) Press **OK** to reveal a list of options.

3) Use the Multi-selector to highlight the required setting, then press **OK**. Alternatively press ▶.

4) If you press ▶, a graphical display appears. Using this, you can fine-tune the setting using the Multi-selector, or just press **OK** to accept the standard value.

5) If you select Fluorescent at Step 3, a sub-menu appears from which you can select an appropriate variety of fluorescent lamp (see table opposite). You can then fine-tune this setting even further by pressing ▶ as in Step 4.

Tips

If images consistently appear color-shifted on your computer screen, don't try and compensate by adjusting the camera's white balance; the problem is far more likely to be with the computer screen settings (see page 240). The end-papers of this book are designed to serve as "gray cards", ideal for reference photos for these purposes.

Notes :

If you use the the Active Information Display to select Fluorescent, the precise value will be whatever was last selected in the sub-menu under the Shooting menu. (The default is 4: Cool-white fluorescent.)

Energy-saving bulbs, which have largely replaced traditional incandescent (tungsten) bulbs, are compact fluorescent units. Their color temperature varies but many are rated around 2700°, equivalent to Fluorescent setting 1 Sodium-vapor lamps. In case of doubt, it's always a good idea to take test shots if possible, or allow for adjustment later by shooting RAW files.

› Preset Manual White Balance

You can set the White Balance to precisely match any lighting conditions, by taking a reference photo of a neutral white object. Frankly, this is a complicated procedure that few will ever employ (see the Nikon Reference manual for details; it takes two pages). It's normally much easier to shoot RAW and tweak the white balance later; a reference photo can also be helpful for this when high precision is required. The RAW route is not only easier in itself, it avoids the pitfall that the Preset Manual setting will go on being applied to shots when it's no longer appropriate.

Icon	Menu option	Color temperature	Description
AUTO	Auto	3500–8000	Camera sets white balance automatically, using information from imaging and metering sensors. Most accurate with Type G and D lenses.
☀	Incandescent	3000	Use in incandescent (tungsten) lighting, e.g., traditional household bulbs.
	Fluorescent:	Submenu offers seven options:	
	1 Sodium-vapor lamps	2700	Use in sodium-vapor lighting, often used in sports venues.
	2 Warm-white fluorescent	3000	Use in warm-white fluorescent lighting
	3 White fluorescent	3700	Use in white fluorescent lighting
☼	4 Cool-white fluorescent	4200	Use in cool-white fluorescent lighting
	5 Day white fluorescent	5000	Use in daylight white fluorescent lighting
	6 Daylight fluorescent	6500	Use in daylight fluorescent lighting
	7 High temp. mercury-vapor	7200	Use in high color temperature lighting, e.g., mercury vapor lamps.
☀	Direct sunlight	5200	Use for subjects in direct sunlight
⚡	Flash	5400	Use with built-in flash or separate flashgun
☁	Cloudy	6000	Use in daylight, under cloudy/overcast skies.
⌂	Shade	8000	Use on sunny days for subjects in shade
K	Choose color temp	2500-10000	Select color temperature from list of values
PRE	Preset Manual	n/a	Derive white balance direct from subject or light source, or from an existing photo.

2 » ISO SENSITIVITY SETTINGS

The ISO setting governs the camera's sensitivity to greater or lesser amounts of light. At higher ISO settings, less light is needed to capture an acceptable image. As well as accommodating lower light levels, higher ISO settings are also useful when you need a small aperture for increased depth of field *(see page 129)* or a fast shutter speed to freeze rapid movement *(see page 133)*. Conversely, lower ISO settings are useful in brighter conditions, and/or when you want to use wide apertures or slow shutter speeds. The D5200 offers ISO settings from 100 to 6400. There is some tendency for image noise *(see page 149)* to increase at higher settings, though the D5200 manages this very well. In addition there are Hi settings beyond the standard range, but here noise is often more obvious. These settings are

HIGH ISO ❯❯
Good image quality at high ISO ratings helps avoid the use of flash. *16mm, 1/100 sec., f/8, ISO 3200.*

Hi0.3 (equivalent to 8000 ISO), Hi0.7 (10400 ISO), Hi1.0 (12800 ISO), and Hi2.0 (25600 ISO). You can go even higher using Night Vision in the Special Effects modes *(see page 93)*.

› Auto-ISO

By default, the D5200 sets the ISO automatically. It's possible to change to a manual setting in most exposure modes (except 📷, 🌃, and 🎞). This new setting will continue to apply if you switch exposure modes. However, if you switch to P, S, A, or M mode and then back to a Scene mode, the camera reverts to Auto-ISO. The D5200 only permanently "remembers" manual settings in P, S, A, or M modes.

The ISO sensitivity settings item in the Shooting menu has a sub-menu called Auto ISO sensitivity control. If this is set to ON, you can still select an ISO setting manually, but the D5200 will automatically deviate from this if it determines that this is required for correct exposure. Extra options within this menu allow you to limit the maximum ISO and minimum shutter speed which the camera can employ when applying Auto ISO sensitivity control.

› Setting the ISO

Setting the ISO in the Active Information Display

» COLOR SPACE

Setting Color space in the Setup menu

The usual way to set the ISO is through the Active Information Display:

1) Select the **ISO** item and press **OK** to reveal a list of options.

2) Use the Multi-selector to highlight the required setting, then press **OK** to accept it.

Alternatively, use the **ISO sensitivity settings** item in the Shooting menu.

A third option is available, by assigning **Fn** to **ISO sensitivity** in Custom setting f1. If this is done, pressing the button highlights the **ISO** item in the Information Display and settings can then be changed simply by rotating the Command Dial. If you change ISO settings regularly, this is an option well worth considering.

Color spaces define the range (or gamut) of colors which can be recorded. Like most DSLRs, the Nikon D5200 offers a choice between sRGB and Adobe RGB color spaces. The chosen color space will apply to all shots taken in all exposure modes. To select the color space, use the Color space item in the Setup menu.

> ### Tip
>
> *Variable ISO is one of the greatest advantages of digital over film, as you'll appreciate if you've ever struggled with a 35mm camera and film of the wrong speed. Being able to vary the ISO at any time gives terrific flexibility and many digital photographers change it almost as frequently as they do aperture and shutter speed.*

sRGB (the default setting) has a narrower gamut but images often appear brighter and more punchy. It's the standard color space on the Internet and in photo printing stores, for example, and is a safe choice for images that are likely to be used or printed straight off, with little or no post-processing.

Adobe RGB has a wider gamut and is commonly used in professional printing and reproduction. It's a better choice for images that are destined for professional applications or where significant post-processing is anticipated. However, images straight from the camera may look flat and dull on most computers and web devices or if printed without full color management.

» TWO-BUTTON RESET

The D5200 offers a quick way to reset a large number of camera settings (listed below) to default values. Hold down **MENU** and ◄🟐► (marked with green dots) together for at least 2 seconds. The Information Display will blank out briefly while the reset is completed. There are also options in the Shooting menu and Custom Setting menu to reset any changes you may have made there.

Item	Default setting	
Image quality	JPEG Normal	
Image size	Large	
Release mode	Single frame (Continuous H in 🏃 and 🐕)	
ISO sensitivity	Auto and scene modes	Auto
	User-control modes	100
White Balance	Auto (fine-tuning off)	
Nikon Picture Controls	Resets any modifications to current Picture Control	
Autofocus mode	AF-A (except 🖼 , *see page 93*)	
Autofocus mode (Live View)	AF-S	
AF-Area mode	🌷 👤 🍴 🏞 Hi Lo	Single-point
	🏃 🐕	Dynamic-area [⊡]
	P, S, A, M, 📷, 🐠, 🏊, 🖼, 🎆, 🏖, 🎭, 🏝, 🌆, 🌃, 🌅, 🌄, 🍂, 🐾, 🖊	Auto-area
AF-Area mode (Live View)	📷, 🐠, 🏊, 🖼, 🎆, 🏖, 🎭, 🏝, 🌃, 🌅, 🌄	Face-priority
	P, S, A, M 🏃, 🖼, 🐕 🖼, 🌃, 🌆, 🖊, 🏞, Hi, Lo	Wide-area
	🌷, 🍴	Normal-area
Focus point	Center	
Metering	Matrix	
AE-L/AF-L hold	Off	
Active D-Lighting	Auto	
Flexible program	Off	
Exposure compensation	Off	
Flash compensation	Off	
HDR mode	Off	
Multiple exposure	Off	
Bracketing	Off	
Flash mode	📷, 🏊, 🌷, 🏖, 🐕, 🌃	Auto
	🖼	Auto slow sync
	🎭	Auto with red-eye reduction
	P, S, A, M	Front-curtain sync

Live View mode lets you frame pictures using the LCD screen rather than the viewfinder, in the same way as most compact digital camera users. However, Live View on DSLRs has generally been seen as secondary to the viewfinder. SLRs are essentially designed around the viewfinder and it still has many advantages for general picture-taking; it's more intuitive, offers the sense of a direct connection to the subject, and carries much less risk of camera shake. Viewfinder-based autofocus is also much faster. It can also be very hard to see the screen in bright sunlight, unless you use a shade (see Accessories and care, page 228).

However, Live View has some definite advantages at times. The screen image shows 100% of the picture area, which the viewfinder does not; this aids precise framing. Also, Live View focusing, though noticeably slower than viewfinder AF, is more accurate. These advantages are fully realized when the camera is on a tripod—which also neutralizes much of the viewfinder's advantage in handling.

Live View is also the jumping-off point for shooting movies with the D5200. Movies are covered in Chapter 6 (see page 186); however, familiarity with Live View is a big help in preparing you for movie shooting.

› Using Live View

To activate Live View, pull back and release the **Lv** switch on top of the camera, by the Mode Dial. To exit Live View pull it again.

The mirror flips up, the viewfinder blacks out, and the LCD screen displays a continuous live preview of the scene. A range of shooting information is displayed at top and bottom of the screen, partly overlaying the image. Pressing **INFO** changes this information display, cycling through a series of screens as shown in the table; a further press returns to the starting screen.

When Live View is active, pressing ▄ᴵ▪ superimposes a modified Active Information Display on the screen and you can select options in the usual way. Press ▄ᴵ▪ again, or press the shutter, to hide this display.

Show indicators

Live View info	Details
Show indicators (default)	Information bars superimposed at top and bottom of screen.
Show movie indicators	Information for movie shooting superimposed; movie frame area also indicated.
Hide indicators	Top information bar disappears, key shooting information still shown at bottom.
Framing grid	Grid lines appear, useful for critical framing.

Press the release button fully to take a picture, as when shooting normally. In the continuous release modes the mirror stays up, and the monitor remains blank, between shots, making it almost impossible to follow moving subjects.

If Auto or Scene modes are selected, exposure control is fully automatic, except that in Scene modes exposure level can be locked by pressing and holding **AE-L/ AF-L**. In P, S, A, or M modes, exposure control is much the same as in normal shooting. If you use exposure compensation in P, S, or A modes, the brightness of the Live View display changes to reflect this. However, this can't be relied on as a preview of the final image. In M mode the brightness of the display does not change as you adjust settings.

› Focusing in Live View

The focus area (red rectangle) can be positioned anywhere on screen

Focusing in Live View operates differently from normal shooting; because the mirror is locked up, the usual focusing sensor is unavailable. Instead, the camera reads focus information directly from the main image sensor. This is slower than normal AF operation (often very noticeably so), but very accurate. You can also zoom in the view, which helps in placing the focus

point exactly where you want it (and in manual focusing too).

Live View has its own set of autofocus options, with two AF modes and four AF-area modes.

You can zoom in on the focus area for greater precision

› Live View AF modes

The AF-mode options are Single-servo AF (AF-S) and and Full-time servo AF (AF-F). AF-S corresponds to AF-S in normal shooting: the camera focuses when the shutter release is pressed halfway, and focus remains locked as long as the shutter release remains depressed.

AF-F corresponds roughly to AF C in normal shooting. However, the camera continues to seek focus as long as Live View remains active. When you press the shutter-release button halfway, the focus will lock, and remains locked until you release the button or take a shot.

› Selecting the Live View AF mode

1) Activate LIve View with the **Lv** switch.

2) Press **⋅⊞⋅** to engage the Active Information Display and use the Focus mode item to select between AF-S and AF-F (Manual Focus is also available).

3) Press **⋅⊞⋅** again to return to Live View.

› Live View AF-area mode

Selecting Live View AF-area mode

AF-area modes determine how the focus point is selected. There are four Live View AF-area modes, which are different from those used in normal shooting (see table above opposite). Again, selection is through the Active Information Display.

AF- area Mode	Description
🙂 Face priority	Uses face detection technology to identify people. Yellow border appears outlining faces. If multiple subjects are detected the camera focuses on the closest. Default in most Scene modes.
[꘎] WIDE Wide-area	Camera analyzes focus information from area approximately ⅙ the width and height of the frame; area is shown by red rectangle. Default in 🍔, 🍴.
[꘎] NORM Normal area	Camera analyzes focus information from a much smaller area, shown by red rectangle. Useful for precise focusing on small subjects. Default in 🏃, 🏞, 🐈, ⛰, 🄷ⁱ, 🄻ᵒ.
⊕ Subject tracking	Camera follows selected subject as it moves within the frame.

› Using Live View AF

[꘎] WIDE Wide-area AF and [꘎] NORM Normal area AF

In both these AF modes, you can move the focus point (outlined in red) anywhere on the screen, using the Multi-selector in the usual way. Pressing 🔍 zooms the screen

Tip

The ability to move the focus point anywhere on screen is useful for off-center subjects, especially when using a tripod. In handheld shooting it's often quicker and easier to use the viewfinder and employ focus lock (see page 67).

NORMAL AREA AF 《
Normal area AF is the best choice for precision and accuracy. *50mm macro, 1/125 sec. (tripod), f/9.*

view—press repeatedly to zoom closer. Helpfully, the zoom centers on the focus point. This allows ultra-precise focus control, especially when shooting on a tripod; it's excellent for macro photography *(see page 174)*. Once the focus point is set, autofocus is activated as normal by half-pressing the shutter-release button. The red rectangle turns green when focus is achieved.

💁 Face-priority AF

When this mode is active, the camera automatically detects up to 35 faces and selects the closest. The selected face is outlined with a double yellow border. You can override this and focus on a different person by using the Multi-selector to shift the focus point. To focus on the selected face, press the shutter-release button halfway.

⊡ Subject tracking AF

When Subject tracking is selected, a white rectangle appears at the center of the screen. Align this with the desired subject using the Multi-selector, then press **OK**.

Warning!

Subject tracking can't keep up with rapidly moving subjects. Using the viewfinder is much more effective for these.

The camera "memorizes" the subject and the rectangle then turns yellow. It will now track the subject as it moves, and can even reacquire the subject if it temporarily leaves the frame. To focus, press the shutter-release button halfway; the target rectangle blinks green as the camera focuses and then becomes solid green. If the camera fails to focus, the rectangle blinks red instead. Pictures can still be taken but focus may not be correct. To end focus tracking press **OK** again.

Manual focus

Manual focus is engaged as in normal shooting *(see page 64)*. However the Live View display continues to reflect the selected Live View AF mode. It's helpful to have Wide-area AF or Normal-area AF selected, as the display still shows a red rectangle of the appropriate size. You don't have to focus manually on this point, but if you zoom in for more precise focusing, the zoom centers on the area defined by the rectangle.

» IMAGE PLAYBACK

The D5200's large, bright LCD screen makes image playback a pleasure. Perhaps more importantly, it's also full of useful information, which can really help you in making the images you shoot a better match for your vision.

At default settings, the most recent image is automatically displayed immediately after shooting, as well as whenever ▶ is pressed. (In continuous release mode, playback only begins after the last image in a burst has been captured; images are then shown in sequence.) This default behavior, and many other playback options, can be changed through the Playback menu.

› Viewing additional pictures

To view images on the memory card, other than the one most recently taken, scroll through them using the Multi-selector. Scroll right to view images in the order of capture, scroll left to view in reverse order ("go back in time").

› Viewing photo information

The D5200 records masses of information (metadata) about each image taken, and this can also be viewed on playback, using the Multi-selector to scroll (up or down) through up to seven pages of information.

However, by default, just two pages are available—a full-screen view and an overview page which includes basic information and a simplified histogram.

To make other screens available select **Playback display options** in the Playback menu and check the required options, then scroll up to **Done** and press **OK**.

› Highlights

The Highlights display (this image is taken from Adobe Lightroom, and shows clipped highlights in red: on the camera they flash black)

The Highlights screen displays a flashing warning for any parts of the image with "burnt-out" highlights, i.e. completely white with no detail recorded *(see pages 140 and 150)*. This is a big help in assessing whether an image is correctly exposed, and it's more objective than relying solely on a general impression of the image on the monitor.

Playback display options

Additional photo info	None (image only)	Full-screen image with no superimposed data.
	Highlights	Areas of "blown" highlights are shown as black, blinking areas in full-screen playback.
	RGB histogram	Makes available a separate playback page with histograms for the three individual color channels.
	Shooting data	Makes available three further playback pages containing detailed information about the image.
	Overview	Shows small image, single histogram, and key shooting data.

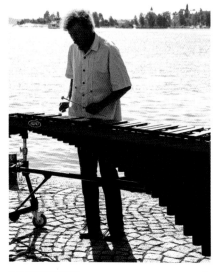

TONE PERFECT ⌃
I wanted the image to sparkle but not to lose detail in clipped highlights, so checked the highlight display after the first shot. *55mm, 1/320 sec., f/11, ISO 200.*

› Histogram displays

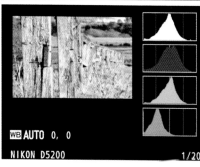

RGB histogram display

The histogram is a kind of graph showing the distribution of dark and light tones in an image. As a way of assessing if an image is correctly exposed it's much more precise than just looking at the full-frame playback, especially in bright sunlight, when it's hard to see the screen image clearly. The overview page (see above)

shows a single histogram during playback. By selecting **Playback mode** in the Playback menu and checking **RGB histogram**, you gain access to a more detailed display which shows individual histograms for the three color channels (red, green, and blue). The histogram display is the single most useful feature of image playback and it's normally the first thing I look at. Learning to interpret the histogram is a massive help in getting the best results from your D5200. For more on this, *see pages 140 and 150.*

› Playback zoom

Playback zoom

To assess sharpness, or for other critical viewing, it's possible to zoom in on a section of an image. For Large images (including RAW files) the maximum magnification is approximately 38x.

1) Press ⊕ to zoom in on the image currently displayed (or the selected

image in thumbnail view). Press repeatedly—up to 10 times—to increase the magnification; press ⊖▣ to zoom out again. A small navigation window appears briefly, with a yellow outline indicating the area currently visible in the monitor.

2) Use the Multi-selector to move the zoom area, i.e. to view other areas of the image.

3) Rotate the Command Dial to view corresponding areas of other images at the same magnification.

4) To return to full-frame viewing, press **OK** to return instantly to full-frame view. Or exit playback by pressing ▶ or the shutter-release button.

› Viewing images as thumbnails

Thumbnail View

To view more than one image at a time, press ⊖▣ once to display 4 images, twice for 9 images, three times for 72 images.

Use the Multi-selector to scroll up and down to bring other images into view. The currently selected image is outlined in yellow. To return to full-frame view, press \mathcal{Q} once or more, as required.

› Calendar View

Calendar View

An extension to Thumbnail View, Calendar View can display images grouped by the date(s) when they were taken. Having pressed \mathcal{Q} repeatedly to display 72 images, press once more to reach the first calendar page (Date View). The most recent date is highlighted, and pictures from that date appear in a vertical strip on the right (the thumbnail list). In this view, the Multi-selector can be used to navigate to different dates.

If you press \mathcal{Q} again, you highlight the thumbnail list for the selected date and can then scroll through pictures taken on that day. Press \mathcal{Q} to see a larger preview

of the currently selected image. Press \mathcal{Q} again to go back to Date View. Press **OK** at any point to return to full-frame view.

› Deleting images

To delete the current image, or the selected image in Thumbnail View, press 🗑. A confirmation dialog appears. To proceed with deletion press 🗑 again; to cancel, press ▶.

In Calendar View (Date View) you can also delete all images taken on a selected date. Highlight that date in Date View, then press 🗑; when the confirmation dialog appears press 🗑 again to delete or ▶ to cancel.

› Protecting images

To protect the current image, or the selected image in Thumbnail View/ Calendar View, against accidental deletion, press **AE-L/AF-L**. To remove protection, press **AE-L/AF-L** again.

Warning!

Protected images will be deleted when the memory card is formatted.

» IMAGE ENHANCEMENT

The D5200 enables you to adjust and enhance images in various ways in-camera. These adjustment options divide into two kinds. First, there are settings which are selected before shooting, and affect how the camera processes the image. Second, changes can be made to images already on the memory card; these changes don't alter the original photo but create a retouched copy.

It's easy to get confused between the similarly-named Active D-Lighting (applied pre-shoot) and D-Lighting (applied post-shoot). D-Lighting, and other adjustments which can be applied to images already on the memory card, are gathered in the Retouch menu *(see page 116)*.

› Pre-shoot controls

We've already covered settings which affect the qualities of the final image, such as exposure and white balance. The D5200 offers further options which affect the look of the picture, principally Nikon Picture Controls and Active D-Lighting. However, these can only be accessed when shooting in P, S, A, or M modes. In Auto and Scene modes, Active D-Lighting is off and Picture Controls are preset *(see page 88)*. Special Effects modes *(page 93)* have a very obvious effect on the look of an image.

Note:
These settings are useful for improving the quality of JPEG images. When shooting RAW files, they have no effect on the basic raw data. However, they do affect the appearance of the preview/playback image on the LCD screen so it's still worth using appropriate settings for Picture Controls and Active D-Lighting.

› Active D-Lighting

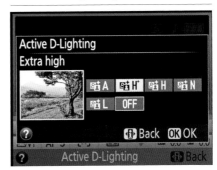

Setting Active D-Lighting in the Active Information Display

Active D-Lighting is designed to enhance the D5200's ability to cope with scenes that show a wide range of brightness (dynamic range). In simple terms, it reduces the overall exposure in order to capture more detail in the brightest areas, while mid-tones and shadows are

ACTIVE D-LIGHTING
The same scene with Active D-Lighting Off and Extra High helps to retain shadow and highlight detail. *40mm, 1/15, and 1/30 sec., f/11, ISO 100.*

subsequently lightened as the camera processes the image.

1) In the Active Information Display, select the **ADL** item and press **OK**. Alternatively, in the Shooting menu, select Active D-Lighting.

2) Select from the list of options to determine the strength of the effect (the default setting is Auto). Press **OK**.

ADL bracketing

You can set the camera to take two shots, one with Active D-Lighting off and one with it on, using the current setting (see above).

1) Set Custom setting e2 to ADL bracketing.

2) In the Active Information Display, highlight the **BKT** item (bottom right) and press **OK**.

3) Select **ADL** and press **OK**.
From now on, alternate shots will be taken with and without Active D-Lighting, until bracketing is cancelled. To cancel, repeat Steps 2 and 3, selecting **OFF** in Step 3.

› Nikon Picture Controls

Picture Controls influence the way JPEG files are processed by the camera. In Full Auto and Scene modes the Picture Control is predetermined, but when shooting in P, S, A, or M modes you have a free hand to choose and fine-tune them.

The D5200 offers six preset Picture Controls. Names like **Neutral (NL)** and **Vivid (VI)** are self-explanatory, and **Monochrome (MC)** even more so. **Standard (SD)** gives a compromise setting which works reasonably well in a wide range of situations. **Portrait (PT)** is designed to deliver slightly lower contrast

IN CONTROL ⌃
Vivid (L) and Neutral (R) Picture Controls applied to the same subject. *55mm, 1/200 sec., f/11, ISO 200.*

and saturation, with color balance that is flattering to skin tones. **Landscape (LS)** produces higher contrast and saturation for more vibrant, punchy images.

› Selecting Nikon Picture Controls

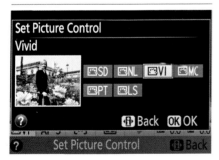

Selecting a Picture Control in the Active Information Display

1) In the Active Information Display, highlight 🖼 Picture Control and press **OK**. Alternatively, in the Shooting menu, select Set Picture Control.

2) Use the Multi-selector to highlight the required Picture Control and press **OK**.

This Picture Control will apply to all images taken in P, S, A, or M modes until the setting is changed again. Scene modes continue to apply their preset Picture Controls.

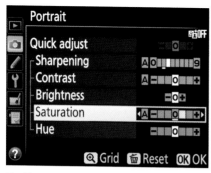

Modifying a Picture Control

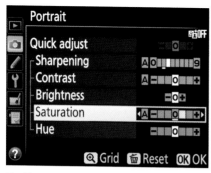

› Modifying Picture Controls

You can also modify the standard Nikon Picture Controls to create more personal results. Use **Quick Adjust** to make swift, across-the-board changes, or adjust the parameters individually (Sharpening, Contrast, and so on).

1) From the Shooting menu, select Set Picture Control.

2) Use the Multi-selector to highlight the required Picture Control and press ▶.

3) Scroll up or down with the Multi-selector to select Quick Adjust or one of the specific parameters. Use ▶ or ◀ to change the value as desired.

4) When all parameters are as required, press **OK**. The modified values are retained until that Picture Control is modified again.

› Creating Custom Picture Controls

You can create up to nine additional Picture Controls, either in-camera or using Nikon's Picture Control Utility software. Custom Picture Controls can also be shared with other Nikon DSLRs. For further details see the D5200 Reference Manual and Picture Control Utility's Help menu.

Creating Custom Picture Controls in-camera

1) From the Shooting menu, select **Manage Picture Control**

2) Select **Save/edit** and press ▶.

3) Use the Multi-selector to highlight an existing Picture Control and press ▶.

4) Edit the Picture Control (as described under Modifying Picture Controls). When all parameters are as required, press **OK**.

5) On the next screen, select a destination for the new Picture Control.

By default, its name derives from the existing Picture Control on which it is based, plus a two-digit number (e.g. VIVID-02) but you can apply a new name (up to 19 characters long) using the Multi-selector to select text. (For more on text entry *see page 114*.)

6) Press **OK** to store the new Picture Control.

ON REFLECTION

Shaded by a broad canopy, the windows were as good as mirrors. The question was what to focus on. I toyed with focusing on the Beatles sign but the image just seemed a bit messy. It made far more sense when I focused instead on the reflection of the Mersey Docks and Harbour Board building, one of the "Three Graces" of Liverpool's famous waterfront. *58mm, 1/250 sec., f/5.6, ISO 100.*

2 » HDR (HIGH DYNAMIC RANGE)

High dynamic range describes images which capture a very wide range of brightness. The D5200 can create high dynamic range images in-camera. It does this by combining two separate shots with different exposures, one for the shadows and one for the highlights. HDR can be combined with Active D-Lighting for even greater range, but is only available when Image Quality is set to JPEG (not RAW+JPEG).

1) Select HDR in the Active Information Display. Select **On** and press ▶. If you shoot HDR regularly you can assign **Fn** to this function (Custom setting f1). You can also access HDR from the Shooting menu.

2) Choose the strength of the effect. Auto allows the camera to determine this automatically, or you can select **Low**, **Normal**, **High**, or **Extra High**.

3) Shoot as normal. Two exposures are made, so it's a good idea to use a tripod or some other solid support.

4) The camera automatically shoots two images in quick succession. It then takes a few seconds to combine them and display the results. During this interval **Job Hdr** appears in the viewfinder and you can't take further shots.

5) HDR shooting is automatically cancelled. To shoot more HDR images, repeat the process from Step 1.

An HDR image and two (simulated) source frames (above) *18mm, 1/50, and 1/10 sec. (tripod) ("source" images), f/11, ISO 200.*

SPECIAL EFFECTS

Special Effects modes are rather like extreme Picture Controls; they process JPEG images to produce various striking effects. (If Image quality is set to RAW, a JPEG image will be created instead.) The built-in flash does not operate (except in 🖌 Color Sketch); a separate flash can be used but will often undermine the effect. Some of these effects can also be applied to existing images through the Retouch menu.

Effects modes can be used in Live View or Movie mode. This gives a preview of the effect, which is helpful, but the screen refreshes more slowly and movies may play back jerkily.

› To use Special Effects modes

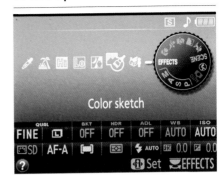

1) Set the Mode Dial to **EFFECTS**.

2) Rotate the Command Dial to select the required option on the screen (this is just like selecting Scene modes with the dial set to **SCENE**).

The following effects are available.

🕶 Night Vision
Uses extreme high ISO settings (maximum Hi 4 or ISO 102400); produces monochrome images. Autofocus only in Live View/movie and not always then: manual focus may be required.

🖌 Color Sketch
Turns a photo into something resembling a colored pencil drawing. Movies can be recorded; the Nikon Reference Manual says they play back like a slide show or series of stills but I haven't found this to be true.

Color Sketch

📽 Miniature Effect

Mimics the recent fad for shooting images with extremely small and localized depth of field *(see page 129)*, making real landscapes or city views look like miniature models. When used for movie shooting, clips play back at high speed.

🖋 Selective Color

Selects particular color(s); other hues are rendered in monochrome. Colors can only be selected in Live View (select the color under the focus point by pressing ▲) but this selection is retained if you then take shots using the viewfinder.

🏔 Silhouette

The camera's metering favors bright backgrounds such as vivid skies; foreground subjects record as silhouettes. Most effective for subjects with interesting outlines.

🔆 High key

Produces images filled with light tones, usually with no blacks or deep tones at all. It's not clear, in practical terms, whether this mode does anything more than simple overexposure.

🔅 Low key

Low key is basically the opposite, creating a deep, low-toned image. Again, it's not clear whether this mode does anything more than simply underexpose the image.

USING MENUS

The options that you can access through buttons, Command Dial, and the Active Information Display are just the tip of the iceberg. There are many other ways in which you can customize the D5200 to suit you, but these are only revealed by delving into the menus. There are six main menus: Playback menu, Shooting menu, Custom Setting menu, Setup menu, Retouch menu, and Recent Settings/My Menu.

The menu screen also shows a **?** icon but there isn't a separate Help menu; instead you access help from within the other menus by pressing 🔍.

The Playback menu, outlined in blue, covers functions related to playback, including viewing, naming, or deleting images. The Shooting menu, outlined in green, covers shooting settings, such as ISO speed or white balance (also accessible via buttons and dials), as well as Picture Controls and Active D-Lighting. The Custom Setting menu, outlined in red, is where you can fine-tune and personalize many aspects of the camera's operation. The Setup menu, outlined in orange, is used for functions like LCD brightness, plus others that you may touch only rarely, like language and time settings. The Retouch menu, outlined in purple, is used to create modified copies of images on the memory card. Finally Recent Settings/My Menu is outlined in gray and allows fast access to

favorite or recently used items from any of the other menus.

› Navigating menus

1) To display the menu screen, press **MENU**.

2) Scroll up or down with the Multi-selector to highlight the different menus. To enter the desired menu, press ▶ or **OK**.

3) Scroll up or down with the Multi-selector to highlight the different menu items. To select a particular item, press ▶ or **OK**. This will take you to a further set of options.

4) Scroll up or down with the Multi-selector to choose the desired setting. To select, press ▶ or **OK**. In some cases it's necessary to select **DONE** and then press **OK** to make the changes effective.

5) To return to the previous screen, press ◀. To exit the menu without effecting any changes, press **MENU**.

» PLAYBACK MENU

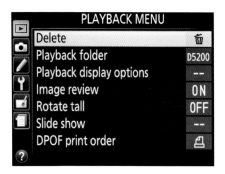

The D5200's Playback menu contains seven different options which affect how images are viewed, stored, deleted, and printed.

› Delete

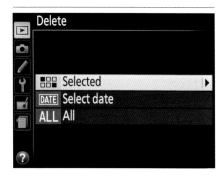

This function allows images stored on the memory card to be deleted, either singly or in batches.

1) In the Playback menu, highlight **Delete** and press ▶.

2) In the options screen, choose **Selected**. Images in the active playback folder or folders *(see next page)* are displayed as thumbnail images.

3) Use the Multi-selector to scroll through the displayed images. Press and hold ⊕ to view the highlighted image full-screen. Press ⊖⊞ to mark the highlighted shot for deletion. It will be tagged with a 🗑 icon. If you change your mind, highlight a tagged image and press ⊖⊞ again to remove the tag.

4) Repeat this procedure to select further images. (To exit without deleting any images, press **MENU**.)

5) Press **OK** to see a confirmation screen. Select **YES** and press **OK** to delete the selected image(s); to exit without deleting any images, select **NO**.

Note:
Individual images can also be deleted when using the playback screen, and this is usually more convenient *(see page 86).*

› Select date

Allows deletion of all images taken on a selected date.

1) In the Playback menu, highlight **Delete** and press ▶.

2) In the menu options screen, choose **Select date** and press ▶. A list of dates appears (corresponding to images on the memory card), with a sample image shown for each date. Scroll up or down to a desired date then press ▶ to select it.

3) Press **OK** again to delete all images taken on that date. Or, to review those images, press ⚎ to see a screen of thumbnails. You can navigate through this in the usual way with the Multi-selector and press ⚈ to see an image larger, but you can't zoom in any further. Press ⚎ again to return to the date-selection screen.

4) With one or more dates checked, press **OK** to see a confirmation screen. Select **YES** and press **OK** to delete all image(s). To exit without deleting any images, select **NO**.

› All

1) To delete all images on a card (strictly, all images in the current folder—*see page 99*), highlight **Delete** and press ▶.

Note:
Deleting all images this way can take time and it is generally quicker to format the card instead *(see page 28)*. However, there is a significant difference. **Delete all** does not delete protected or hidden images; whereas formatting the card does do so. (To protect/hide images, exit the Playback menu and use the playback screen instead, *see page 86*.)

2) In the menu options screen, choose **All**.

3) Press **OK** to see a confirmation screen. Select **YES** and press **OK** to delete all image(s); to exit without deleting any images, select **NO**.

› Playback folder

By default, the D5200's playback screen only displays images in the current folder (chosen via Storage folder in the Shooting menu, *see page 99*). If multiple folders exist on the memory card, images in other folders will not be visible. This menu allows you to change this behavior, so the camera will display images in all folders on the memory card.

Playback folder options

Current (default)	Displays images in the current folder only.
All	Displays images in all folders on the memory card.

› Playback display options

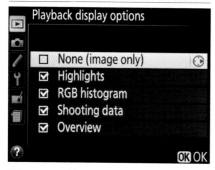

This menu enables you to choose what information about each image is displayed on playback, as described on *page 83*

› Image review

If Image review is **ON** (the default setting) images are automatically displayed on the monitor immediately after shooting. If **OFF**, this is not so and they can only be displayed by pressing [►].

› Rotate tall

Enables you to determine whether portrait format images will be displayed the "right way up" during playback. When **OFF** (default), this does not happen and you must turn the camera through 90° to view them correctly. If **ON**, these images will be displayed "correctly" but will appear smaller. **ON** is most useful when displaying images through a TV *(see page 249)*.

› Slide show

Enables you to display images as a standard slide show, on the camera's own screen, or when connected to a TV. All the images in the folder or folders selected for playback (under the Playback Folder menu) will be played in chronological order, but you can choose whether to include stills only, movies only, or both.

1) In the Playback menu, select **Slide show**.

2) Select **Image type** to decide whether the slide show will include **Still images and movies**, **Still images only**, or **Movies only**.

3) Select **Frame interval**. Choose between intervals of 2, 3, 5, or 10 seconds. Press **OK**. This determines how long each still image will appear; movies will play for their full length.

4) Select Start and press **OK**.

5) When the show ends, a dialog screen is displayed. Select **Restart** and press **OK** to play again. You can also revise **Frame interval**. Select **Exit** and press **OK** to exit.

6) If you press **OK** during the slide show, the slide show is paused and the same screen is displayed. The only difference is that if you select **Restart** and press **OK**, the show will resume where it left off.

7) To skip ahead, or skip back, while a slide show is playing, press ▶ or ◀ respectively.

8) To change display mode while a slide show is playing (e.g. to see a histogram for each image), press ▲ or ▼.

› DPOF print order

This allows you to select image(s) to be printed when the camera is connected to, or the memory card is inserted into, a suitable printer. For more on printing generally see Chapter 9 *(page 247)*.

›› SHOOTING MENU

The Shooting menu contains numerous options, but many of these have already been covered, so will be discussed only briefly here.

› Reset shooting menu

Restores all Shooting menu options to default settings.

› Storage folder

By default the D5200 stores images in a single folder, named "100D5200". If multiple memory cards are used they will all end up holding folders of the same name. This isn't usually a problem but a few users might wish to avoid it. You might also want to create specific folders for different shoots or different types of image. Generally, it's organizing images on the computer that counts *(see page 238)*, but having separate folders in the camera sometimes helps.

New folders are also created automatically if an existing folder becomes full. "Full" is defined as containing 999 photos, irrespective of image quality or size. If you regularly copy images to your computer and then format the memory card, which of course is recommended, the folder may never reach this capacity. However, a new folder will also be created

when photo-numbering reaches 9,999, and it is certainly possible to take more than 10,000 photos in the lifetime of a Nikon D5200.

In naming folders, you can't just use any name you like: only the last five digits of the name are editable. (In fact the first three digits are hidden when you use this menu, but the full name appears when the camera is connected to a computer.)

To create a new folder

1) In the Shooting menu, select **Storage folder** and press **OK**.

2) Select **New** and press **OK**.

3) A text entry screen numbers appears. Enter a new name (for text entry *see page 114*).

4) Press ⊕ to create the new folder and return to the **Shooting menu**. It automatically becomes the active folder.

You can also rename an existing folder: at step 2 above select **Rename** and press **OK**; the procedure is then similar.

› Image quality and Image size

Use these to choose between RAW and JPEG options, and Small, Medium, and Large image sizes, as described on *page 69*.

› White balance

Use this to set and fine-tune white balance, as described on *page 70*. It is only available in P, S, A, and M exposure modes; other modes use Auto or preset.

› Set Picture Control and Manage Picture Control

These menus govern the use of Nikon Picture Controls, as described on *page 89*. Set Picture Control is only available in P, S, A, and M exposure modes.

› Auto distortion control

If **ON**, this corrects for distortion *(see page 147)* which may arise with certain lenses. It's applicable only with Type G and D lenses *(see page 214)*, excluding fisheye and PC lenses, and only affects JPEG images.

› Color space

Allows you to choose between sRGB and Adobe RGB color spaces *(see page 75)*.

Tip

To correct distortion manually (e.g. when using lenses other than Type G and D) there's Distortion control in the Retouch menu (see page 122).

› Active D-Lighting

Governs the use of Active D-Lighting, as described on *page 87*. Only available in P, S, A, and M exposure modes; in other modes ADL is automatic.

› HDR

Enables and controls HDR shooting, as described on *page 92*.

› Long exposure NR

Photos taken at long shutter speeds may manifest increased "noise" *(see page 149)*. The D5200 offers extra image processing (Long exposure noise reduction) to counteract this. If **ON**, it applies to exposures of 1 sec. or longer. During processing, **Job nr** appears, blinking, in the viewfinder. The time this takes is roughly equal to the shutter speed in use, and no more pictures can be taken until processing is complete. As this delays further shooting, it's often preferable to tackle image noise in post-processing instead, and Long exposure NR is OFF by default.

› High ISO NR

Photos taken at high ISO settings may also display increased noise *(see page 149)*. High ISO noise reduction is applied during JPEG processing; the default setting of Normal can be changed to **Low** or **High**. High ISO NR can also be set to **OFF**, but a modest level of NR will still be applied to images taken at ISO 1600 or above.

› ISO sensitivity settings

Controls ISO sensitivity settings, as described on *page 74*. Generally it's much quicker to change ISO through the Active Information Display (quicker still if you assign **Fn** to ISO control). However, this menu also contains options governing the operation of Auto-ISO control.

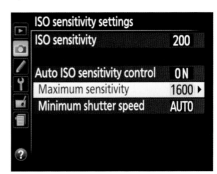

› Release mode

Controls Release mode options, as described on *page 34*. Generally it's much quicker to change the Release mode using ⚐.

› Multiple exposure

When it's so easy to combine images, precisely and flexibly, on computer, it might seem that the D5200 scarcely needs a multiple exposure facility. However, Nikon claim that "multiple exposures... produce colors noticeably superior to those in software-generated photographic overlays." This is debatable, especially if you shoot individual RAW images for careful post-processing before combining them on the computer, but there's no question that this is an effective way to combine images for immediate use.

Multiple exposures cannot be created in Live View shooting.

To create a multiple exposure

1) In the Shooting menu, select **Multiple exposure** and press ▶.

> **Note:**
> Auto gain (ON by default) adjusts the exposure, so that if you are shooting a sequence of three shots, each is exposed at ⅓ the exposure value required for a normal exposure. You might turn Auto gain OFF where a moving subject is well lit but the background is dark, to keep the subject well-exposed and avoid over-lightening the background.

2) Select **Multiple exposure mode** and select **On**.

3) Select **Number of shots** (2 or 3) then press **OK**.

4) Select **Auto gain** (ON or OFF) (explanation below) then press **OK**.

5) Frame the photo and shoot normally. In Continuous release mode, the images will be exposed in a single burst. In Single Frame release mode, one image will be exposed each time the shutter-release button is pressed. Normally the maximum interval between shots is 30 sec. This can be extended by setting a longer monitor-off delay in Custom setting c4.

› Interval timer shooting

The D5200 can take a number of shots at pre-determined intervals.

1) In the Shooting menu, highlight Interval timer shooting and press ▶.

2) Choose a start time. If you select Now, shooting begins 3 sec. after you complete the other settings, and you can skip Step 3. To choose a different start time, select Start time and press ▶.

3) Use the Multi-selector to set the desired time in the next 24 hours (check the camera's clock is set correctly). Press ▶.

4) Use the Multi-selector to choose the interval between shots. Press ▶.

5) Choose the number of intervals (up to 999) and the number of shots to be taken at each interval (up to 9). The resulting total number of shots is also displayed. Press ▶ to complete setup.

6) Highlight **Start> On** and press **OK**. Once Interval timer shooting has begun, you can't change any other settings. If you want to cancel Interval timer shooting, switch the camera OFF or turn the Mode Dial to a different position.

› Movie settings

Used for key movie settings *(see page 191)*.

ON THE MOVE ⌄
The Movie settings menu is a first step towards successful movie shooting.

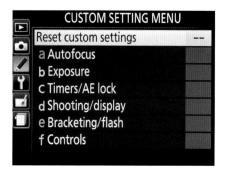

CUSTOM SETTING MENU

Reset custom settings	--
a Autofocus	
b Exposure	
c Timers/AE lock	
d Shooting/display	
e Bracketing/flash	
f Controls	

The Custom Setting menu allows many aspects of the camera's operation to be fine-tuned to your individual preferences. There are six sub-menus, identified by key letters and a color: a: Autofocus (Red); b: Metering/Exposure (Yellow); c: Timers/AE Lock (Green); d: Shooting/display (Light blue); e: Bracketing/flash (Dark blue); and f: Controls (Lilac). There is also an option to **Reset custom settings**, which restores all current Custom settings to standard default values.

Navigating the Custom Setting menu is essentially the same as the other menus. However, from the main menu screen, the first press on ▶ takes you into the list of sub-menus. Scroll through these to the desired group and press ▶ to see the items it contains. Once you've entered one of the sub-menus, all the items appear as a continuous list, so you can scroll straight on from a4 to b1 or from a1 to f5 in the other direction. The custom setting identifier code (e.g. a3) is shown in the appropriate color for that group. If the setting has been changed from default, an asterisk appears over the initial letter.

a: Autofocus

Custom setting	a1	AF-C priority selection
Options		Release Focus (default)
Notes		Applies when the camera is in AF-C release mode *(see page 64)*.

Custom setting	a2	Number of focus points
Options		39 points (default) 11 points
Notes		Governs the number of focus points available in Single-area AF mode.

Custom setting	a3	**Built-in AF-assist illuminator**
Options		On (default) Off
Notes		Governs whether the the AF-assist illuminator operates when lighting is poor *(see page 67).*

Custom setting	a4	**Rangefinder**
Options		On (default) Off
Notes		Governs if the exposure indicator shows if the camera is correctly focused in Manual focus mode. Not available in shooting mode M *(see page 65).*

b: Exposure

Custom setting	b1	**EV steps for exposure cntrl**
Options		⅓ step (default) ½ step
Notes		Governs the increments used by the camera for setting shutter speed and aperture, and also for exposure/flash compensation and bracketing.

c: Timers/AE Lock

Custom setting	c1	**Shutter-release button AE-L**
Options		On Off (default)
Notes		Governs whether exposure is locked by half-pressure on the shutter-release button. If Off, exposure can only be locked using the **AE-L/AF-L** button *(see page 60).*

2

Custom setting	c1	Shutter-release button AE-L
Options		On Off (default)
Notes		Governs whether exposure is locked by half-pressure on the shutter-release button. If Off, exposure can only be locked using the **AE-L/AF-L** button *(see page 61)*.

Custom setting	c2	Auto off timers		
Interval for:		**Short**	**Normal**	**Long**
Playback/menus		20 sec.	1 min.	5 min.
Image review		4 sec.	4 sec.	20 sec.
Live view		5 min.	10 min.	20 min.
Standby timer		4 sec.	8 sec.	1 min.

Notes	Governs the interval before the relevant displays turn off when idle. A shorter delay improves battery life. The displays do not turn off automatically when the D5200 is connected to a mains adapter. **Standby timer** determines the interval before exposure meter, viewfinder display, and information display turn off.

Custom setting	c3	Self-timer delay
Self-timer delay		2 sec. 5 sec. 10 sec. (default) 20 sec.
Notes		Governs the delay in self-timer release mode *(see pages 34 and 35)*. You can also select **Number of shots** (from 1–9); if number is more than 1, interval between shots is fixed at 4 sec.

Custom setting	c4	Remote on Duration (ML-L3)
Options		1 min. (default) 5 min. 10 min. 15 min.
Notes		When using the optional ML-L3 remote control *(see page 227)*, this governs how long the camera will remain on standby for a signal from the remote. After this, it reverts to the previously selected release mode.

d: Shooting/display

Custom setting	d1	Beep
Options		High Low (default) Off
Notes		Governs the beep which optionally sounds when the self-timer operates, and to signify that focus has been acquired when shooting in single-servo AF mode.

Custom setting	d2	Viewfinder grid display
Options		Off (default) On
Notes		Displays grid lines in the viewfinder to aid precise framing.

Custom setting	d3	ISO display
Options		On Off (default)
Notes		If **On**, figure at bottom right of viewfinder shows the selected ISO. If **Off**, the figure shows number of exposures remaining.

Custom setting	d4	File number sequence
Options		On Off (default) Reset
Notes		Controls how file numbers are set. If **Off**, file numbering is reset to 0001 whenever a memory card is inserted/formatted, or a new folder is created. If **On**, numbering continues from the previous highest number used. Reset creates a new folder and begins numbering from 0001.

Custom setting	d5	Exposure delay mode
Options		On Off (default)
Notes		Creates a 1 sec. delay when the shutter-release button is pressed. Mirror flips up immediately to allow vibrations to subside before shutter is released.

Custom setting	d6	Print date
Options		Off (default)
		Date
		Date and time
		Date counter
Notes		Governs whether date or date and time are imprinted on photos (JPEG only) as they are taken. **Date counter** imprints number of days to/from a selected date.
		Date and time info is always embedded in metadata, without needing to mar the visible image.

e: Bracketing/flash

Custom setting	e1	Flash cntrl for built-in flash
Options		TTL
		Manual
Notes		Governs control of the built-in flash. TTL means flash output is regulated automatically. Manual means you set it manually, using a sub-menu; options are Full, $\frac{1}{2}$, $\frac{1}{4}$, $\frac{1}{8}$, $\frac{1}{16}$, and $\frac{1}{32}$.

Custom Setting	e2	Auto bracketing set
Options		AE bracketing
		WB bracketing
		ADL bracketing
Notes		Determines which settings are bracketed when auto bracketing is activated: Exposure (default), White Balance, or Active D-Lighting. WB bracketing creates three JPEG images with different white balance settings *(see page 62)*. ADL bracketing takes two photos, one with Active D-Lighting off, the second with it on at the current setting *(see page 87)*.

f: Controls

Custom setting	f1	Assign Fn. button

Options		
QUAL	Hold button and rotate Command Dial to select image quality/size.	All modes
ISO (default)	Hold button and rotate Command Dial to select ISO sensitivity.	All modes
WB	Hold button and rotate Command Dial to select white balance.	P, S, A, M modes only
ᴱ⁺ᴃ	Hold button and rotate Command Dial to select Active D-Lighting.	P, S, A, M modes only
HDR	Hold button and rotate Command Dial to change HDR settings.	P, S, A, M modes only
+NEF (RAW)	When Image quality is JPEG, records a NEF copy of the next shot taken.	All modes (except 🏞, 🌅, 🎭, ✏)
BKT	Hold button and rotate Command Dial to choose bracketing increment or toggle ᴱ⁺ᴃ On/Off.	P, S, A, M modes only
AF-area mode	Hold button and rotate Command Dial to select AF-area mode.	All modes
Live View	Press **Fn** to start Live View; press again to end.	All modes
AE/AF lock	Press and hold button to lock focus and exposure.	All modes
AE lock only	Press and hold button to lock exposure.	All modes
AE lock (Hold)	Exposure locks when Fn button is pressed and remains locked until button is pressed again.	All modes
AF lock only	Press and hold button to lock focus	All modes

AF-ON Makes Fn button initiate autofocus All modes
 instead of shutter-release button.

Notes Various functions can be assigned to the **Fn** button; in most cases you then
use the Command Dial to choose between options. It's well worth thinking
about which settings you change most often; assigning **Fn** to a key setting
can save much time in the Active Information Display/Shooting menu.

Custom Setting f2 Assign AE-L/AF-L button

AE/AF lock (default)	Press and hold button to lock focus and exposure
AE lock only	Press and hold button to lock exposure
AE lock (Hold)	Exposure locks when Fn button is pressed and remains locked until button is pressed again.
AF lock only	Press and hold button to lock focus
AF-ON	Makes Fn button initiate autofocus instead of shutter-release button.

Custom setting f3 Reverse dial rotation

Options	Exposure compensation
	Shutter speed/aperture

Notes Use this to reverse the normal rotation of the Command Dial; e.g, when turning
dial to right makes shutter speed slower rather than faster.

Custom Setting f4 Slot empty release lock

Options	Release locked
	Enable release (default)

Notes If Enable release is selected, the shutter can be released even if no memory
card is present. Images are held in the camera's buffer and can be displayed
on the monitor (demo mode), but are not recorded.

Custom Setting f5 Reverse indicators

Options	+ 0 – (default)
	– 0 +

Notes Governs how the exposure displays in the Viewfinder and Control Panel are
shown, i.e. with overexposure to left or right.

›› SETUP MENU

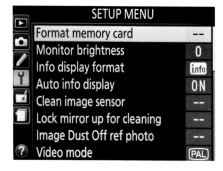

The Setup menu controls many important camera functions, though many are ones you will need to access only occasionally, if at all.

› Format memory card

The one item in this menu that you probably will employ regularly *(see page 28).*

› Monitor brightness

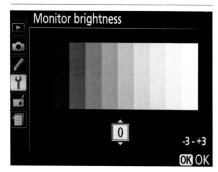

Allows you to change the brightness of the LCD display with ▲/▼.

Use with care; making Live View/review/ playback images appear brighter does not mean the images themselves (e.g. as viewed on your computer) will be any brighter.

› Info display format

Choose between **Graphic** (default) and **Classic** modes for the Information Display *(see page 32).* You can also select different background colors for each display mode.

There are separate options for User-control modes (P, S, A, or M) and for Auto/ Scene/Effects modes; setting a different screen mode, or just a different background color, could be a handy reminder of which of which group of modes you're in.

However, the default for both groups is the same (Graphic mode with blue background).

› Auto info display

Choose whether the Information Display appears automatically when the shutter-release button is half-pressed. It can also be displayed straight after a shot is taken, but only if Image Review is Off.

If this item is Off, the Information Display only appears when you press **INFO** or ⊞. You can turn it off to save power or if you're working entirely through the viewfinder.

› Clean image sensor

Strictly speaking, it's not the sensor itself but its protective low-pass filter that can attract dust and require cleaning. The D5200 has an automated procedure to do this, by vibrating the low-pass filter at

Note:
It's suggested that cleaning is most effective if the camera is placed base-down at the time. This is the normal working attitude, but you might be in the habit of switching on/off while you're stowing the camera in a bag, or taking it out again, which could put it in a different attitude.

various frequencies. In general this is highly effective, greatly reducing both the incidence of dust spots on images, and the need for more invasive forms of cleaning. This menu allows you to actuate cleaning at any time, and also to set the camera to clean automatically at startup and/or shutdown.

› Lock mirror up for cleaning

Allows access to the low-pass filter for manual cleaning (see page 232).

› Image Dust Off Ref Photo

Nikon Capture NX2 (not supplied with the camera, see page 243) features automatic removal of dust spots on images by reference to a photo which maps dust on the sensor. If you know that there are stubborn dust spots which don't succumb to the normal sensor cleaning, this can save a lot of tedious work in Capture NX2 (or other imaging applications).

To take a dust-off reference photo

1) Fit a CPU lens of at least 50mm focal length. Locate a featureless white object (e.g. a sheet of plain paper), large enough to fill the frame.

2) In the Setup menu, select **Dust Off Ref Photo** and press **OK**.

3) Select **Start** or **Clean sensor and then start** and press **OK**. Select **Start** if you have already taken the picture(s) from which you want to remove spots.

4) Frame the white object at a distance of about 10cm. Press the shutter-release button halfway; focus is automatically set at infinity. This creates a soft white background against which dust spots stand out clearly.

5) Press the shutter-release button fully to capture the reference image.

› Video mode

The name is potentially confusing, as this is not directly related to the camera's movie mode. You can connect the camera to a TV or VCR to view images; this menu sets the camera to **NTSC** or **PAL** standards to match the device you're connecting to. NTSC is used in North America and Japan, but most of the world uses PAL.

› HDMI

You can also connect the camera to HDMI (High Definition Multimedia Interface) TVs; you'll need a special cable. This menu sets the camera's output to match the HDMI device (get this information from that device's specs or instructions). The **Device control** submenu applies when connected to an HDMI-CEC television, and allows the TV remote to be used to navigate through images.

› Flicker reduction

Some light sources (e.g. fluorescent lamps) can produce visible flicker in the Live View screen image and in movie recording. To minimize this, use this menu to match the frequency of the local power supply. Usually, the Auto setting will apply the correct frequency automatically, but there are manual settings just in case. 60Hz is common in North America, 50Hz is normal in Europe, including the UK.

› Time zone and date

› Image comment

Sets date, time, and time zone, and specifies the date display format (**Y**/**M**/**D**, **M**/**D**/**Y**, or **D**/**M**/**Y**). Set your home time zone first, then set the time correctly. If you travel to a different time zone, simply set the time zone accordingly and the time will be updated automatically

› Language

Set the language which the camera uses in its menus. The options include most major European languages, Arabic, Indonesian, Chinese, Japanese, Korean, and Thai.

This allows you to add text comments to images as they are shot. Comments appear in the third detail page of the photo info display (when this is activated using **Display mode** in the Playback menu) and can also be viewed in Nikon View NX2 and Nikon Capture NX2.

The process of text input is similar to text-messaging on a mobile phone. To input a comment, select **Input comment** and press **OK**. Use the Multi-selector to move through the available characters, and press **OK** to use the highlighted character. Use the Command Dial to move the cursor forward or back in the text. When finished press ⊕.

If you select **Attach comment**, select **Done**, and press **OK**, the comment will be attached to all new shots until turned off again.

› Auto image rotation

If set to **ON** (default) information about the orientation of the camera is recorded with each photo taken, ensuring that they will appear right way up when viewed with Nikon View NX2, Nikon Capture NX2 or most third-party imaging applications.

Exceptions can occur if shots are taken with the camera pointing steeply up or down, or when panning; in these cases orientation data may not be recorded. It might be worth setting Auto image rotation to **OFF** if a sequence of such shots is planned, but in practice there's little to be gained.

› Accessory terminal

Used to set up connection between the D5200 and compatible remote release and/or GPS devices *(see pages 228 and 246).*

› Eye-Fi upload

Set up a WiFi network connection using an Eye-Fi card *(see page 245).*

› Wireless mobile adapter

If you're using the WU-1a wireless mobile adapter *(see page 228)*, this menu allows the camera to connect to compatible smartphones and other devices.

› Firmware version

Firmware is the onboard software that controls the camera's operation. Nikon issues updates periodically. This menu shows the version presently installed, so you can verify whether it is current.

When new firmware is released, download it from the Nikon website and copy it to a memory card. Insert this card in the camera then use this menu to update the camera's firmware.

> **Note:**
> Firmware updates may include new functions and new menu items, which can make this *Guide* (and the Nikon manual) appear out of date.

2 » RETOUCH MENU

RETOUCH MENU
- D-Lighting
- Red-eye correction
- Trim
- Monochrome
- Filter effects
- Color balance
- Image overlay
- NEF (RAW) processing

The Retouch menu is used to make corrections and enhancements to images, including cropping, color balance, and much more. This does not affect the original image but creates a copy to which the changes are applied. Further retouching can be applied to the new copy, but you can't apply the same effect twice to the same image.

Copies are always created in JPEG format but the size and quality depends on the format of the original (a few exceptions, such as **Trim** and **Resize**, produce copies smaller than the original).

Format of original photo	Quality and size of copy
NEF (RAW)	Fine, Large
JPEG	Quality and size match original.

There are two ways to access the retouch options and create a copy: the steps of the process are broadly the same, but in a slightly different sequence.

› From the Image Playback screen

1) Display the image you wish to retouch.

2) Press **OK** and the Retouch menu appears, overlaying the image.

3) Select the desired retouch option and press ▶. If more options appear, make a selection and press ▶ again. A preview of the retouched image appears.

4) Depending on the type of retouching to be done (see details below), there may be further options to choose from.

5) Press **OK** to create a retouched copy. (◀ takes you back to the options screen and ▶ exits without creating the copy.)

Note:
Image Overlay is not available from Image Playback, only through the Retouch menu. For Side-by-side Comparison the reverse is true.

Note:
Retouched copy images are indicated by a ☑ icon in normal image playback.

› From the Retouch menu

1) In the Retouch menu, select a retouch option and press ▶. If subsidiary options appear, make a further selection and press ▶ again. A screen of image thumbnails appears.

2) Select the required image using the Multi-selector, as you would during normal image playback. Press **OK**. A preview of the retouched image appears.

3) Continue as from Step 4 above.

Color Sketch

» RETOUCH MENU OPTIONS

› D-Lighting

Despite similar names, and broadly similar effects, D-Lighting is not identical to Active D-Lighting. Active D-Lighting *(see page 87)* is selected before shooting and affects the way the original image is exposed and processed; D-Lighting is applied after shooting and creates a retouched copy. Both aim to improve results with high-contrast subjects, mainly by lightening darker areas of the image. However, because it affects the original exposure, Active D-Lighting is more effective in recovering over-bright highlights.

The D-Lighting screen shows a side-by-side comparison of the original image and the retouched version; a press on 🔍 zooms in on the retouched version. Use ▲ and ▼ to select the strength of the effect—High, Normal, or Low.

› Red-eye correction

Ugly "red-eye" often appears when using on-camera flash; retouching is one solution, though prevention is usually better than cure *(see page 166)*. This option can only be selected for photos taken with flash. The camera analyzes the photo for evidence of red-eye; if none is found the process will go no further. If red-eye is detected a preview image appears

and you can use the Multi-selector and 🔍 to view it more closely. If you've used the zoom, press **OK** to resume full-screen view; press **OK** again to create a retouched copy.

› Trim

Use this to crop image(s), e.g. to better fit a print size. When Trim is selected, a preview screen appears with the crop area shown by a yellow rectangle. Change the aspect ratio of the crop by rotating the Command Dial: choose from 3:2 (the same as the original image), 4:3, 5:4, 1:1 (square), and 16:9. Adjust the size of the crop area using 🔍 and 🔍; dimensions of the cropped image (in pixels) are shown at top left. Adjust the position of the crop area using the Multi-selector; press **OK** to save a cropped copy.

› Monochrome

This creates a monochrome copy of the original. You can choose from straight **Black-and-white**, **Sepia** (a brownish-toned effect like many antique photos), and **Cyanotype** (a bluish toned effect). If you select **Sepia** or **Cyanotype**, a preview screen appears and you can make the toning effect stronger or weaker with ▲ and ▼.

Aspect ratio	Possible sizes for trimmed copy									
3:2	5760 x 3840	5120 x 3416	4480 x 2984	3840 x 2560	3200 x 2128	2560 x 1704	1920 x 1280	1280 x 856	960 x 640	640 x 424
4:3	5120 x 3840	4480 x 3360	3840 x 2880	3200 x 2400	2560 x 1920	1920 x 1440	1280 x 960	960 x 720	640 x 480	
5:4	5008 x 4000	4800 x 3840	4208 x 3360	3600 x 2880	3008 x 2400	2400 x 1920	1808 x 1440	1200 x 960	896 x 720	608 x 480
1:1	4000 x 4000	3840 x 3840	3360 x 3360	2880 x 2880	2400 x 2400	1920 x 1920	1440 x 1440	960 x 960	720 x 720	480 x 480
16:9	6000 x 3376	5760 x 3240	5120 x 2880	4480 x 2520	3840 x 2160	3200 x 1800	2560 x 1440	1920 x 1080	1280 x 720	960 x 536

(16:9 additional: 640 x 360)

Black-and-white

› Filter effects

Mimics several common photographic filters (or they used to be common in the days of film). **Skylight** reduces the blue cast which can affect photos taken on clear days with a lot of blue sky. Applied to other images its effect is very subtle, even undetectable. **Warm filter** has a much stronger warming effect. **Red**, **green**, and **blue intensifier** are all fairly self-explanatory, as is **Soft**, but unlike **Cross screen**. This creates a "starburst" effect around light sources and other very bright points (like sparkling highlights on water). Perhaps "Star" would have been a better name?

There are multiple options within the **Cross screen** item (see the table on the next page).

Filter option heading	Options available
Number of points	Create 4-, 6-, or 8-pointed star
Filter amount	Choose brightness of light sources that are affected
Filter angle	Choose angle of the star points
Length of points	Choose length of the star points
Confirm	See a preview of the effect; press 🔍 to see it full-screen
Save	Create a copy incorporating the effect

› Color balance

Creates a copy with modified color balance. When this option is selected a preview screen appears and the Multi-selector can be used to move a cursor around a color grid. The effect is shown in the preview and the histograms alongside.

› Image overlay

Image overlay allows you to combine two existing photos into a new image. This can only be applied to originals in RAW format. Nikon claim (debatably) that the results are better than combining the images in applications like Photoshop because Image overlay makes direct use of the RAW data from the camera's sensor.

This is the only Retouch menu Item which allows you to create a new RAW image. You can also create JPEG images at any size and quality; the output will match the current Image quality and Image size options *(see page 68)*.

Creating an overlaid image

1) Select **Image overlay** and press **OK**. A dialog screen appears with sections labelled **Image 1**, **Image 2**, and **Preview**. Initially, **Image 1** is highlighted. Press **OK**.

2) The camera displays thumbnails of available RAW images. Select the first image you want to use and press **OK**.

3) Select **Gain**: this determines how much "weight" this image has in the final overlay. Use ▲ and ◄ to adjust gain (default value is 1.0).

4) Press ► to move to **Image 2**. Repeat steps 2 and 3 for the second image.

5) Press ◄ to return to Image 1 to readjust gain, or press **OK** to change the image.

6) Use ► to highlight **Preview**. Select **Overlay** and press **OK** to preview the result. If necessary, return to the previous stage by pressing 🔍⊞. When satisfied, press **OK** again to save the new combined image. You can also skip the preview stage by highlighting **Save** and pressing **OK**.

› NEF (RAW) processing

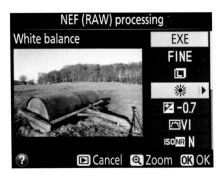

This menu creates JPEG copies from images originally shot as RAW files. While it is no substitute for full RAW processing on computer *(see page 242)* it allows the creation of quick copies for immediate sharing or printing. The screen shows a preview image, with processing options in a column on the right. These do give considerable control over the resulting JPEG image.

When satisfied with the previewed image, select **EXE** and press **OK** to create the JPEG copy. Pressing ▶ or **MENU** exits without creating a copy.

Option	Description
Image quality	Choose Fine, Normal, or Basic *(see page 68)*.
Image size	Choose Large, Medium, or Small *(see page 69)*.
White balance	Choose a white balance setting; options are similar to those described *on page 70*.
Exposure comp.	Adjust exposure (brightness) levels from +2 to -2.
Set Picture Control	Choose any of the range of Nikon Picture Controls *(see page 88)* to be applied to the image.
High ISO NR	Choose whether or not to apply noise reduction *(see page 101)*.
Color space	Choose sRGB or Adobe RGB *(see page 75)*.
D-Lighting	Choose D-Lighting setting *(see page 118)*.

Option	Size (pixels)	Suitable display
2.5M	1920 x 1280	HD TV and larger computer monitor, latest iPad
1.1M	1280 x 856	Typical computer monitor, older iPads
0.6M	960 x 640	Standard (not HD) television, iPhone 4
0.3M	640 x 424	Mobile devices including older iPhones
0.1M	320 x 216	Standard mobile phone

› Resize

This option creates a small copy of the selected picture(s), suitable for immediate use with various external devices. Five possible sizes are available *(see the table above)*.

› Quick retouch

Provides basic "quick fix" retouching, boosting saturation and contrast. D-Lighting is applied automatically to retain shadow detail. Use ▲ and ▼ to increase or reduce the strength of the effect, then press **OK** to create the retouched copy.

› Straighten

It's best to get horizons level at time of shooting, but this option offers a fall-back, with correction up to 5° in 0.25° steps. Use ▶ to rotate clockwise, ◀ to rotate anticlockwise. Inevitably, this crops the image.

› Distortion control

Some lenses create noticeable curvature of straight lines *(see page 147)*. This menu allows in-camera correction, but inevitably crops the image. **Auto** compensates automatically for the known characteristics of Type G and D Nikkor lenses, but can't be used with other lenses. **Manual** can be applied whatever lens was used.

> ### Tip
>
> *You can pre-apply distortion control to all JPEG images (if shot with Type G and D Nikkor lenses) using Auto distortion control (see page 100).*

› Fisheye

This is almost the reverse of the previous effect, applying exaggerated barrel distortion to give a fisheye lens effect. Use ▶ to strengthen the effect, ◀ to reduce it.

› Color outline

This detects edges in the photograph and uses them to create a "line-drawing" effect. This could be used as a starting point for painting or illustration, either by hand or using illustration software. There are no options for fine-tuning the effect in-camera.

› Color sketch

Turns a photo into something resembling a colored pencil drawing. There are options for Vividness (change strength of colors) and Outlines (makes lines thinner or thicker).

› Perspective control

Corrects the convergence of vertical lines in photos taken looking up, for example, at tall buildings. Grid lines help you assess the effect; adjust its strength with the Multi-selector. The process inevitably crops the original image, so it's vital to leave room around the subject. For other approaches to perspective control, and an example, *see page 211.*

› Miniature effect

This option mimics the fad—already done to death—for shooting images with extremely localized depth of field, making real scenes look like miniature models. It usually works best with photos taken from a high viewpoint, which typically have clearer separation of foreground and background. A yellow rectangle shows the area which will remain in sharp focus. You can reposition and resize this using the Multi-selector. Press \oplus to preview the results and press **OK** to save a retouched copy.

Also available as a Special Effect *(see page 94)* when shooting.

› Selective color

Select specific color(s) (up to three); other hues are rendered in monochrome.

1) Use the Multi-selector to place the cursor over an area of the desired color. Press **OK** to choose that color.

2) Turn the Command Dial then use ▲/▼ to alter the color range (i.e. to be more or less selective).

3) To select another color, turn the Command Dial again to highlight another "swatch" and repeat steps 1 and 2.

4) To save the image, press **OK**. Also available as a Special Effect *(see page 94)* when shooting.

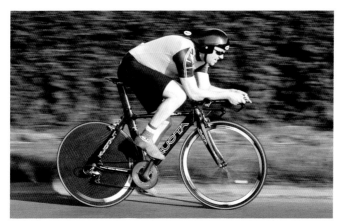

Selective color

› Edit movie

This allows you to trim the start and/or end of movie clips. It's a long way from proper editing *(see page 198)*, but has its uses.

To trim a movie clip

1) Select a movie clip and begin playback. Pause (press ▼) on a frame you want to use as the new start- or end-point.

2) Press **AE-L/AF-L** to reveal an Edit Movie screen.

3) Select **Choose start point** or **Choose end point** and press ▲.

4) Select **Yes** and press **OK** to save the trimmed clip as a copy.

5) Repeat if necessary to trim the other end of the clip.

› Side-by-side comparison

This is only available when a retouched copy, or its source image, is selected in full-frame playback; you can't access this option from the Retouch menu.

With an image selected, press **OK**; scroll through the options to **Side-by-side comparison** then press **OK** again. The screen displays the copy alongside the original source image. Highlight either image then press and hold ⊕ to view it full-frame. Press ▶ to return to normal playback; to return to the main playback screen, press **OK**.

RECENT SETTINGS AND MY MENU

RECENT SETTINGS

Color sketch
Color outline
Quick retouch
NEF (RAW) processing
Color balance
Monochrome
Trim
D-Lighting

The Recent Settings menu automatically stores the most recent settings (up to 20 items) made using any of the other menus, and provides a quick way to access controls that you have used recently.

Alternatively, you can activate My Menu. This is a handy way to speed up access to "favorite" menu items. Items from any other menu can be added to My Menu to create a shortlist of up to 20 items.

To activate My Menu
1) In Recent Settings, select **Choose tab** and press ▶.

2) Select My Menu and press **OK**.

To add items to My Menu
1) In My Menu, highlight **Add items** and press ▶.

2) A list of the other menus now appears. Select the appropriate menu and press ▶.

3) Select the desired item and press **OK**.

4) The My Menu screen reappears with the newly added item at the top. Use ▼ to move it lower down the list if desired. Press **OK** to confirm the new order.

To remove items from My Menu
1) In My Menu, highlight **Remove items** and press ▶.

2) Highlight any listed item and press ▶ to select it for deletion. A check mark appears beside the item.

3) If more than one item is to be deleted, use ▲/▼ to select items in the same way.

4) Highlight **Done** and press **OK**. A confirmation dialog appears. To confirm the deletion(s) press **OK** again. To exit without deleting anything, press **MENU**.

To rearrange items in My Menu
1) In My Menu, highlight **Rank items** and press ▶.

2) Highlight any item and press **OK**.

3) Use ▲/▼ to move the item up or down: a yellow line shows where its new position will be. Press **OK** to confirm.

4) Repeat steps 2 and 3 to move more items. Press **MENU** to exit.

Chapter 3
IN THE FIELD

Nikon

3 IN THE FIELD

At a basic level, cameras like the D5200 can usually be relied upon to get focusing and exposure right. However, there's a big difference between photos that "come out" and those that turn out exactly the way you want them. A fundamental thing to remember—and this is true of all cameras—is that the camera does not simply record what you see. We could call this the "point-and-shoot fallacy". Cameras, lenses, and digital image sensors do not work in the same way as the human eye and brain.

Take motion, for example: we see movement but the camera records a still image. Once we understand that cameras see differently, we can make it a strength, not a weakness. Many of the best photographs work precisely because they don't just mimic what the unaided eye sees. There are no point-and-shoot cameras, only point-and-shoot photographers.

Understanding how light works and how lenses and digital images behave all make it easier to take charge and realize your own vision. And if this seems like a lot to take on board, fortunately the D5200 does not force you to dive in at the deep end and master all aspects simultaneously. Experimenting with Scene modes is a good place to start; just try shooting the same subject using different modes to see how different the results can be. Program mode leaves the camera in charge of the key shooting parameters, aperture, and shutter speed, while allowing you to make choices over other important settings such as White Balance, Picture Controls, or Active D-Lighting. Aperture-priority and Shutter-priority modes give control over these vital parameters but still allow the camera to determine correct exposure.

RIGHT PLACE, RIGHT TIME «
Camera skills are important, but there's still no substitute for being in the right place at the right time. *165mm, 1/160 sec., f/11, ISO 400.*

›› DEPTH OF FIELD

Depth of field is a perfect illustration of the difference between what the camera sees and what the eye sees. In simple terms, depth of field means what's in focus and what isn't. A more precise definition is as follows: the depth of field is the zone, extending in front of and behind the point of focus, in which objects appear to be sharp in the final image.

The eye scans the world dynamically: whatever we're looking at, near or far, we normally see it in focus (assuming you have good eyesight, or appropriate glasses/contact lenses). Photographs often fail to match this: even if we've focused perfectly on the main subject, objects in front or behind of the subject may appear soft or blurred.

Sometimes this is welcome, as it makes the main subject stand out; sometimes it isn't. In landscape photography—where there usually is no single "subject"—the

DEPTH OF FIELD ⌃
The same setup, focused on the second-nearest post, taken at f/4, f/8 and f/16 (clockwise from top left), shows the effect on depth of field. Which shot you prefer is, of course, subjective.

traditional approach is to try and keep everything in focus. In other words, we try to maximize depth of field. But this is a choice, not a fundamental law.

Three main factors determine depth of

field: focal length of the lens, aperture, and distance to the subject. Both focal length and subject distance are often determined by other factors, so aperture is key. The simple rule is: small aperture = big depth of field, and vice versa. Only two modes give direct control over aperture: Aperture-priority and Manual.

Depth of field gets smaller as focal length gets longer. This naturally relates to camera–subject distance, but in a complex way. Suppose you're photographing a single subject like a tree. To maximize depth of field you might fit a wide-angle lens but then, to keep the subject the same size in the frame, you need to move in closer, reducing the benefit to depth of field. If you're photographing a broader landscape, you may already have decided on the viewpoint and angle you want, so changing the lens may not be an option anyway.

Tip

Aperture numbers are really fractions, so f/16 is a small aperture while f/4 is large. The D5200's Information Display (in Graphic mode) illustrates this (see photo on page 32).

Depth of field preview

When you look through the D5200's viewfinder, the lens is set at its widest aperture; if a smaller aperture is selected, the lens stops down at the moment the picture is actually taken. As a result, the viewfinder image may have much less depth of field than the final shot. Many Nikon DSLRs, but not the D5200, have a depth of field preview button. This stops the lens down to the selected aperture, but it also darkens the image and assessing sharpness isn't always easy.

Fortunately, there are alternatives. One is by using Live View. When you enter Live View, the camera stops down to the currently set aperture. However, it doesn't readjust if you change the aperture setting with the Command Dial. It will only reset the aperture if you exit and resume Live View (or take a picture). Still, this is a useful benefit of Live View.

You can also get a sense of the depth of field by taking a test shot and reviewing it on the monitor. Both Live View and image review allow you to zoom in for a closer look. If you take time to use them, both can give you more information than the depth of field preview button ever did.

Hyperfocal distance

When you really need an image to be sharp from front to back, where should you focus? Focusing on the most distant object wastes all the potential depth of

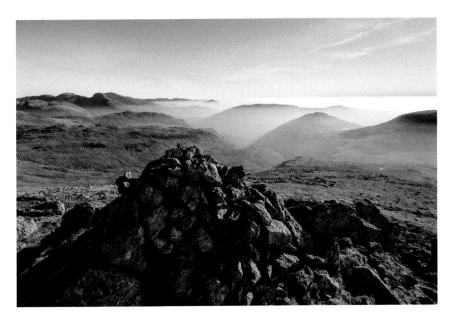

field beyond it; focusing on the closest object equally wastes potential depth of field in front of it. Clearly you should focus in between, but where, exactly?

If you need depth of field to extend right out to "infinity" (in practical terms, anything at a great distance), the answer is what's called the hyperfocal distance. This is not fixed, but varies with focal length and aperture. You can get tables and calculators to work it out, but usually this is overkill.

In an attempt to simplify things, you'll often see advice to "focus one third of the way into the picture". However, there's a small problem: it doesn't actually mean

HYPERFOCAL DISTANCE ⌃
I wanted everything sharp, from the nearest stones to the distant skyline. The focus point was just beyond the cairn. *13mm, 1/100 sec., f/16, ISO 160.*

anything (what's one third of the way to infinity?). Occasionally you might find focusing about a third of the way up from the bottom of the picture works quite well, but only when the shot is very conventionally framed. Alternative advice, which seems at least equally helpful, is to "focus at the far end of the foreground". Or, simpler still: the hyperfocal point is closer than you think.

In any case, it's not always possible to guarantee depth of field stretching from your toes to the horizon. Sometimes you'll have to compromise. An out-of-focus foreground usually looks less natural and more distracting than a bit of softness in the far distance, so it's usually better to err on the nearer side in focusing.

While depth of field is very important, and hyperfocal distance is a useful concept, it's easy to become obsessive about it, and always use the smallest apertures. This may be overkill unless you plan to make big prints or submit images for magazine reproduction. There's much

more tolerance in images which will be used at smaller sizes. And remember, not every image has to have maximum depth of field anyway. Sometimes shallow depth of field is exactly what you want.

Apparent sharpness

Details may appear to be sharp in a small print or a web image but start to look fuzzy when the image is enlarged. "Pixel-peeping" at 100% magnification on your computer screen will often reveal a bit of softness in some areas, yet they can appear perfectly sharp when viewing the image as a whole or in a moderate-size print.

STRENGTH IN DEPTH
Depth of field is shallow enough to emphasize the subject but deep enough to keep a sense of the setting. *55mm, 1/1250 sec., f/4.5, ISO 400.*

» PHOTOGRAPHING MOTION

Of course the D5200 is a capable video camera, but still images can also convey movement extremely well. However, this is a classic example of the camera not seeing what the eye sees: we see movement, but the camera produces still images. This isn't necessarily a drawback: it often reveals drama and grace that may be missed with the naked eye.

Freezing the action

Dynamic posture and straining muscles shout "movement"; the pin-sharp definition delivered by a fast shutter speed can enhance this impression. But what does "fast" mean? Should you set the D5200's maximum 1/4000 sec. every time?

The answer to the second question is definitely "No", but the first question is harder to resolve. The exact shutter speed needed to capture a sharp, frozen image depends on various factors: not just the speed of the subject, but its size and distance. It can be easier to get a sharp image of a train travelling at 180 mph (300 kph) than of a cyclist doing 18 mph, because you need to shoot from much closer range. The direction of movement is another factor: subjects travelling across the frame need faster shutter speeds than those moving towards or away from the camera.

FREEZING THE ACTION ❯❯
A high shutter speed was needed for a sharp image of the dog—as I was handholding a 300mm lens I needed it to avoid camera shake too. *300mm, 1/1250 sec., f/5.6, ISO 800.*

3

There's no "right" shutter speed, but you can play safe by setting the fastest shutter speed possible under the prevailing light conditions, as the D5200's Sports mode does. For more precise control, Shutter-priority is the obvious choice.

Review images on the monitor whenever possible, and if a faster shutter speed appears necessary, be prepared to up the ISO setting *(see page 74)*. If you shoot certain activity/ies on a regular basis, you'll soon discover what works for your particular needs.

Panning

With subjects moving across the field of view, panning is an excellent way to convey a sense of movement. By tracking the subject with the camera, it is recorded crisply while the background becomes blurred. The exact effect varies, so experimentation is advisable, especially before a critical shoot. Panning usually requires relatively slow shutter speeds: anything from 1/8–1/125 sec. can work and you may even go outside this range. Faster shutter speeds diminish background blur but help keep the main subject sharp. Sports mode is no use here; Shutter-priority or Manual are the only options.

Panning is usually easiest with a standard or short telephoto lens, but the decision is often out of your hands because shooting distance is fixed (e.g. behind barriers at sports events).

PANNING ⌃

A classic panning shot. A relatively high shutter speed works well for such a fast-moving subject. *85mm, 1/125 sec., f/14, ISO 400.*

To maintain a smooth panning movement during the exposure, keep following through even after pressing the shutter.

Blur

Blurred images can also convey motion very effectively. It may be a necessity, because you can't set a fast enough shutter speed, or it may be a creative choice, like the silky effect achieved by shooting waterfalls at exposures measured in seconds rather than fractions. Again,

> ### *Tip*
>
> *When you want to embrace creative blur, turn Vibration Reduction OFF on VR lenses.*

finding the right shutter speed often requires trial and error. To ensure that only the moving elements are blurred, use a tripod or other solid support. You can also try for a more impressionistic effect by handholding. Again, Shutter-priority is the natural choice. You can also add flash to the mix, combining a sharp image of the subject with the background blur.

Camera shake

Sometimes you'll move the camera deliberately, as you do when panning. Unintentional movement is another story. Camera shake can produce anything from a slight loss of sharpness to a hopeless mish-mash. Careful handling or the use of camera support *(page 229)* help to alleviate it. Many Nikon lenses have a Vibration Reduction (VR) function *(see page 215)*.

BLUR ⌄
A slow shutter speed captures motion in a special way. *28mm, 4 sec. (tripod), f/25, ISO 100.*

3 » COMPOSITION

Composition is a small word but a big subject. Composition, understood in its widest sense, is why some photos are perfectly exposed and focused but visually or emotionally dull, while others can be heart-stopping even if technically flawed. Composition is where to shoot from, where to aim the camera, how wide a view you want, what to include and what to leave out. All of these come before and stand above any so-called "rules of composition". Get these things right and you'll probably do pretty well without worrying about "rules"; ignore them and "rules" are useless anyway.

The essence of composition is simple (though not necessarily easy). Taking a photograph means selecting some part of our boundless, three-dimensional world and turning it into a two-dimensional rectangle. Most of the time, apart from perhaps looking out of a window, we don't really see the world in rectangles, yet we're very happy to confine it this way in photographs (not to mention the vast majority of paintings and drawings).

THE WHOLE PICTURE ⌄
Framing is about seeing a picture as a complete entity. To label the woman as "the subject" is to miss the point. *135mm, 1/500 sec., f/8, ISO 250.*

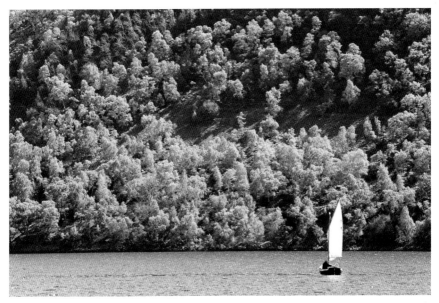

BREAKING THE RULES ⌃
The shoreline and the boat are a long way from where they "should be" according to the "rules", but who cares? *200mm, 1/250 sec., f/8, ISO 125.*

When we really think about photographs as rectangles, we should start to become very aware of edges—both the edges of the viewfinder/screen and the edges of the picture itself. They're key to what's included and what's left out. Our eyes and brains can "zoom in" selectively on the interesting bits of a scene, but the camera will happily and indiscriminately record all

sorts of bits that we didn't even notice. This, all too often, produces pictures that seem cluttered or confusing. So it's important to see what the camera sees, not just what we want to see.

It's intriguing to think about the difference between using the viewfinder and using Live View for framing. Does the obviously two-dimensional nature of the Live View screen make it more "picture-like?" Does it encourage us to see the

Tip

As Ansel Adams said, "There are no rules for good photographs, there are only good photographs."

Tip

There is another, less happy difference between the viewfinder and Live View. Live View gives 100% coverage, showing you the entire image; the viewfinder only shows you 95% of the horizontal and vertical extent, or about 90% of the total image area.

image as a whole rather than mentally zooming in on one bit of it?

Whether you use the viewfinder or Live View, make a conscious effort to see it as a picture: look at the whole image, take note of the edges and what's included, and try to seek out distracting and irrelevant elements.

Framing the landscape

Generally, landscapes don't offer up neat, pre-defined "subjects"; you have to start by deciding which bit or bits of the landscape you want to photograph. There are no right and wrong ways to do this: a lot of it is about how you feel and how you react to the landscape. This often starts with the foreground. After all, it's where you're standing, and it's what connects you to the landscape.

Foregrounds are especially valuable when the distant scene is hazy or flatly-lit, making long-range shots look dull.

FRAMING THE LANDSCAPE ⌄
The line of the wall, leading on to a shadowy distant ridge, creates an almost narrative flow in this image. *30mm, 1/50 sec., f/18, ISO 160.*

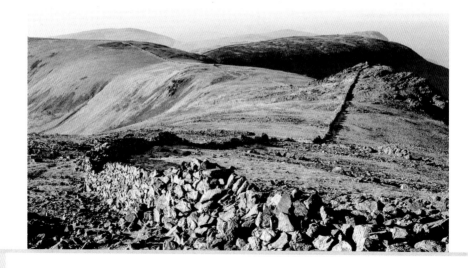

Foregrounds also show texture and detail, which imply sound, smell, and touch. They can also help to convey depth and distance, and strengthen a sense of scale. Strong foregrounds are usually close foregrounds. Get close, and don't be afraid to exploit the third dimension: sit, kneel, crawl, climb.

Wide-angle lenses excel at encompassing both foregrounds and distant vistas. The D5200 has a 1.5x magnification factor, so that a typical wide-ish zoom lens, with a minimum focal length of 18mm, gives the same coverage as a 27mm lens would on a "full-frame" DSLR like the D600. Photographers looking to exploit foregrounds, or big vistas, will soon hanker after something wider, like

the Nikkor 12–24mm f/4G *(see page 216)*. Not every landscape is on the grand scale. Small details can also convey the essence of a place. And if the light is not magical, if distant prospects look flat or hazy, details and textures and the miniature landscapes of a rockpool or forest clearing can bring the pictures back to life. Variations in scale, focus, and so on also help liven up sequences of pictures. However good they are individually, an unrelieved sequence of big landscape images will eventually become oppressive.

VARIATIONS ⌄
Smaller details say much about the landscape.
35mm, 15 sec. (tripod), f/22, ISO 100.

3 » LIGHTING

Light is our raw material; without it there are no photos. We can easily take it for granted—"let the camera take care of it"—but photography is far more rewarding when we tune in to what light is doing, and the pictures are nearly always better too.

Light varies in many ways: color, direction, "hardness" and, most obvious of all, intensity—whether it's bright or dim. We've already considered responses to this, such as exposure, metering, and ISO settings.

Light sources

Natural light essentially means sunlight—direct or indirect (even moonlight is reflected sunlight). The sun itself varies little, but its light can be wildly altered by atmospheric conditions and by reflection. Shining from a clear sky, it is strongly directional, creating hard-edged shadows. On an overcast day it spreads across the entire sky, giving soft, even illumination. Studio photographers use massive "softboxes" to mimic this effect, we can sometimes get close to it with bounce flash (see page 169).

> ### Tip
>
> *Never let the "wrong" light stop you taking a shot; there's nothing to lose.*

Beyond sun and flash there are many other light sources, which can also vary enormously in color, direction, and contrast.

Contrast and dynamic range

"Contrast", "dynamic range", "tonal range": these all refer to the range of brightness between the brightest and darkest areas of a scene. Our eyes adjust continuously, allowing us to see detail in both bright areas and deep shade. By comparison, even the best cameras often fall short, losing detail in shadows, highlights, or even both. This loss of information is called "clipping" (see page 150). Large-sensor cameras like the D600 are generally less susceptible to this, but the D5200 holds its own very well, especially at lower ISO settings.

> ### Tip
>
> *For any camera, dynamic range steadily declines as ISO setting increases. When shooting in high-contrast conditions, use the lowest possible ISO setting for best results. This may of course require slow shutter speeds, which can be tricky with moving subjects. For static subjects, this is yet another reason to use a tripod.*

HIGH CONTRAST ⌃

With deep shadow on the near side of the bridge and dazzling reflections on the water beyond, contrast is pretty extreme, but the camera has coped very well. Compare the highlights display *on page 83*; the image (shot in RAW) is seen here after some recovery on both highlights and shadows. *112mm, 1/320 sec., f/11, ISO 200.*

Shooting RAW gives some chance of recovering highlight and/or shadow detail in post-processing. Active D-Lighting or D-Lighting *(see pages 87 and 118)* can help with JPEG images. However, all have their limits. Sometimes it's simply impossible to capture the entire brightness range of a scene in a single exposure. Both the histogram display *(page 84)* and the highlights display *(page 83)* help to identify such cases.

Digital imaging offers another solution: taking multiple shots, at different exposure levels, which can then be merged. The D5200's HDR (high dynamic range) feature *(see page 92)* does this in-camera, though

it's limited to two source images. For greater flexibility you can shoot several JPEG or RAW images and combine them in post-processing. HDR software can automate this merging; I've found the LR/Enfuse plugin for Lightroom does a good job, but I often still process manually, using Layer Masks in Photoshop. For all these

MERGING IMAGES ⏶
This isn't one photo, it's two: one exposure for the relatively dim interior and another for the brighter scene outside the window (which also originally had a very different color balance). *18mm, 3 sec., and 1/30 sec., f/13, ISO 125.*

approaches, a solid tripod is essential to keep source images aligned.

In overcast, "soft", lighting conditions, contrast is much lower. This is much easier for the camera to deal with but can still produce great images of suitable subjects, such as portraits and flower studies.

> ### Tip
>
> *With nearby subjects, like portraits, you can compensate by throwing some extra light into the shadows, using fill-in flash (see page 159) or a reflector. Reflectors can often be improvised, e.g. by standing your subject near a white wall.*

Direction of light

And then there's the question of where the light is coming from: in front, behind, overhead, or from the side?

Frontal lighting is what you get with on-camera flash, or with the sun behind you: head-on, drenching everything with light, leaving few visible shadows. Images may look flat and uniform, but frontal lighting can accentuate pure color, shape, or pattern. It rarely creates extremes of contrast, so exposure is usually straightforward.

Oblique lighting ("side-lighting") is more complex and usually more interesting, defining forms and textures. At really acute angles, the light accentuates fine details, from crystals in rock to individual blades of grass. This is one

Tip

To sharpen up your sense of the direction and quality of the light, look at your own shadow: where does it point, and how sharp or soft is it? (This doesn't work if you're standing in the shade.)

reason why landscape photographers love the beginning and end of the day. However, in hillier terrain, even a high sun may still cast useful shadows. In deep gorges, direct light may only penetrate when the sun's at the zenith. Side-lighting is terrific for landscapes, and many other subjects, but often implies high contrast.

Backlighting can give striking and beautiful results, but needs care.

FRONTAL LIGHTING ⌃
Frontal lighting can work well for landscapes and other subjects with strong shapes and colors. *12mm, 1/125 sec., f/11, ISO 100.*

OBLIQUE LIGHTING ⌄
Oblique lighting emphasizes the detail and texture of this ancient site in Menorca. *14mm, 1/250 sec., f/11, ISO 200.*

BACKLIGHTING ⌄
Backlighting can give a special luminosity to the simplest of subjects. *200mm, 1/80 sec., f/10, ISO 200.*

MORNING LIGHT ⌃
The warm light of the rising sun contrasts with cool shadows illuminated by a blue sky. *110mm, 1/200 sec., f/8, ISO 400.*

Translucent materials like foliage and fabric glow beautifully when backlit, but more solid subjects can appear as mere silhouettes. Sometimes this is ideal: bare trees look fantastic against a colorful sky. If so, meter for the bright areas to maximize color saturation there, perhaps using exposure lock *(page 60)* or, of course, Silhouette mode *(page 94)*. When you don't want a silhouette, a reflector or fill-in flash can help. Positive exposure compensation *(page 59)* will also lighten the subject, but will weaken the background too.

Color

Light comes in—literally—all the colors of the rainbow, but generally we barely notice; instead we see, or think we see, the colors of things. Cameras, however, are more observant.

Most of the time, Auto White Balance will accommodate changing light and keep colors looking pretty natural, but there are times when it may stumble (especially under artificial light).

The warmer light of a low sun is one

reason why landscape photographers traditionally favor mornings and evenings. It's not just that we tend to find warm colors more pleasing; if that was all, the effect could be easily replicated with a Photoshop adjustment. In the real world, however, sunlit surfaces pick up a warm hue, while shadows get their light from the sky, tinting them blue. This is most obvious in snow scenes, but it's generally true.

This difference in color between sunlit and shadow areas increases as the direct sunlight becomes redder, adding vibrancy to morning and evening shots. Filters can't duplicate this effect. When such shifting colors are part of the attraction, you don't want to "correct" them back to neutral.

Tips

Sunset mode is aimed at shooting the evening sky itself, rather than a landscape illuminated by a red sun. It can't hurt to try it, but be prepared to try Landscape or Aperture-priority modes too.

Shooting RAW gives far more scope for adjusting the white balance later. Another option, especially when shooting JPEGs, is white balance bracketing (page 61).

However, if White Balance is set to **Auto** (as it is in 📷 Auto and the majority of Scene modes), the D5200 may attempt to do exactly this. Instead, try shooting in one of the user-control modes with White Balance set to **Direct sunlight**. Or shoot RAW; this gives you latitude to adjust the color balance later.

It's the same with artificial light; sometimes you'll want to correct its color, sometimes it's better to leave it alone. Portraits shot under fluorescent lamps often acquire a ghastly greenish hue, which you will surely want to avoid. Auto White Balance usually improves matters, but it's less reliable with artificial light than natural light.

Conversely, when shooting floodlit buildings, the variations in color may be part of the appeal. Results with Auto White Balance (as in Night landscape mode) are somewhat unpredictable and may not match what you see or what you want.

3 » OPTICAL ISSUES

There are still more ways in which what the camera sees doesn't match what the eye sees. Some of these arise from the fact that camera lenses are very different from the human eye.

Flare

Lens flare results from stray light bouncing around within the lens. It's most prevalent when shooting towards the sun, whether the sun itself is in frame or just outside. It may produce a string of colored blobs, lined up as if radiating from the sun, or a more general veiling of light. You'll usually be able to see it in the viewfinder or on the LCD screen, but check again on playback.

Advanced lens coatings, like those in Nikkor lenses, greatly reduce the incidence of flare. Keeping lenses and filters scrupulously clean also helps.

If the sun's actually in frame, some flare

FLARE FOR THE OCCASION ⌄
Flare is evident in the first shot but a change of position shaded the lens and eliminated the flare. *14mm, 1/640 sec., f/4, ISO 200.*

DISTORTION »

Barrel distortion is evident, especially looking at the top of the building. This shot was taken on a full-frame DSLR (Nikon D600), which exposes the shortcomings of the lens more obviously. *24mm, 1/80 sec., f/8, ISO 320.*

may be inescapable. You may want to look for ways to reframe the shot or to mask the sun, for instance behind a tree.

If the sun isn't in shot, try to shield the lens. A good lens hood is essential, but further shading may be needed, especially with zoom lenses. You can use a piece of card, a map, or even your hand. This is easiest with the camera on a tripod; otherwise it may demand one-handed shooting (or you can enlist a friend). Check the viewfinder and/or monitor playback carefully to see if the flare has gone—and make sure the shading object hasn't crept into shot.

Distortion

Distortion makes lines that are actually straight appear curved in the image. As lens design continually improves it's less prevalent than it once was. The worst offenders are usually zoom lenses that are old, cheap, or both. Distortion is often worst at the extremes of the zoom range.

When straight lines bow outwards, it's called barrel distortion; when they bend inwards it's pincushion distortion. Both can be forestalled using Auto Distortion Control (Shooting menu) or subsequently corrected

using Distortion Control in the Retouch menu, or with software like Nikon Capture NX or Adobe Lightroom. However, all methods crop the image; ideally, avoid the issue in the first place by using good lenses.

Distortion may go unnoticed when shooting natural subjects with no straight lines, but can still manifest when level horizons appears in landscapes or seascapes, especially near top or bottom of the frame.

Aberration

Chromatic aberration occurs when light of different colors is focused in slightly different planes, appearing as colored fringing when images are examined

closely. The D5200 has built-in correction for chromatic aberration during processing of JPEG images. Aberration can also be corrected in post-processing; with RAW images this is the only option.

Although it's a lens property, chromatic aberration can be exaggerated by the way light strikes a digital sensor. It's best to use lenses specifically designed for digital cameras.

maximum aperture, but it usually disappears on stopping down. Software, such as Adobe Lightroom, provides controls which can compensate for vignetting by certain lenses.

Vignetting can also be caused, or exaggerated, by unsuitable lens hoods or filter holders, or by "stacking" multiple filters on the lens (rarely a good idea).

Vignetting

Vignetting is a darkening towards the corners of the image. It's most conspicuous in even-toned areas like clear skies. Most lenses show slight vignetting at

SUNSET VIGNETTE ☒
Vignetting is very obvious in this shot of Ravenglass, Lake District, UK (it has been slightly exaggerated in post-processing). *16mm, 1/100 sec., f/11, ISO 400.*

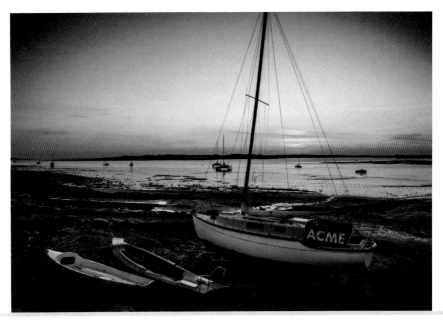

» DIGITAL ISSUES

Image noise is created by random variations in the amount of light recorded by each pixel, and appears as speckles of varying brightness or color. It's most conspicuous in areas that should have an even tone, and normally most severe in darker areas. Unfortunately, cramming more megapixels onto a sensor creates a greater tendency to noise, but there have (so far) been compensating improvements in other aspects of sensor technology and in processing software which compensates for image noise. Although the D5200 has more than 24 million photosites on its 23.5 x 15.6mm sensor, general noise levels are low, but noise does increase noticeably at the higher ISO settings. To minimize noise, shoot at the lowest possible ISO rating and expose carefully: underexposure increases the risk of visible noise. Noise Reduction (NR) is often applied to JPEG images as part of in-camera processing *(see pages 68 and 101)* but can also be applied during post-processing; this is normal for RAW files.

NOISE　　　　　　　　　　　　　　　　　❯❯

Shot at maximum ISO with all noise reduction off, noise is quite evident here (left)! Compare the result with NR set to High; the noise largely disappears, but so does a lot of fine detail. *86mm, 1/5 sec., f/16, ISO 12,800.*

3

Clipping

Clipping occurs when highlights and/or shadows are recorded without detail, turning shadows an empty black and highlights a blank white. Clipping is indicated by a "spike" at either extreme of the histogram display. You can also set the D5200 to show highlight clipping during playback by flashing affected parts of the image (see Playback display options, *see page 83*).

The D5200 is a good performer, but no camera is totally immune to clipping. There is some scope to recover clipped areas if you shoot RAW, while Active D-Lighting can help with JPEG images (*see page 87*).

Normally when viewing a digital image we don't notice that it is made up of individual pixels, but small clumps of pixels can sometimes become apparent as "artefacts" of various kinds.

Aliasing is most evident on diagonal or curved lines, giving them a jagged or stepped appearance. *Moiré* or *maze artefacts* can occur when there's interference between areas of fine pattern in the subject and the grid pattern of the sensor itself. This often takes the form of aurora-like swirls or fringes of color. To compensate for such issues, digital cameras employ a low-pass filter directly in front of the sensor itself. This actually works by blurring the image slightly; this is very effective in removing artefacts but

means that images then need to be re-sharpened either in-camera or in post-processing (see below).

JPEG artefacts look a lot like aliasing, but are created when JPEG images are compressed, either in-camera or on the computer. Avoid them by limiting JPEG compression: use the *Fine* setting for images that may later be printed or viewed at large sizes.

Sharpening images

Because of the low-pass filter in front of the sensor, some sharpening is required to make digital camera images look acceptable. However, too much sharpening can produce artefacts, including white fringes or halos along defined edges.

JPEG images are sharpened during in-camera processing. Sharpening settings are accessed through Nikon Picture Controls (*page 90*), and are therefore pre-determined when shooting in Auto and Scene modes. In P, S, A, or M modes, you can change sharpening levels; however, be wary about increased sharpening unless images are solely destined for screen use. It's easy to add sharpening in post-processing, when you can judge the effect at 100% magnification on the computer screen. However, it's virtually impossible to eliminate existing artefacts created by oversharpening.

With RAW images, sharpening takes place on the computer.

» FINDING FOREGROUNDS

On a good day the Howgill Fells give some of the finest and loneliest walking in England, but their broad ridges can look rather featureless in photos. I wandered some way off the path before I found this spring scar, which gave shape to the foreground. It was in just the right place to align with the shadowy valley sides beyond.

Settings
> Focal length: 18mm
> Shutter speed: 1/250 sec.
> Aperture: f/11
> Sensitivity: ISO 125

HOWGILL FELLS, CUMBRIA

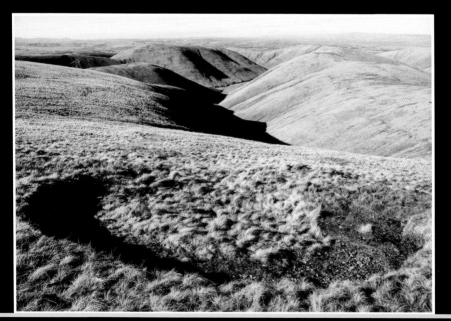

The slightly misty light was gorgeous and I took a lot of pure landscape shots, but I wanted something that related to the experience of being there. Moving a few paces off the path can make all the difference to many walking (and cycling) photos, and so it proved here. I had the exposure settings already sorted so just needed to time the shot when my partner reached the obvious gap in the trees.

Settings
> Focal length: 30mm
> Shutter speed: 1/100 sec.
> Aperture: f/7.1
> Sensitivity: ISO 250

LATTERBARROW, LAKE DISTRICT

» FRAMING CHOICES

Rules are made to be broken—at least, that's true of the so-called rules of composition. In fact, I wasn't even thinking about them—I rarely do. In this case, because I was shooting from the shoreline, I couldn't play with perspective by moving closer or further from the boat. The key choice was focal length—if I'd taken a wider view to show more of the distant skyline, the boat would also have been smaller (the full panorama, spanning more than 180 degrees, is beyond the range of any lens). In fact, I used the longest lens I had with me.

Settings
> Focal length: 300mm
> Shutter speed: 1/200 sec.
> Aperture: f/8
> Sensitivity: ISO 100
> Support: tripod

MORECAMBE BAY FROM BARE, LANCASHIRE

3 » A STITCH IN TIME

Setting out on a long walk, with just one camera and one lens, I arrived at Llyn Idwal in Snowdonia early in the morning.

The 18mm lens was nowhere near wide enough to capture the whole of this impressive scene, so I shot several overlapping frames to be "stitched" together later using Adobe Photoshop. When shooting images for stitching, it's a good idea to allow plenty of overlap and this composite is made from six original shots. It's also wise to shoot in manual, or use exposure lock, to ensure that all the source images are completely consistent.

I took the source shots in portrait format to take in more foreground, so looking at the short edge of this image gives you an idea of the coverage I could have achieved in a single shot with the 18mm lens.

Settings
› Focal length: 18mm
› Shutter speed: 1/100 sec.
› Aperture: f/11
› Sensitivity: ISO 200

LLYN IDWAL, SNOWDONIA

» INTO THE LIGHT

This was a rather special morning in the Brock valley in Lancashire. Even after the early mist had cleared I found lots of exciting possibilities. The lighting was just about perfect on this tree, which glowed brilliantly against the still-shadowy background of the opposite slope. I used a tripod and remote release to maximize sharpness and checked the histogram carefully after the first test exposure.

Shooting straight into the light, flare could have been a problem, but partly masking the sun behind the tree trunk kept it at bay.

Settings
> Focal length: 34mm
> Shutter speed: 1/20 sec.
> Aperture: f/11
> Sensitivity: ISO 100
> Support: tripod

BROCK VALLEY, LANCASHIRE

Chapter 4
FLASH

4 FLASH

Flash can be immensely useful, and the D5200 has great capabilities, but flash photography can also lead to great confusion and frustration. All flashguns are small. All flashguns are weak. These two statements are key to understanding flash photography. They are especially true for built-in units like that on the D5200 and most other DSLRs (those on compact cameras are typically even smaller and weaker).

» PRINCIPLES

Because it's small, the flash produces very hard light. It's similar to direct sunlight, but even the strongest sunlight is slightly softened by scattering and reflection; we can sometimes soften the flash, too.

The weakness of flash is even more fundamental. All flashguns have a limited range, and on-camera flash is more limited than most accessory flashguns.

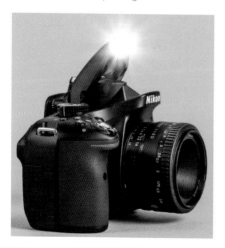

Guide Numbers

The Guide Number (GN) is a measure of the power of a flash. In the past, photographers used GNs constantly to calculate flash exposures and working range. With modern flash metering, such computations are rarely needed, but the GN does help us compare different flashguns. For instance, the GN for the built-in flash is 12 (meters, ISO 100); for the Nikon SB-910 it is 34, indicating almost three times the power. This allows shooting at three times the distance, at a lower ISO, or with a smaller aperture.

Tip

GNs are specified in feet and/or meters and usually for an ISO rating of 100. When comparing different units, be sure that both GNs are stated in the same terms.

TUNNEL VISION «
The limited range of the built-in flash means that it lights the foreground but doesn't reach into the tunnel. *12mm, 1/50 sec., f/8, ISO 1000.*

Built-in flash units raise a third issue, too, namely their fixed position close to the lens, which makes the light one-dimensional—and tediously similar for every shot. See Operating the built-in flash on *page 161.*

Flash is not the answer to every low-light shot. Understanding its limitations helps us understand when to seek alternatives, as well as when and how we can use flash effectively.

» FILL-IN FLASH

A key application for flash is for "fill-in" light, giving a lift to dark shadows like those cast by direct sunlight. This is why pros regularly use flash in bright sunlight (exactly when most people wouldn't think to use it).

Fill-in flash doesn't need to illuminate

GLOVE LIGHT »
The background exposure is the same for both shots, but without flash the glove is almost black. *127mm, 1/8 sec., f/10, ISO 400.*

the shadows fully, only to lighten them a little. This means the flash can be used at a smaller aperture, or greater distance, than when it's the main light (averaging around two Ev smaller, or four times the distance).

i-TTL balanced fill-flash for DSLR

Nikon's i-TTL balanced fill-flash helps achieve natural-looking results when using fill-in flash. It comes into play automatically provided (a) matrix or center-weighted metering is selected, and (b) a CPU-equipped lens is attached.

The flash (built-in or compatible accessory flash) emits several virtually invisible pre-flashes immediately before exposure. Reflected light from these is analyzed by the metering sensor, together with the ambient light. If Type D or G lenses are used, distance information is also incorporated.

Standard i-TTL flash for DSLR

When spot metering (*see page 58*) is selected, this mode is activated instead. Flash output is controlled to illuminate the subject correctly, but background illumination is not taken into consideration. This mode is appropriate when using flash as the main light source rather than for fill-in.

BALANCED FILL-FLASH ⌄

It's not (I hope!) too obvious that flash has been used, but without it the walker would be much less clear. *16mm, 1/125 sec., f/11, ISO 200.*

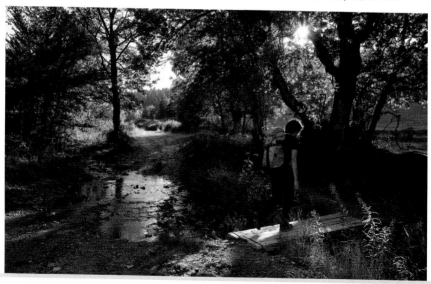

» OPERATING THE BUILT-IN FLASH

The D5200's built-in flash, like all such units, is small, low-powered, and fixed in position close to the lens axis. Together, these factors mean it has a limited range, and produces a flat and harsh light which is unpleasant for, say, portraits. It may be better than nothing, but it only really comes into its own when used for fill-in light.

In ▢ Auto, and many of the Scene modes, the flash activates when the camera deems it necessary (**Auto flash**). However, it can be turned off using the Active Information Display. In ⊕ Auto (flash off), and certain Scene modes, the built-in flash is not available. In P, S, A, or M modes and ¶¶ Food the flash is always available but you must activate it manually.

Activating the built-in flash

1) Select a metering method *(see page 58)*: matrix metering is advised for fill-in flash. Spot metering is appropriate when flash is the main light.

2) Press ⚡ and the flash will pop up and begin charging. When it is charged the ready indicator ⚡ is displayed in the viewfinder.

3) Choose a flash mode from the Active Information Display. Highlight the current flash mode (bottom left) and press **OK**. Select the desired flash mode and press **OK** again. (*See page 164* for explanation of flash modes.)

4) Take the photo in the normal way.

5) When finished, lower the built-in flash, pressing gently down until it clicks into place.

> ### *Tip*
>
> *The built-in flash is recommended for use with CPU lenses between 18mm and 300mm focal length. Some lenses may block part of the flash output at close range; removing the lens hood often helps. The Nikon manual details limitations of use with certain lenses.*

Whether the shutter speed is 1/200 sec., ½ sec. or 20 sec., the flash normally fires just once during this time and therefore delivers the same amount of light to the subject. If there were no other light, the subject would look the same whatever shutter speed was used. Shutter speed only becomes relevant when there is other light

Exposure mode	Shutter speed	Aperture
P	Set by the camera. The normal range is between 1/200 and 1/60 sec., but in certain flash modes all settings up to 30 sec. are available.	Set by the camera
S	Selected by user. All settings between 1/200 and 30 sec. are available. If the user sets a faster shutter speed, the D5200 will fire at 1/200 sec. while the flash is active.	Set by the camera
A	Set by the camera. The normal range is between 1/200 and 1/60 sec., but in certain flash modes all settings up to 30 sec. are available.	Selected by user
M	Selected by user. All settings between 1/200 and 30 sec. are available. If user sets a faster shutter speed, the D5200 will fire at 1/200 sec. when the flash is active.	Selected by user
📷, 🏃, 👤, 🌸, 🐕, 🌙	Set by camera, between 1/200 and 1/60 sec.	Set by the camera
🌷, 🍴	Set by camera, between 1/200 and 1/60 sec.	Set by the camera
🖼	Set by camera, between 1/200 and 1 sec.	Set by the camera

around, which we call ambient light. Slower shutter speeds give the ambient light more chance to register.

Aperture, however, is relevant to both flash exposure and ambient exposure. The camera's flash metering takes this into account but it is useful to understand this distinction for a clearer sense of what's going on, especially with slow-sync shots.

The combinations of shutter speed and aperture that are available when using flash depend on the Exposure mode in use.

Flash range

The range of any flash depends on its power, ISO sensitivity setting, and the aperture set. The table details the approximate range of the built-in flash for selected distances, apertures, and ISO settings. These figures are based on the table in the D5200 manual, confirmed by practical tests. There's no need to

memorize these figures, but it does help to have a general sense of the limited range that always applies when using flash. A quick test shot will tell you if any given subject is within range.

Tip

If flash appears too weak, or the range is insufficient, turning up the ISO setting may help, but check first that flash compensation (see page 167) is not in effect.

| ISO setting | | | | | | Range | |
100	200	400	800	1600	3200	feet	meters
1.4	2	2.8	4	5.6	8	3ft–27ft 11in.	1.0–8.5
2	2.8	4	5.6	8	11	2ft 4in.–20ft	0.7–6.1
2.8	4	5.6	8	11	16	2ft–13ft 9in.	0.6–4.2
4	5.6	8	11	16	22	2ft–9ft 10ft	0.6–3.0
5.6	8	11	16	22	32	2ft–6ft 11in.	0.6–2.1
8	11	16	22	32		2ft–4ft 11in.	0.6–1.5
11	16	22	32			2ft–3ft 7in.	0.6–1.1
16	22	32				2ft–2ft 4in.	0.6–0.7

» FLASH SYNCHRONIZATION AND FLASH MODES

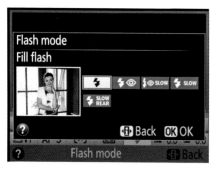

Flash mode setting in the Active
Information Display

Flash, as the name implies, is virtually
instantaneous, lasting just a few
milliseconds. If the flash is to cover the
whole image frame it must be fired when
the shutter is fully open, but at faster
shutter speeds SLRs like the D5200 do not
in fact expose the whole frame at once.
In the case of the D5200, the fastest shutter
speed which can normally be used with
flash is 1/200 sec. This is therefore known
as the sync (for synchronization) speed.

The D5200 has several flash modes; the
differences between them are largely to
do with options relating to synchronization
and shutter speed. Choose a flash mode
by pressing 🗲 and rotating the
Command Dial, or through the Active
Information Display.

Standard flash mode (front-curtain sync)

This is the default flash mode in most
exposure modes. However, the flash mode
item in the Active Information Display
labels it "Fill-flash" when using P, S, A, and
M exposure modes and "Auto flash" in
other modes.

In standard flash operation, the flash
fires as soon as the shutter is fully open, i.e.
as soon as possible after the shutter-release
button is pressed. This gives a fast response
and the best chance of capturing the
subject as you see it. However, it can create
odd-looking results when dealing with
moving subjects; for these rear-curtain
sync (see below) may be more suitable.

In P and A exposure modes, the camera
will set a shutter speed in the range 1/60–
1/200 sec. In S and M exposure modes, you
can set any shutter speed down to 30 sec.,
which means that standard flash also
encompasses Slow sync (see below).

Slow sync

Slow sync combines a flash image with a
motion-blurred image from the ambient
light, but front-curtain sync makes the
latter trail ahead of the flash image, not
behind it.

This mode allows longer shutter speeds
(right up to 30 sec.) to be used in P and A
exposure modes, so that backgrounds can

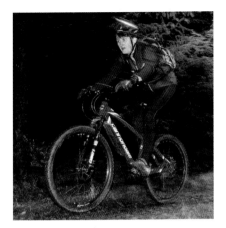

be captured even in low ambient light. Movement of the subject or camera (or even both) can result in a partly blurred image created by the ambient light, combined with a sharp image where the subject is lit by the flash. This may be unwelcome, but can also be used for creative effect.

This mode is also available, in a limited form (longest exposure 1 sec.), with 🌃 Night portrait mode—here it's known as Auto slow sync. You can't select Slow sync in S and M exposure modes, but it isn't necessary, as longer shutter speeds are available anyway.

REAR-CURTAIN SYNC IN ACTION »
Rear-curtain sync means that the motion-blurred elements of the image appear behind the sharp image created by the flash.

FRONT-CURTAIN SYNC IN ACTION «
Slow sync combines a flash image with a motion-blurred image from the ambient light, but front-curtain sync makes the movement trail ahead of the flash image, not behind it.

Rear-curtain sync

Rear-curtain sync triggers the flash not at the first available moment (as front-curtain sync does), but at the last possible instant. This makes sense when photographing moving subjects because any image of the subject created by the ambient light then appears behind the sharp flash image, which looks more natural than having it appear to extend ahead of the direction of movement. Rear-curtain sync can only be selected when using P, S, A, and M exposure modes. In P and A modes it also allows slow shutter speeds (below 1/60 sec.) to be used, and is then called slow rear-curtain sync.

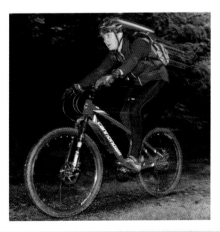

When using longer exposure times, shooting with rear-curtain sync can be tricky, as you need to predict where your subject will be at the end of the exposure, rather than immediately after pressing the shutter-release button. It is often best suited to working with co-operative subjects—or naturally repeating action, like races over numerous laps of a circuit—so you can fine-tune your timing after reviewing images on the monitor.

Red-eye reduction

On-camera flash, especially built-in units, is very prone to "red-eye", where light reflects off the subject's retina. Red-eye reduction works by shining a light on the subject about a second before the exposure, causing their pupils to contract.

This delay makes it inappropriate with moving subjects, and kills spontaneity. It's generally better to remove red-eye using the Red-eye correction facility in the Retouch menu *(see page 118)* or on the computer. Better still, use a separate flash, away from the lens axis, or no flash at all, perhaps shooting at a high ISO rating.

Unfortunately, red-eye reduction is on by default in 🎉 Party/indoor, but can be changed in the Active Information Display.

Red-eye reduction with slow sync

This combines the two modes named, allowing backgrounds to register. This mode is only available when using P and A exposure modes and, in a more limited form, with 🌃 Night portrait.

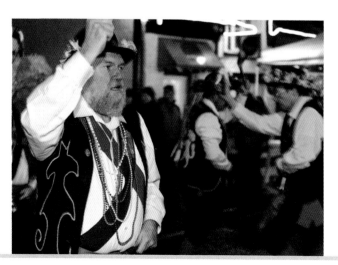

FESTIVE LIGHTING «
Flash lightens the nearest figure and, perhaps more importantly, gives a sharper image of this moving subject. *35mm, 1/60 sec., f/2.8, ISO 3200.*

FLASH COMPENSATION

Setting flash compensation in the Active Information Display

Although the D5200's flash metering is extremely sophisticated, it's not 100% infallible. You may also want to adjust flash output for creative effect. Immediate playback helps you assess the effect of the flash, allowing compensation to be applied with confidence to further shots.

Flash compensation is only available in P, S, A, and M modes and is activated via the Active Information Display. Compensation can be set from −3 Ev to +1 Ev in increments of ⅓ Ev. Positive compensation will brighten areas lit by the flash, while leaving ambient-lit areas unaffected. However, if the subject is already at the limit of flash range, positive compensation can't make it any brighter. Negative compensation reduces the brightness of flash-lit areas, again leaving other areas unaffected.

After use, reset flash compensation to zero. Otherwise the camera will retain the setting next time flash is used.

Manual flash

If item **e1 Flash cntrl for built-in flash** in the Custom settings menu is set to **Manual**, you can control flash output even more precisely, from full power to as low as 1/32.

WATCH THE BIRDIE ⹖
Three shots taken with compensation set to −1, 0, and +1 respectively. *190mm, 1/20 sec., f/8, ISO 100.*

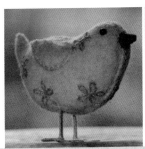

» USING OPTIONAL SPEEDLIGHTS

If you're serious about portrait or close-up photography, in particular, you'll soon find the built-in flash inadequate. Accessory flashguns, which Nikon calls Speedlights, enormously extend the power and flexibility of flash with the D5200.

Nikon Speedlights integrate fully with Nikon's Creative Lighting System for outstanding results using flash. There are currently four models, all highly sophisticated units mainly aimed at professional and advanced users, and priced accordingly. The flagship SB-910 is particularly impressive—but costs more than many Nikkor lenses.

Independent makers such as Sigma offer alternatives, some of them also compatible with Nikon's i-TTL flash control. However such "dedicated" units are also hardly cheap.

Many possibilities can be explored with much cheaper units. For instance, any flashgun, however basic, that allows manual triggering with a "test" button can be used for the "painting with light" technique outlined below. You may have an old flashgun at the back of a cupboard, and it's also worth checking the bargain bin at the local camera shop.

› Mounting an external Speedlight

1) Check that the camera and the Speedlight are both switched OFF, and that the pop-up flash is down. Remove the hotshoe cover.

2) Slide the foot of the Speedlight into the camera's hotshoe. If it does not slide in easily, check whether the mounting lock on the Speedlight is in the locked position.

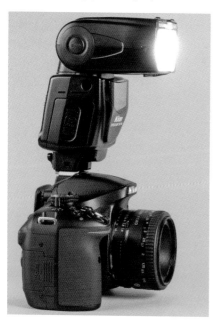

D5200 and Speedlight SB-700

3) Rotate the lock lever at the base of the Speedlight to secure it in position.

4) Switch ON both the camera and the Speedlight.

› Bounce flash and off-camera flash

The fixed position of the built-in flash throws odd shadows on close subjects and gives portraits an ugly "police mugshot" look. A hotshoe-mounted Speedlight will improve things slightly, but you can make a much bigger difference by either:

1) Bouncing the flash light off a ceiling, wall, or reflector.

2) Taking the Speedlight off the camera.

› Bounce flash

Bouncing the flash light off a suitable surface both spreads the light, softening hard-edged shadows, and changes its

> ### Tip
>
> *Speedlights are greedy for battery power. It is always wise to carry at least one set of spares. Rechargeables are both more economical and environmentally friendlier.*

direction, eliminating the flatness of direct on-camera flash.

Nikon's SB-910 and SB-700 Speedlights have heads which can be tilted and swivelled through a wide range, allowing light to be bounced off walls, ceilings, and other surfaces. The SB-400 has a more limited tilt capability, allowing light to be bounced off the ceiling or a reflector.

› Off-camera flash

Taking the flash off the camera gives you complete control over the direction of the light. The flash can be fired using a flash cord; Nikon's dedicated cords preserve i-TTL metering (see under Flash accessories, *page 172*).

> ### Tip
>
> *Most surfaces will absorb some of the light, and in any case the light has to travel further to reach the subject; i-TTL metering will automatically adjust for this, but the effective range is reduced. However, most accessory flashguns have more power than the built-in unit.*

› Painting with light

You can try this intriguing technique with any flashgun, even the cheapest, that can be triggered manually. By firing multiple flashes at the subject from different directions, you build up overall coverage of light without losing the sparkle that directional light gives. It requires trial and error, but that's part of the fun. The basic steps are:

1) Set up so that neither camera nor subject can move during the exposure.

2) Use Manual mode. Set a long shutter speed such as 20 or 30 sec., or even B. Set a small aperture such as f/16 (this may need trial and error). Focus on the subject then turn the focus selector to **M** so the camera doesn't try to refocus.

3) Turn out the lights. It helps to have just enough background light to see what you are doing, but no more.

HEN LIGHT
The first shot was taken using the built-in flash, which makes this three-dimensional arrangement look distinctly flat. The second uses indirect flash from the right. The third uses bounce flash, giving softer, more even light, but retaining a 3D quality. *125mm, f/5.6, ISO 400.*

4) Trip the shutter and then fire the flash at the subject from different directions (without aiming directly into the lens).

5) Review the result and start again. For example, if results are too bright, use fewer flashes, a lower ISO, a smaller aperture, fire from further away, or a combination. If the flash has a variable power setting this could be turned down.

» NIKON SPEEDLIGHTS

	SB-910	SB-700	SB-400	SB-R200
Flash coverage (lens focal length range)	17–200	24–120		
Guide number (ISO 100 meters}	34	28	21	
Twist/swivel	Yes	Yes	Tilt only	No
Dimensions (width x height x depth, mm)	78.5 x 145 x 113	71 x 126 x 104.5	66 x 56.5 x 80	80 x 75 x 55
Weight (without batteries)	420g	360g	127g	120g
Use as Commander	Yes	Yes	No	No*

(*Cannot be used in camera hotshoe, only as a slave within Creative Lighting System)

The table above summarizes key features of current Nikon Speedlights.

› Wireless flash

Nikon's Creative Lighting System includes the ability to regulate the light from multiple Speedlights through a wireless system. The built-in flash units on professional DSLRs like the D800 can be used as the "commander" for a wireless setup, as can the SB-910 and SB-700 Speedlights. There's also a stand-alone commander, the SU-800. The D5200 can operate within such a system but must be physically connected to a commander unit.

» FLASH ACCESSORIES

To add even more flexibility and control of lighting effects, a wide variety of flash accessories is available. Nikon has an extensive range, but when time is short or money is tight substitutes for some of these can be improvised.

› Battery packs

Nikon produces add-on power packs for some of its Speedlights to speed up recycling and extend battery life.

› Color filters

Flash filters can be used to create striking color effects, or to match the color of the flash to that of the background lighting. Nikon produces various filters to fit its Speedlight range.

› Flash cords

Because the D5200's built-in flash can't act as a wireless commander, you can only maintain full metering and control of an external Speedlight if it's physically connected to the camera in the hotshoe or with a flash cord (also known as a sync lead). Dedicated cords like Nikon's SC-28 allow full communication between camera and Speedlight, retaining i-TTL flash control. The SC-28 extends up to 1.5m.

› Flash diffusers

Flash diffusers are a simple, economical way to spread and soften the hard light from a flashgun. They may slide over the flash head or be attached by low-tech means like elastic bands or Velcro. Sto-Fen make Omni-Bounce diffusers to fit most flashguns, and an Omni-Flip for built-in units like the D5200's. Even a white handkerchief can be used at a pinch (but beware, flash units can get hot). Diffusers reduce the light reaching the subject; the

A D5200 and a HONL "softbox"

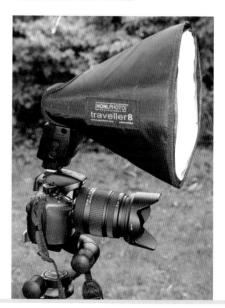

D5200's metering system will allow for this, but the effective range will be shorter.

A step beyond a simple diffuser is the portable "softbox" which can attach to a Speedlight to create a wider spread of light.

› Flash extenders

A flash extender slips over the flash head, using mirrors or a lens to create a tighter beam and extend the effective range of the flash. Again, the D5200's metering system will automatically accommodate the use of an extender. Nikon do not make flash-extenders, so a third-party option will be required.

› Flash brackets

The ability to mount the flash off-camera, and therefore change the angle at which the light hits the subject, is invaluable in controlling the quality of light. Nikon's Speedlights can be mounted on a tripod or stand on any flat surface using the AS-19 stand, but for a more portable solution many photographers prefer a light, flexible arm or bracket which attaches to the camera and supports the Speedlight. Novoflex produces a range of such products.

CHICK LIT ⌃
This shot was made using two Speedlights, one to each side. The system took care of regulating the lighting very well. However, it would have been possible to replicate this shot using the painting-with-light technique. *125mm, f/22, ISO 100.*

Nik

Chapter 5
CLOSE-UP

5 CLOSE-UP

Most photography is about capturing what you can see with the naked eye. Close-up photography goes beyond this into a whole new world, or at least a new way of seeing the world. For close-up photography the 35mm SLR and its digital successors like the Nikon D5200 reign supreme. Reflex viewing, once essential in close-up work, is now supplemented by Live View.

Depth of field *(see page 129)* is a key issue. As you move closer to the subject, depth of field becomes narrower. This has several consequences. First, it's often necessary to use small apertures, which can dictate long exposures. Second, the slightest movement of either subject or camera can ruin the

focus. A tripod or other solid camera support is often required, and it may also be necessary to prevent the subject from moving (within ethical limits, of course!).

Because depth of field is so slim, focusing becomes critical. Merely focusing on "the subject" is no longer good enough and you must decide which part of the subject—an insect's eye, the stamen of a flower—should be the point of sharp focus. With its 39 AF points, the D5200 is capable of focusing accurately within much of the frame, but this is also where Live View mode really shines. By selecting [WIDE] Wide-area AF or [NORM] Normal area AF *(see page 81)*, the focus point can be set anywhere in the frame. Live View, with its ability to zoom in, also makes manual focusing ultra-precise—and it's impeccably accurate. For many years I was a "Live View luddite" but now it's my first choice for macro photography, especially with static subjects.

UP CLOSE AND PERSONAL «
Close-up subjects are everywhere. *100mm macro, 1/250 sec., f/11, ISO 200.*

» MACRO PHOTOGRAPHY

There's no exact definition of "close-up", but "macro" should be used more precisely. Macro photography really means photography of objects at life-size or larger, implying a reproduction ratio (see below) of at least 1:1. Many zoom lenses are branded "macro" when their reproduction ratio is around 1:4, or 1:2 at best. This still allows much fascinating close-up photography, but it isn't "proper" macro.

› Reproduction ratio

The reproduction ratio is the ratio between the actual size of the subject and the size of its image on the D5200's imaging sensor. This measures 23.5 x 15.6mm; therefore at 1:1 an object of these dimensions would exactly fill the image frame (a bit smaller than the SD memory cards the camera uses). Of course when the image is printed, or viewed on a screen, it may appear many times larger, but that's another story.

A 1:4 reproduction ratio means that the smallest subject that gives you a frame-filling shot is four times as long/wide as the sensor. With the D5200 this is approximately 4 x 2½ inches (94 x 62mm)—somewhat larger than a credit card.

SAME SIZE ⌃
Using a 100mm macro lens at the closest possible distance gives approximately life size (1:1) reproduction. *100mm macro, 1/3 sec. at f/8 , ISO 400.*

› Working distance

The working distance is the distance required to obtain the desired reproduction ratio with any given lens. It is related to the focal length of the lens: with a 200mm macro lens the working distance for 1:1 reproduction is double that of a 100mm lens. Because the D5200's sensor is smaller than a full-frame DSLR, the effective focal length of any lens is multiplied by approximately 1.5x, and therefore working distance increases also. This is often helpful with living subjects which are susceptible to disturbance.

DEPTH OF FIELD ⌃

The minimal depth of field in close-up work is exemplified in this image of a hoverfly, at close to 1:1 reproduction ratio. Not even the whole of each eye is sharp. *100mm macro, 1/320 sec. (tripod), f/5.6, ISO 400.*

Tip

When using the built-in flash with close-up subjects (rarely a good idea), a longer working distance also reduces the likelihood that the lens/lens hood will cast a shadow on the subject.

» EQUIPMENT FOR CLOSE-UP PHOTOGRAPHY

› Close-up attachment lenses

These simple magnifying lenses screw into the filter thread of the lens. They are light, portable, (relatively) inexpensive and fully compatible with the camera's exposure and focusing systems.

Nikon produces seven close-up attachment lenses *(see table below)*.

› Extension tubes

Extension tubes are another simple, relatively inexpensive, way of extending the close-focusing capabilities of a lens. An extension tube is essentially a simple tube fitting between the lens and the camera. This decreases the minimum focusing distance and thereby increases the magnification factor. Again they are light, compact, and easy to carry and attach.

The Nikon system includes four extension tubes, PK-11A, PK-12, PK-13, and PN-11, which extend the lens by 8mm, 14mm, 27.5mm, and 52.5mm respectively. The PK-11 incorporates a tripod mount. The basic design of these tubes has not changed for many years, which means that many of the camera's functions are not available. In particular, there's no autofocus. Used on the D5200, you may be restricted to Manual (M) mode and exposure determination will be by trial and error—but that's what the histogram's for!

Tip

Compatible extension tubes are also produced by other manufacturers, notably Kenko. These do support exposure metering but still do not permit autofocus on the D5200.

Product number	Attaches to filter thread	Recommended for use with
0, 1, 2	52mm	Standard lenses
3T, 4T	52mm	Short telephoto lenses
5T, 6T	62mm	Telephoto lenses

5

› Bellows

Bellows work on the same principle as extension tubes, by extending the spacing between the lens and the camera body, but are not restricted to a few set lengths. Again, there's no extra glass to impair the optical quality of the lens. However, bellows are expensive, heavy, and cumbersome, and take time to set up.

> **Note:**
> Because accessories like extension tubes and bellows increase the physical length of the lens, they also increase the effective focal length. However, the physical size of the aperture does not change. The result is to make the lens "slower"; a lens with a maximum aperture of f/2.8 starts to behave like an f/4 or f/5.6 lens. This makes the viewfinder image dimmer, and of course affects the exposure required.

They are usually employed in controlled settings, such as a studio.

Nikon's PB-6 bellows offer extensions from 48mm to 208mm, giving a maximum reproduction ratio of about 11:1. Focusing and exposure are manual only.

› Reversing rings

Also known as reverse adapters, or—in Nikon's jargon—inversion rings, these allow lenses to be mounted in reverse; the adapter screws into the filter thread. This allows much closer focusing than when the lens is used normally. These are the cheapest way to experiment with macro photography but can be hard to find (try eBay). Most reversing rings lose all automatic functions.

» MACRO LENSES

True macro lenses achieve reproduction ratios of 1:1 or better and are optically optimized for close-up work, though are normally very capable for general photography too. This is certainly true of Nikon's Micro Nikkor lenses, of which there are currently five.

The most recent addition to the range is the **40mm f/2.8G AF-S DX Micro Nikkor**; like the 85mm model (below) it's specifically designed for DX-format cameras like the D5200. It's also Nikon's least expensive macro lens.

The **60mm f/2.8G ED AF-S Micro Nikkor** is an upgrade to the previous 60mm f/2.8D. Advances include ED glass

40mm f/2.8G AF-S DX Micro Nikkor

ON THE FLY ❯❯
Longer lenses are very useful for some subjects—especially highly mobile ones! *100mm macro, 1/250 sec., f/11, ISO 200.*

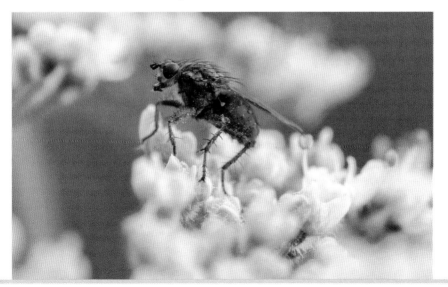

for superior optical quality and Silent Wave Motor for ultra-quiet autofocus.

The **85mm f/3.5G ED VR AF-S DX Micro Nikkor** also achieves 1:1 reproduction and has VRII, internal focusing, and ED glass.

The **105mm f/2.8G AF-S VR Micro Nikkor** also features internal focusing, ED glass and Silent Wave Motor. It was also the world's first macro lens with VR (Vibration Reduction).

Though rather more venerable, the **200mm f/4D ED-IF AF Micro Nikkor** is particularly favored for shooting the animal kingdom, as its longer working distance reduces the risk of disturbing your subject. This lens lacks a built-in motor and so can't autofocus with the D5200; you'd have to work around this when shooting animals, but it's really not a problem when shooting static subjects.

Tip

As the slightest camera shake is magnified at high reproduction ratios, VR (Vibration Reduction) technology is extremely welcome, allowing you to employ shutter speeds up to four stops slower than otherwise possible. However, it can't compensate for movement of the subject. Remember, too, that at close range the slightest change in subject–camera distance can completely ruin the focus, so a tripod is still invaluable.

85mm f/3.5G ED VR AF-S DX

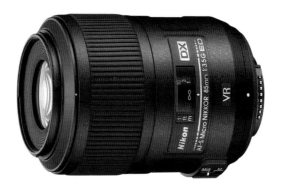

» MACRO LIGHTING

We've already observed that macro photography often requires small apertures. This may lead to long exposure times, creating particular problems with mobile subjects. To counteract this, additional lighting is often required, which usually means flash. However, regular Speedlights are not designed for such close-range use. If they're mounted on the hotshoe, short working distances mean that the lens may throw a shadow onto

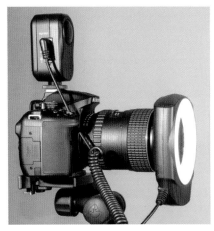

Sunpak LED Macro Ring Light

RING LIGHT ☆
Typical, virtually shadowless, results with the Sunpak Ring Light. *100mm macro, 1/2 sec. (tripod), f/16, ISO 640.*

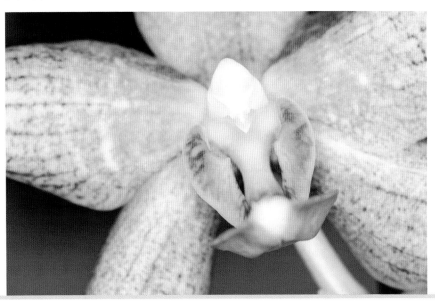

5

the subject. The built-in flash is even less suitable for real close-up work, yet in 🌷 Close-up mode it regularly pops up automatically; perhaps it should be called "Not too close" mode instead.

Specialist macro flash units usually take the form of either ring flash or twin flash. Because of the close operating distances they do not need high power and can be

relatively light and compact. Ring-flash units encircle the lens, giving an even spread of light even on ultra-close subjects (they're also preferred by some portrait photographers). Nikon's discontinued SB-29 may still be found in the secondhand marketplace; a good alternative is Sigma's EM-140 DG Macro Flash.

Nikon now favors a twin-flash approach with its Speedlight Commander Kit R1C1 and Speedlight Remote Kit R1. These are both based around two Speedlight SB-R200 flashguns, mounting either side of the lens. The R1C1 uses a Wireless Speedlight Commander SU-800 unit which fits into the camera's hotshoe, while the R1

DIFFUSED FLASH ⌄

The same subject as on the previous page, lit by a Speedlight SB-700 with HONL softbox (shown *on page 172*), off-camera to the left and connected by a sync cable. The lighting is still soft but has more sense of direction. *100mm macro, 1/160 sec. (tripod), f/5.6, ISO 640.*

uses either a separate Speedlight or the D600's own built-in flash as the commander. These kits are expensive but give very flexible and precisely controllable light on macro subjects.

Alternatively, you can use LED lights, like the Sunpak LED Macro Ring Light. Its continuous output allows you to preview the image in a way not possible with flash. However, its low power limits it to close, and usually static, subjects (but it is very cheap).

› Improvisation

Dedicated macro-flash units aren't cheap, and may be unaffordable or unjustifiable when you just want a taste of macro work. Fortunately, you can do lots with a standard flashgun, plus a flash cord. With more basic

units, you'll lose the D5200's advanced flash control, but it only takes a few test shots to establish settings that you can use repeatedly (make sure you keep notes). The other essential is a small reflector, perhaps just a piece of white card; position it as close as possible to the subject for maximum benefit.

This setup (which I use regularly) can even be more flexible than twin flash or ring flash, allowing the light to be directed wherever you choose. On static subjects, "painting with light" *(page 170)* is also an interesting option.

HARD LIGHTING ⌄
Taken with an undiffused Speedlight off to the left, and no reflector, contrast in this shot is quite high. *100mm macro, 1/16 sec. (tripod), f/5.6, ISO 320.*

Chapter 6
MOVIES

6 MOVIES

The ability to record moving images is now widespread among DSLRs, but it was as recently as August 2008 that the Nikon D90 became the first DSLR from any manufacturer to offer this feature. The Movie mode is really an extension of Live View *(see page 78)*, and therefore familiarity with Live View is a big asset when you start shooting movies.

» MOVIE SIZE AND QUALITY

The D5200 can shoot movies in Full HD (High Definition) quality with a frame size of 1920 x 1080 pixels. It can also record 1280 x 720 pixel ("720p") footage. Shooting at the maximum frame size is by no means always essential. For example, 720p is the standard on Vimeo.com, the real home of quality video online, and will look excellent on most computer screens. However, the latest iPads have a 2048 x 1536 display, boasting more pixels than Full HD.

The smaller size setting allows you to record more video on the same memory card, as well as consuming less disk space on your computer. However, it must be said, footage shot in Full HD may be more "future-proof".

WIDE FIELD OF VIEW ⪼
The D5200 allows wide-angle lenses to be used, such as an 18mm lens as for this shot.

› Advantages

Today many compact cameras and camcorders also deliver HD resolution, but because the D5200 has a larger sensor, its image quality is superior in many respects. It can also use the entire array of Nikon-fit lenses (see chapter 7, *page 200*), giving a range that is difficult to match with any conventional video camera, especially for wide-angle shooting.

Another plus is that the D5200's larger sensor and access to lenses with wide maximum apertures mean it's possible to achieve very shallow depth of field, which is virtually unattainable with compact cameras or camcorders. This can give some very striking effects, and is one of key reasons why dedicated movie-makers have embraced DSLRs.

Note:
Most digital video cameras claim enormous zoom ranges (often 800x or more) but these are only achieved by "digital zoom", which is a software function that enlarges the central portion of the image—with an inevitable loss of image quality. "Optical zoom" range is what really matters, and interchangeable lenses give a potential range of at least 80x (10mm–800mm). The widest range currently available in a single lens is 18–300mm.

SHALLOW ALPACA ⌃
It's much easier to get really shallow depth of field than with most video cameras. *300mm lens, f/4.*

The D5200's large sensor and high-ISO shooting ability mean that results in low light should be better than most of the alternatives. In addition, the full range of exposure modes, Nikon Picture Controls, and many other options can be used, giving a high level of creative control. (In practice, however, P, S, A, and M modes are less flexible when shooting movies than when shooting stills.)

› Limitations

Functionally, the D5200's movie mode is among the best of any current DSLR, but some limitations remain. Live View AF isn't really slick enough for fast-moving subjects, and sound quality from the built-in microphone is only moderate, even if it is stereo. However, you can attach a separate microphone.

> ## Image effects

The D5200, like other DSLRs, captures video from the sensor by a "rolling" scan, rather than capturing the whole frame at one go. This has an odd effect when dealing with fast movement, whether it's a rapid pan of the camera or movement of the subject itself; objects can appear distorted, with rectangular shapes turning to parallelograms and so on. If you rock the camera violently from side to side you can even achieve a remarkable wobbly effect which has become known as "jello-cam". Some movie-editing software can now compensate for this.

LOW LIGHT ⌃

The D5200 also scores when it comes to low-light shooting.

» MAKING MOVIES

› Preparation

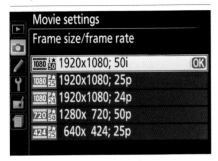

Movie settings—quality

Before shooting, select key settings in the Movie settings section of the Shooting menu (see below). Other settings such as Picture Controls should also be set in advance (if using P, S, A, or M exposure modes). A good way to check the general look of a shot is by taking a still frame; you can do this from Live View without starting movie recording first.

Quality sets the image size, frame rate, and quality for movie recording. The size options are: **1920 x 1080** pixels (default); **1280 x 720** pixels; **640 x 424** pixels. The

frame rate options vary according to the size chosen and whether NTSC or PAL is selected for video mode. **Movie quality** sets the compression level; options are *High* or *Normal*. **Microphone** determines the sensitivity of the built-in microphone (or an external microphone if attached). The options are: *Auto, Manual Sensitivity* (in steps from 1–20), and *Off.* You can see an audio-level display while in this menu, which helps to establish a correct setting. **Manual movie settings** allows you to adjust shutter speed and ISO settings when shooting in M mode. By default this is OFF and so these settings are automated.

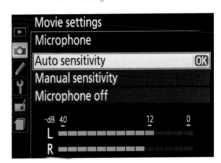

Note:
If you set quality to 1920 x 1080 and frame rate to 50, the movie image is cropped (i.e. only uses a smaller area of the sensor).

Tip
You can't change Manual microphone level settings while actually shooting a clip: this is another setting which needs to be sorted beforehand.

› Focus options

The focus modes and AF-area options for movie shooting are the same as for Live View (see page 79). If Full-time servo AF (AF-F) is selected, the D5200 will automatically maintain focus while movie recording is in progress, though it may lag behind rapid movements of the camera or subject. If Single-servo AF (AF-S) is selected the camera will only refocus when you half-press the shutter-release button, and this is often all too obvious in the final movie clip. However, keeping half-pressure on the button is one way of locking focus.

Manual focusing is also possible, but can be yet another recipe for wobbly pictures. Yet again, this indicates the use of a tripod, especially with longer lenses, where focusing is more critical and wobbles are magnified. Some lenses have a smoother manual focus action than others. The physical design of older lenses often makes them more suitable, with large and well-placed focus rings.

Older lenses often have a distance scale marked on the lens barrel, which can offer a viable alternative to using the Live View display to focus. Pre-focusing manually also avoids undesirable focus shifts during shooting.

Study the credits for major movies and TV shows and you'll often see someone called a "focus puller". This is an assistant camera operator, whose sole task is to adjust the focus, normally between predetermined points (for instance shifting from one character's face to another). This leaves the lead camera operator free to concentrate on framing, panning, and/or zooming. Frequently, the focus puller uses the distance scale on the lens barrel, relying on previously measured distances. Executing this kind of deliberate and controlled focus shift is not easy, especially when you're the sole camera operator— and if it's not right, it will be very obvious in the final footage.

Using a fixed focus for each shot is often perfectly viable, especially when depth of field is good. This reduces operations which can make the image wobbly, and avoids annoying mid-shot shifts of focus.

› Exposure

Exposure control depends on the Exposure mode selected before shooting begins. If Auto or Scene modes are selected, exposure control is fully automatic, except that exposure level can be locked (in Scene modes) using the **AE-L/AF-L** button. This is useful, for instance, to prevent the main subject appearing to darken if it moves in front of a brighter background.

In P, S, or A mode, exposure levels can be adjusted by ±3 Ev using the 🗲 button. In addition, in A mode, aperture can be

manually adjusted during shooting. Normally the camera will set the shutter speed automatically, and adjust the ISO sensitivity if necessary to keep shutter speed within suitable limits. However, in mode M, and providing the Manual movie settings option *(see page 103)* is On, both shutter speed and aperture can be adjusted manually. In this case, also, ISO sensitivity is not adjusted automatically.

While all these adjustment options are welcome, actually doing it while shooting is fiddly. It's hard to avoid jogging the camera unless it's on a very solid tripod, and the built-in microphone may also pick up the sounds of the operations. Another consequence can be abrupt brightness changes in the final footage.

› Shutter speed

You can (if the light's good) set shutter speeds right up to 1/4000 sec., but there are inevitable limits to the slowest speed you can select. For instance, if frame rate is 24, 25, or 30, the slowest possible speed is 1/30 sec. After all, if you're shooting 25 frames a second you can't expect each frame to have a ½-second exposure.

Based on still photography experience, you'll probably expect faster shutter speeds to give sharper pictures. In movies it doesn't work that way. If you shoot at, say, 1/500 sec., you will find that each frame of the movie might appear sharp when

examined individually, but the motion appears jerky when you play the movie. This is because you have recorded 25 tiny slices of continuous action. 25 times 1/500 sec. is just 5% of the action. The nearer the shutter speed is to 1/25 sec., the nearer you get to capturing 100% and the smoother the motion appears.

However, in bright conditions, you can't shoot at 1/25 and at the same time use a really wide aperture to get that "DSLR look" *(see pages 129 and 189)*, even at ISO 100, so sometimes you need to compromise— though a neutral density filter *(see page 226)* could come in handy.

› Sound

The D5200's built-in microphone gives modest quality stereo output. It is liable to pick up any sounds you make during operation (focusing, zooming, even breathing). You always have the option of adding a new soundtrack later. However, this is difficult if your film includes people speaking (though "post-syncing" is standard practice in Hollywood, especially for musicals). If you want to include dialog, keep subjects close to the camera and ensure that background noise is minimized. The D5200 also allows you to attach an external microphone: plug in to the 3.5mm mini-jack socket under the cover on the left side of the camera. This automatically overrides the internal microphone.

6 » SHOOTING MOVIES

● button

> ### Tip
>
> *To take a still photo during movie shooting, press the shutter-release button and keep it pressed until you hear the shutter operate. Still frames can also be extracted from movies but only at the current movie resolution (i.e. max. 1920 x 1080 pixels).*

1) Choose Exposure mode, AF mode, and AF-area mode as for Live View shooting. If using A or M Exposure mode, set the aperture.

2) Activate Live View by flicking the **Lv** switch.

3) Check framing and initial exposure level (possibly taking a still frame as a test). Set initial focus by half-pressure on the shutter-release button.

4) Press ● to start recording the movie. **REC** flashes on the monitor screen while recording, and an indicator shows the maximum remaining shooting time.

5) To stop recording, press ● again.

6) Exit Live View by flicking the **Lv** switch.

› Shooting

The golden rule is: think ahead. If a still frame isn't quite right, you can review it, change position or settings, and be ready to reshoot within seconds. To shoot and review even a short movie clip eats up much more time, and you may not get a second chance anyway. It's doubly important to get shooting position, framing, and camera settings right before you start. It's easy to check the general look of the shot by shooting a still frame beforehand, but this does not allow for movement of subject, camera, or both; you can also do a rehearsal in Live View before shooting for real.

If you're new to the complexities of movies, start with simple shots. Don't try zooming, panning, and focusing simultaneously: do one at a time.

Many subjects can be filmed with a fixed camera: waterfalls, birds at a feeder, musicians playing, and loads more. Equally, you can become familiar with camera movements shooting static subjects: try panning across a wide landscape or zooming in from a broad cityscape to a detail of a single building.

› Handheld or tripod shooting

It's impossible to overstress the importance of a tripod for shooting decent movies. Shooting movie clips handheld is a good way to reveal just how wobbly you really are—especially as you can't use the viewfinder. Of course even "real" movie directors sometimes use handheld cameras to create a specific feel, but there's a huge difference between controlled wobble for deliberate effect, and incessant, uncontrolled shakiness. Using a tripod, or other suitable camera support, is the simplest way to give movie clips a polished, professional look.

In the last few years we've also seen lots of new devices intended to stabilize the camera when you have to shoot handheld, from simple brackets to smaller versions of the legendary Steadicam.

If none of these are available, look for other alternatives, for instance by sitting with elbows braced on knees. Whatever you do, "think steady".

› Panning

The panning shot is a movie-maker's staple. Often essential for following moving subjects, it can also be used with static subjects; for instance, sweeping across a vast panorama. Of course, landscapes aren't always static, and a panning shot combined with breaking waves, running water, or grass blowing in the breeze can produce beautiful results.

Handheld panning is very problematic; it may be acceptable when following a moving subject, but a wobbly pan across a grand landscape will definitely grate. You really, really need a tripod for this and make sure it's properly levelled, or you may start panning with the camera aimed at the horizon but finish seeing nothing but ground or sky: do a "dry-run" before shooting.

Keep panning movements slow and steady. Panning too rapidly can make the

shot hard to "read" and even nauseate the viewer. Smooth panning is easiest with video tripods, but perfectly possible with a standard model: leave the pan adjustment slightly slack. Hold the panning arm on the tripod head, not the camera, and use the front of the lens as a reference to track steadily across the scene.

With moving subjects, the speed and direction of panning is dictated by the need to keep the subject in frame. Accurate tracking of fast-moving subjects is very challenging and takes a lot of practice.

STEAMBOAT ⌄
This is one case where any error in levelling the tripod will quickly become obvious.

Tip

There's now a wide range of devices available to help smooth out movement in the "handheld" camera, from simple brackets to shoulder supports and on up to the famous Steadicam system—though even its base model, the Merlin, costs as much as a D5200 body.

› Zooming

The zoom is another fundamental technique. Moving from a wide view to a tighter one is called *zooming in*, the converse *zooming out*. Again, a little forethought makes all the difference to using the zoom effectively; consider the

EXPLORING THE SCENE ⌃
The camera can "explore" a scene like this either by panning across it or by zooming in on specific aspects.

framing of the shot at both start and finish. If you're zooming in to a specific subject, double-check it's central in the frame.

No current lenses for the D5200 are designed specifically for shooting movies; this is most obvious in relation to zooming. Firstly, none of them have such a wide zoom range as video camera lenses. More seriously, it's hard to achieve a really smooth, even-paced zoom action. Practice does help; firmly mounting the camera on a solid tripod helps even more. Zooming while handholding virtually guarantees jerky zoom and overall wobbliness. It's also worth experimenting to see which lens has the smoothest zoom action.

When zooming, remember that depth of field *(see page 129)* decreases at the telephoto end of the range. Your subject may appear perfectly sharp in a wide-angle view but end up looking soft when you zoom in. Set focus at the telephoto end, whether your planned shot involves zooming out or zooming in.

› Lighting

For obvious reasons, you can't use flash. There are now many LED light units specifically designed for DSLR movie shooting. The D5200's ability to shoot at high ISO ratings is also invaluable.

6 » EDITING MOVIES

The D5200 doesn't shoot movies. Like all movie cameras, it shoots movie *clips*.

In general, turning a collection of clips into a movie that people actually want to see requires editing, and specifically non-linear editing (NLE). This simply means that clips in the final movie don't have to appear in the same order in which they were shot.

With today's software, editing digital camera movies is almost easier to do than to describe. The D600's .MOV movie format is accepted by most editing programs.

For Mac users there's iMovie, part of the iLife suite, included with all new Macs.

Windows Movie Maker

iMovie

The Windows equivalent is Windows Movie Maker, pre-installed with Windows Vista; for Windows 7 or 8 it's a free download from windowslive.com. A somewhat more advanced option, for either platform, is Adobe Premiere Elements.

All offer NLE, which is also non-destructive. This means that editing does not affect your original clips (unlike cutting and splicing bits of film in the "old days"). During editing, you manipulate preview versions of these clips and the software merely keeps "notes" on the edit; this is analogous to the way apps like Lightroom work with photos. At the end, you export the result as a new movie; this can take a long time to "render".

All these programs make it easy to trim and reorder your original clips. Instead of simply cutting instantaneously between shots, you can apply various transitions such as dissolves, wipes, and fades. You can also adjust the look of any clip or segment of the movie. As well as basic controls for brightness, color, and so on, a range of

special effects can be added: you can, for instance, make your movie look scratched and faded, as if it was shot on film 50 years ago rather than yesterday with a DSLR.

› Adding to your movie

You can also add other media, like still photos and sound. You can insert stills individually at appropriate points or create slideshows within the main movie. Again, effects and transitions can be applied to give slideshows a more dynamic feel.

It's equally easy to add a new soundtrack, like a voiceover or music, to part or all of the movie. Last but not least, you can also add titles and captions.

› Taking it further

There's far more to movie-making than we can cover in a single chapter. A useful next step would be *Understanding HD Video* by Chiz Dakin, from this publisher.

Tip

Effects and transitions are great fun—and non-destructive editing means you can experiment to your heart's content—but, for the sake of the audience, it's best to use a limited selection in the final version.

Tip

If you haven't created them yourself, still photos, music, and other media are someone else's copyright. Look for open-source material or get the copyright owner's permission to use their work.

Ni

Chapter 7
LENSES

7 LENSES

There are many reasons to prefer a DSLR like the D5200 over a compact. One of the most important is the ability to use a vast range of lenses, including Nikon's own legendary system as well as lenses from other makers. Nikon's F-mount lens mount is now 50 years old, though it has evolved in that time. Still, most Nikkor lenses will fit the D5200, and work (though sometimes with major limitations).

There are sound reasons why more recent lenses are most suitable for use with the D5200. One is that older lenses lack a CPU and therefore many automatic functions are unavailable. Lenses without a built-in focus motor cannot autofocus on the D5200 (see Loss of functions opposite).

Another reason for preferring lenses designed specifically for digital cameras relates to the way light reaches the minute individual photodiodes or "photosites" on the camera's sensor. Because these are slightly recessed, there can be some cut-off if light hits them at an angle. This is less critical with film, for which older Nikkor lenses were designed. Many older lenses can still be used, and can give very good results, but critical examination may show some peripheral loss of brightness (vignetting), and perhaps a hint of chromatic aberration (color fringing). Wide-angle lenses are usually most susceptible. Much depends on the size of print or reproduction you require, and these shortcomings can to some extent be corrected in post-processing (especially if you shoot RAW).

Nikon's DX-series and other newer lenses are specifically designed for digital cameras, maintaining illumination and image quality right across the frame. DX lenses are listed first in the table of Nikkor lenses on *pages 216–221*.

Warning!

Some older lenses, specifically pre-AI lenses, should not be mounted on the camera as damage can result. Certain other specific (and uncommon) lenses should also be avoided (see the D5200 Reference Manual).

» LOSS OF FUNCTIONS

When older lenses are used on the Nikon D5200, functions may be lost. In particular, autofocus is only available with lenses having a built-in motor. Suitable Nikon lenses are designated AF-I or AF-S. Check carefully when considering lenses from independent makers.

Other AF lenses with a built-in CPU will support some or all of the camera's metering functions and exposure modes, but will require manual focusing. The electronic rangefinder *(see page 65)* can be helpful here. The Nikon manual has detailed information on compatible lenses.

Older lenses without a built-in CPU, such as AI and AI-S types, can be attached, but the camera's metering will not operate, requiring you to use Exposure mode M. Set aperture and shutter speed using an external meter or simply by trial and error, using the histogram *(see page 84)* as a guide to correct exposure. This may seem a lot of hassle but rarely takes more than half a minute. When using flash or indoor lighting, the same exposure settings can be repeated again and again, perhaps with minor variations to suit different subjects.

» FOCAL LENGTH

Though familiar, the term "focal length" is often misapplied. The focal length of any lens is a fundamental optical property, and is *not* changed by fitting the lens to a different camera. Unfortunately, as if to promote confusion, the lenses on most digital compact cameras are described not by their actual focal length but by their "35mm equivalent"; i.e. the focal length that would give the same angle of view on a 35mm or full-frame camera.

Of course, zoom lenses have variable focal length—that's what zoom means— but an 18–55mm zoom is always an 18–55 zoom, regardless of whether it's fitted on a DX format camera like the D5200 or a full-frame (FX) camera like the D3. However, because the D5200 has a smaller sensor than the D3, the actual image shows a smaller angle of view.

7 » CROP FACTOR

The D5200's smaller sensor, relative to the 35mm/FX standard, means that it has a *crop factor*, or *focal length magnification factor*, of 1.5. If you fit a 200mm lens to a D5200, the field of view equates to what you'd see with a 300mm lens on a full-frame camera (e.g. D4 or D600). For sports and wildlife this can be an advantage, allowing long-range shooting with relatively light and inexpensive lenses. Conversely, the crop factor makes wide-angle lenses effectively less wide, which is unwelcome news for landscape shooters. However, this has fostered the development of new ultra-wide lenses, like the 10–24mm f/3.5–4.5G DX Nikkor.

The opposite page shows a series of images taken on a Nikon D5200, from a fixed position, with lenses from 12mm to 300mm.

» FIELD OF VIEW

The field of view, or angle of view, is the area covered by the image frame. While the focal length of a lens remains the same on any camera, the angle of view seen in the image is different for different sensor formats. The angle of view is usually measured on the diagonal of the frame (as in the table on *pages 216–221*).

> ### *Tip*
>
> *Throughout this book, and specifically in the shooting details for the photos, the true focal length is used.*

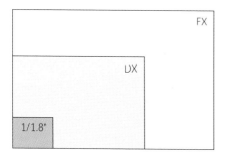

CROP FACTOR ⌃
Comparison chart of digital camera sensor sizes.

IN THE FRAME »
The same landscape shot from the same position, with different focal lengths. *Focal lengths as shown, 1/200 sec., f/8, ISO 400.*

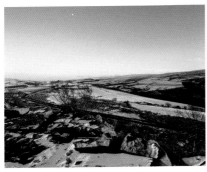

14mm

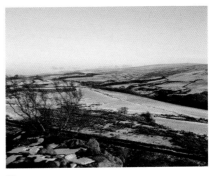

28mm

50mm

100mm

200mm

300mm

7 » PERSPECTIVE

Perspective concerns the visual relationship between objects at different distances. The apparent fading of distant objects due to haze is *atmospheric perspective*, while *optical perspective* relates to the changes in apparent size of objects at different distances.

It's often suggested that different lenses give different perspective. This is untrue: perspective is determined purely by distance. However, different lenses do lend themselves to different working distances

and therefore are often associated with different perspectives.

A strong emphasis on the foreground may be called "wide-angle perspective" because a wide-angle lens allows you to move closer to foreground objects. Similarly, the apparent compression of perspective in telephoto shots is a result of the greater working distance with the long lens. In the series of shots below, the roller remains the same apparent size even though viewed from different distances, but its apparent shape and its relationship to the background change radically.

FLOCK AND ROLLER　　　《 �

Even though the roller remains the same apparent size in each shot, the background has changed substantially. *200mm, 65mm and 18mm 1/80 sec.(tripod), f/11, ISO 200.*

» PRIME LENSES

Prime lenses have a fixed focal length (no zoom function). This makes them relatively light and simple; they are also usually optically excellent and have wide maximum apertures. They may appear less versatile than zoom lenses but this can be a good lesson, making the photographer shift position rather than lazily twiddling a zoom.

POTS AND BELLS ⯆
Standard and prime lenses force the photographer to compose images with more care than they would with zoom lenses. *44mm, 1/200 sec., f/10, ISO 400.*

» STANDARD LENSES

In traditional 35mm film photography, a 50mm lens was called standard, as its field of view was held to approximate that of the human eye. Because of the crop factor of the D5200, the equivalent lens is around 35mm. Zoom lenses encompassing this focal length are often referred to as "standard zooms".

7 » WIDE-ANGLE LENSES

A wide-angle lens is any lens with a wider view than a standard lens; for the D5200 this means any lens shorter than 35mm. Wide-angle lenses are valuable for working close to subjects or emphasizing foregrounds. They excel in photographing expansive scenic views, and also in cramped spaces where you can't step back to "get more in".

Af-S DX Nikkor 10–24mm f/3.5–4.5G ED

BRIDGE OVER STILL WATERS ⌄
Using an extreme wide-angle lens enabled me to fill the frame with virtually the whole bridge.
12mm, 1/20 sec., f/10, ISO 200.

» TELEPHOTO LENSES

Telephoto lenses, or simply "long" lenses, give a narrow angle of view. They are commonly employed in wildlife and sports photography, where working distances are often great, but can also isolate small or distant elements in a landscape. Moderate telephoto lenses are favored for portrait photography, because a greater working distance is felt to give a natural-looking result, and is less intimidating for nervous subjects. The traditional "portrait lens" range is about 85–135mm; roughly equivalent to 60–90mm on the D5200.

The laws of optics, plus greater working distance, mean telephoto lenses produce limited depth of field. This is often welcomed in portraiture, wildlife, and sport, as it concentrates attention on the subject by throwing backgrounds out of focus.

The size and weight of longer lenses makes them hard to handhold comfortably, and their narrow view also magnifies any movement; high shutter speeds and/or a tripod or other camera support are often required. Nikon's Vibration Reduction (VR) technology also mitigates camera shake.

AF-S Nikkor 300MM f/2.8G ED VR II

> **Tip**
>
> *Switch VR OFF when using the camera on a tripod.*

SWAN'S WAY »
A telephoto lens helps you get closer to subjects that might otherwise be uncooperative. *105mm, 1/1000 sec., f/10, ISO 320.*

7 » ZOOM LENSES

The term "zoom" covers lenses with variable focal length. A zoom lens can replace a bagful of prime lenses and cover the gaps in-between, scoring for weight, convenience, and economy. Flexible focal length also allows precise framing. While once considered inferior in optical quality, there is now little to choose between a good zoom and a good prime lens. Cheap zooms, and those with a very wide range (e.g. 28–300mm), may still be optically compromised, or have a relatively small ("slow") maximum aperture, but prove useful for movie shooting, for example.

UP ON THE ROOF ⌃
Zoom lenses are useful for capturing details in a scene, such as these roof tiles. *100mm, 1/40 sec., f/11, ISO 200.*

AF-S Nikkor 300mm F/2.8G ED VRII

» MACRO LENSES

For specialist close-up work there is little to beat a true macro lens. For more on these see chapter 5, *page 181.*

FROSTY FOLIAGE �«
Macro lenses are essential for close-ups like this. *100mm macro, 1/10 sec. (tripod), f/16, ISO 100.*

» PERSPECTIVE-CONTROL LENSES

Perspective-control (PC or "tilt and shift") lenses give unique flexibility in viewing and controlling the image. Their most obvious application is in photographing architecture, where—with a "normal" lens—it often becomes necessary to tilt the camera upwards, resulting in converging verticals (buildings appear to lean back or even to one side). The shift function allows the camera-back to be kept vertical, which in turn means that vertical lines in the subject remain vertical

Nikkor 24mm f/3.5D ED PC-E

in the image. Tilt movements also allow extra control over depth of field, whether to extend or to minimize it.

The current Nikon range features three PC lenses, with focal lengths of 24mm, 45mm, and 85mm. They retain many automatic functions, but require manual focusing.

LEANING BUILDINGS «
The top image shows the original distorted image and the second the result of perspective correction. *100mm, 1/200 sec., f/11, ISO 320.*

» TELECONVERTERS

Nikkor AF-S Teleconverter TC-20E III

Teleconverters are supplementary optics which fit between the main lens and the camera body, and magnify the focal length of the main lens. Nikon currently offers the TC-14E II (1.4x magnification), TC-17E II (1.7x), and TC-20E II (2x). The advantages are obvious, allowing you to extend the focal length range with minimal additional weight (the TC-14E II, for example, weighs just 200g).

However, teleconverters can marginally degrade image quality, and they also cause a loss of light. Fitting a 2x converter to a 300mm f/4 lens turns it into a 600mm f/8. As a result, the camera's autofocus may become very slow or may not work at all.

Warning!

Some recent lenses are incompatible with these teleconverters. Check carefully before use.

» LENS HOODS

A lens hood serves two main functions; it shields the lens against knocks, rain, and so on, and excludes stray light which may degrade the image by causing flare *(see page 146)*. Most Nikkor lenses come with a dedicated hood, but not the "kit" lenses often supplied with the D5200. A suitable hood would be a highly recommended first accessory purchase.

STORYTELLER »
A teleconverter helps to give your lenses a little bit more reach for close-ups, such as of this Hans Christian Andersen statue in Copenhagen, Denmark—but it may result in a slight loss of image quality. *140mm, 1/250 sec., f/6.3, ISO 200.*

7 » NIKON LENS TECHNOLOGY

Nikon lenses have long been renowned for technical and optical excellence, and many lenses incorporate special features or innovations. As these are referred to extensively in the table *on pages 216–221*, brief explanations of the main terms and abbreviations are given here.

Abbreviation	Term	Explanation
AF	Autofocus	Lens focuses automatically. Most current Nikkor lenses are AF, but a substantial manual focus range remains.
ASP	Aspherical lens elements	Precisely configured lens elements that reduce the incidence of certain aberrations. Especially useful in reducing distortion with wide-angle lenses.
CRC	Close-range Correction	Advanced lens design that improves picture quality at close focusing distances.
D	Distance information	D-type and G-type lenses communicate information to the camera about the distance at which they are focusing, supporting functions like 3D Matrix Metering.
DC	Defocus-Image Control	Found in a few lenses aimed mostly at portrait photographers; allows control of the appearance of out-of-focus areas in the image.
DX	DX lens	Lenses specifically designed for DX-format cameras like the D5200.
G	G-type lens	Modern Nikkor lenses with no aperture ring; aperture is set via the camera.
ED	Extra-low Dispersion	ED glass minimizes chromatic aberration *(see page 147)*.
FL	Fluorite	Fluorite glass gives high transmission rates with minimal chromatic aberration and much lower dispersion properties than even ED glass.

Abbreviation	Term	Explanation
IF	Internal Focusing	Only internal elements of the lens move during focusing: the front element does not extend or rotate.
M/A	Manual/Auto	Many Nikkor AF lenses offer M/A mode, allowing seamless transition from automatic to manual focusing if required.
N	Nano Crystal Coat	Advanced lens coating designed to minimize flare *(see page 146)*.
PC	Perspective Control	*(See page 211.)*
RF	Rear Focusing	Lens design where only the rearmost elements move during focusing; makes AF operation faster.
SIC	Super Integrated Coating	Nikon-developed lens coating that minimizes flare and "ghosting".
SWM	Silent Wave Motor	Special in-lens motors delivering very fast and very quiet autofocus operation.
VR	Vibration Reduction	System which compensates for camera shake. VR is said to allow handheld shooting up to three stops slower than would otherwise be possible (i.e. 1/15 instead of 1/125 sec.). New lenses now feature VRII, said to offer an extra stop gain over VR (1/8th instead of 1/125 sec.).

» NIKKOR LENS CHART

This table lists currently available Nikkor autofocus lenses, starting with the DX series, which is specifically designed for DX-format cameras like the D5200.

Optical features/notes

DX lenses

10.5mm f/2.8G DX Fisheye	CRC
10-24mm f/3.5-4.5G ED AF-S DX	ED, IF, SWM
12-24mm f/4G ED-IF AF-S DX	SWM
16-85mm f/3.5-5.6G ED VR AF-S DX	VRII, SWM
17-55mm f/2.8G ED-IF AF-S DX	ED, SWM
18-55mm f/3.5-5.6G AF-S VR DX	VR, SWM
18-55 f/3.5-5.6GII AF-S DX	ED, SWM
18-70mm f3.5-4.5G ED-IF AF-S DX	ED, SWM
18-105mm F/3.5-5.6G ED VR AF-S DX	ED, IF, VRII, NC, SWM
18-200mm f/3.5-5.6G ED AF-S VRII DX	ED, SWM, VRII
18-300mm f/3.5-5.6G ED VR AF-S DX	ED, IF, VRII, SWM
35mm f/1.8G AF-S	SWM
40mm f/2.8G AF-S DX Micro NIKKOR	SWM
55-200mm f/4-5.6 AF-S VR DX	ED, SWM, VR
55-200mm f/4-5.6G ED AF-S DX	ED, SWM
55-300mm f/4.5-5.6G ED VR	ED, SWM
85mm f/3.5G ED VR AF-S DX Micro Nikkor	ED, IF, SWM, VRII

AF prime lenses

14mm f/2.0D ED AF	ED, RF
16mm f/2.8D AF Fisheye	CRC
20mm f/2.8D AF	CRC
24mm f/1.4G ED	ED, NC
24mm f/2.8D AF	
28mm f/1.8G AF-S	NC, SWM

Angle of view on DX format (°)	Minimum focus distance (m)	Filter size (mm)	Dimensions diameter x length (mm)	Weight (g)
180	0.14	Rear	63 x 62.5	300
109–61	0.24	77	82.5 x 87	460
99–61	0.3	77	82.5 x 90	485
83–18.5	0.38	67	72 x 85	485
79–28.5	0.36	77	85.5 x 11.5	755
76–28.5	0.28	52	73 x 79.5	265
76–28.5	0.28	52	70.5 x 74	205
76–22.5	0.38	67	73 x 75.5	420
76–15.3	0.45	67	76 x 89	420
76–8	0.5	72	77 x 96.5	560
76–5.3	0.45	77	83 x 120	830
44	0.3	52	70 x 52.5	210
38.5	0.163	52	68.5 x 64.5	235
28.5–8	1.1	52	73 x 99.5	335
28.5–8	0.95	52	68 x 79	255
28.5–5.2	1.4	58	76.5 x 123	530
18.5	0.28	52	73 x 98.5	355
90	0.2	Rear	07 x 06.5	670
120	0.25	Rear	63 x 57	290
70	0.25	62	69 x 42.5	270
61	0.25	77	83 x 88.5	620
61	0.3	52	64.5 x 46	270
53	0.25	67	73 x 80.5	330

Optical features/notes

28mm f/2.8D AF	
35mm f/2D AF	
35mm f/1.4G AF-S	NC, SWM
50mm f/1.8G AF-S	SWM
50mm f/1.8D AF	
50mm f/1.4D AF	
50mm f/1.4G AF-S	IF, SWM
85mm f/1.4G AF	SWM, NC
85mm f/1.8D AF	RF
85mm f/1.8G AF-S	IF, SWM
105mm f/2D AF DC	DC
135mm f/2D AF DC	DC
180mm f/2.8D ED-IF AF	ED, IF
200mm f/2G ED-IF AF-S VRII	ED, VRII, SWM
300mm f/4D ED-IF AF-S	ED, IF
300mm f/2.8G ED VR II AF-S	ED, VRII, NC, SWM
400mm f/2.8G ED VR AF-S	ED, IF, VRII, NC
400mm f/2.8D ED-IF AF-S II	ED, SWM
500mm f/4G ED VR AF-S	IF, ED, VRII, NC
600mm f/4G ED VR AF-S	ED, IF, VRII, NC
800mm f/5.6E FL ED VR AF-S	ED, NC, SWM, FL

AF zoom lenses

14-24mm f/2.8G ED AF-S	IF, ED, SWM, NC
16-35mm f/4G ED VR	NC, ED, VR

Angle of view on DX format (°)	Minimum focus distance (m)	Filter size (mm)	Dimensions diameter x length (mm)	Weight (g)
53	0.25	52	65 x 44.5	205
44	0.25	52	64.5 x 43.5	205
44	0.3	67	83 x 89.5	600
31.3	0.45	58	72 x 52.5	185
31.3	0.45	52	63 x 39	160
31.3	0.45	52	64.5 x 42.5	230
31.3	0.45	58	73.5 x 54	280
18.5	0.85	77	86.5 x 84	595
18.5	0.85	62	71.5 x 58.5	380
18.5	0.8	67	80 x 73	350
15.2	0.9	72	79 x 111	640
12	1.1	72	79 x 120	815
9.1	1.5	72	78.5 x 144	760
8.2	1.9	52	124 x 203	2930
5.2	1.45	77	90 x 222.5	1440
5.2	2.2	52	124 x 267.5	2900
4	2.9	52	159.5 x 368	4620
4	3.8	52	160 x 352	4800
3.1	4	52	139.5 x 391	3880
2.4	5	52	166 x 445	5060
2	5.9	52	160 x 461	4590
90–61	0.28	None	98 x 131.5	970
83–44	0.29	77	82.5 x 125	680

	Optical features/notes
17–35mm f/2.8D ED-IF AF-S	IF, ED, SWM
18–35mm f/3.5–4.5G ED AF-S	ED, SWM
24–70mm f/2.8G ED AF-S	ED, SWM, NC
24–85mm f/2.8–4D IF AF	IF
24–85mm f/3.5–4.5G ED VR AF-S	ED, VRII, SWM
24–120mm f/4G ED-IF AF-S VR	ED, SWM, NC, VRII
28–300mm f/3.5–5.6G ED VR	ED, SWM
70–200mm f/2.8G ED-IF AF-S VRII	ED, SWM, VRII
70–200mm f/4G ED AF-S VRIII	ED, IF, SWM, NC, VRIII
70–300mm f/4.5–5.6G AF-S VR	ED, IF, SWM, VRII
80–400mm f/4.5–5.6D ED VR AF	ED, VR
200–400mm f/4G ED-IF AF-S VRII	ED, NC, VRII, SWM

Macro lenses

60mm f/2.8G ED AF-S Micro	ED, SWM, NC
105mm f/2.8G AF-S VR Micro	ED, IF, VRII, NC, SWM
200mm f/4D ED-IF AF Micro	ED, CRC

Perspective control lenses

24mm f/3.5D ED PC-E (manual focus)	ED, NC
45mm f/2.8D ED PC-E (manual focus)	ED, NC
85mm f/2.8D ED PC-E (manual focus)	ED, NC

Angle of view on DX format (°)	Minimum focus distance (m)	Filter size (mm)	Dimensions diameter x length (mm)	Weight (g)
79–44	0.28	77	82.5 x 106	745
76–44	0.28	77	83 x 95	385
61–22.50	0.38	77	83 x 133	900
61–18.5	0.5	72	78.5 x 82.5	545
61–18.5	0.38	72	78 x 82	465
61–13.5	0.45	77	84 x 103.5	710
53–5.2	0.5	77	83 x 114.5	800
22.5–8	1.4	77	87 x 209	1540
22.5–8	1	67	78 x 178.5	850
22.5–5.20		67	80 x 143.5	745
20–4	2.3	77	91 x 171	1340
8–4	2	52	124 x 365.5	3360
26.3	0.185	62	73 x 89	425
15	0.31	62	83 x 116	720
8	0.5	62	76 x 104.5	1190
56	0.21	77	82.5 x 108	730
34.5	0.25	77 x 94	83.5 x 112	780
18.9	0.39	77	82.7 x 107	650

Chapter 8
ACCESSORIES AND CARE

8 ACCESSORIES AND CARE

As part of the vast Nikon system, a wide choice of accessories is available for the D5200. Third-party items extend the options still further. Accessories can be grouped under four main headings: image modification (e.g. filters and flash); camera performance; camera support; and storage.

» IMAGE MODIFICATION: FILTERS

Flash and close-up accessories have already been covered, leaving filters as the other main category for image modification. As a general principle, avoid using filters unnecessarily. Adding extra layers of glass in front of the lens can increase flare or otherwise degrade the image. "Stacking" of multiple filters increases this risk, and that of vignetting (*see page 148*).

Some types of filter are almost redundant with digital cameras. Variable white balance, for instance (*page 70*), has virtually eliminated the need for color-correction filters, essential for accurate color on film. However, it's prudent to keep a UV or skylight filter (see below) attached to each lens as a defence against knocks and scratches. Filters are much cheaper to replace than lenses!

› Types of filter

Filters can attach to the lens in several ways: round, screw-in filters are the commonest, but you may also encounter slot-in filters and rear or drop-in filters.

Screw-in filters are normally made of high-quality optical glass. The filter-thread diameter (in mm) of most Nikon lenses is

POLAR EXPLORATION ⌄
A polarizing filter can control reflections. The only difference in these shots is that the filter was rotated. *86mm, 1 sec., f/16, ISO 200.*

specified in the table *on pages 216–221*, and usually marked somewhere on the lens beside a Ø symbol. Nikon produces screw-in filters in sizes matching the range of Nikkor lenses and to the same high optical standards. Larger ranges come from Hoya and B+W.

Slot-in filters are more economical and convenient if you use filters extensively. The filters—square or rectangular and made of optical resin or gelatin—fit into a slotted holder. With a simple adapter ring for each lens, one holder and one set of filters can serve any number of lenses. The best-known maker is Cokin, while the Lee Filters range is respected by the most demanding users.

A few specialist lenses, such as super-telephotos with huge front diameters, or extreme wide-angle and fish-eye lenses with protruding front elements, require equally specialist filters, either fitting to the rear of the lens or dropping in to a slot in the lens barrel.

› UV and skylight filters

These filters are almost interchangeable; both cut out excess ultraviolet light which can make images appear excessively cool and blue. The skylight filter also has a slight warming effect. A major benefit is in protecting the front element of the lens.

› Polarizing filters

The polarizing filter, much loved by landscape photographers, cuts down reflections from most surfaces, intensifying colors in rocks and vegetation, for instance. It can make reflections on water and glass virtually disappear, restoring transparency; this is most effective at an angle of around 30 degrees to the surface. Rotating the filter in its mount strengthens or weakens its effect.

The polarizer can also "cut through" atmospheric haze (though not mist or fog) like nothing else, and can make blue skies appear more intense. The effect is strongest when shooting at right angles to the direction of the sunlight, vanishing when the sun is directly behind or in front. Results can sometimes appear unnatural.

DUST BEATER ⌄
A UV or skylight filter helps to protect the lens from snow, rain, dust, dirt, and other hazards; useful in a very dusty environment, such as the Jordan desert. *86mm, 1/250 sec., f/9, ISO 100.*

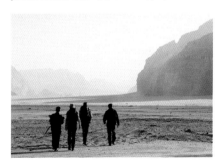

With wide-angle lenses the effect can be conspicuously uneven across the field of view. The polarizer should be used with discrimination, not permanently attached. However, many of its effects cannot be fully replicated in any other way, even in digital post-processing. You may only use it occasionally, but then it can be priceless.

› Neutral density filters

Neutral density (ND) filters reduce the amount of light reaching the lens. "Neutral" simply means that they don't affect the color of the light, only its intensity. ND filters can be either plain or graduated. A plain ND filter is useful when you want to set a slower shutter speed and/or wider aperture, and the ISO setting is already as low as it can go. A classic

example is when shooting waterfalls, where a long shutter speed is often favored to create a silky blur. Graduated ND filters ("grads") have neutral density over half their area, with the other half being clear, and a gradual transition in the middle. They are widely used in landscape photography to compensate for wide differences in brightness between sky and land. However, the straight transition of an ND grad filter is unpleasantly obvious when the skyline is irregular, as in mountainous areas. You can invest time at the computer to replicate, or even improve on, the effect of a graduated ND filter. However, the original image must have captured detail in both highlights and shadows, so an ND grad is still important; it can also be useful when shooting movies, where this sort of post-processing is not an option.

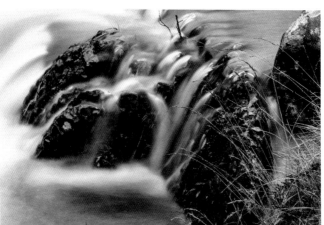

SMOOTH OPERATOR «
A plain ND filter may be useful when you want to use really low shutter speeds.
180mm, 4 sec. (tripod), f/16, ISO 100.

» CAMERA PERFORMANCE: ESSENTIALS

Numerous add-ons are available to improve or modify the performance of the D5200. Nikon includes several items with the camera, but these are really essentials, not extras.

› EN-EL14 battery

Without a live battery, your D5200 is useless deadweight. It's always wise to have a fully charged spare on hand—especially in cold conditions, when using the screen extensively, or when shooting movies.

› MH-24 charger

Vital to keep the EN-EL14 battery charged and ready.

› BF-1A body cap

Protects the interior of the camera when no lens is attached.

» CAMERA PERFORMANCE: OPTIONAL EXTRAS

A selection from Nikon's extensive range is listed here. (For wireless connection see the chapter 9 on connection, *page 245*.)

› AC Adapter EH-5a/EH-5b

Can be used to power the camera directly from the AC mains, allowing uninterrupted shooting in, for example, long studio sessions. (A Power Connecter EP-5A is also required.)

› Wireless remote control ML-L3

This inexpensive little unit allows the camera to be triggered from a distance of up to 16ft (5m).

Wireless remote control ML-L3

› WU-1a Wireless Mobile Adapter

The WU-1a Wireless Mobile Adapter plugs into the camera's USB port and connects wirelessly to a suitable (iOS or Android) smartphone or tablet. You can use this connection to transfer photos and movies, or use the D5200 for remote shooting *(see page 245)*.

› GPS Unit GP-1

Dedicated Global Positioning System device *(see page 246)*.

› ME-1 Stereo Microphone

Greatly improves sound quality in movie shooting *(see page 193)*.

› Diopter adjustment

The D5200's viewfinder has built-in dioptric adjustment *(see page 26)*. If your eyesight is beyond its range, Nikon produces a series of viewfinder lenses between −5 and +3m^{-1}, with the designation DK-20C.

Tip

It's usually easier to wear contact lenses or glasses. My prescription is around −5m^{-1} and I've never had any problem using the D5200 while wearing contacts.

› Screen shades

The LCD screen can be impossible to see properly in bright sunlight. This can be a real issue when using Live View and even more for shooting movies. Various third-party companies produce accessory screen shades: one of the best-known names is Hoodman. However, if you only need one occasionally, a screen shade can be improvised; I have heard of people using the cardboard core from a toilet roll!

» CAMERA SUPPORT

There's much more to camera support than tripods, although these remain a staple.

› Tripods

VR lenses, plus the D5200's ability to produce fine images at high ISO settings, do encourage handholding, but there are still many occasions when nothing replaces a tripod. While light weight and low cost always appeal, beware of tripods that simply aren't sturdy enough to provide decent support, especially with longer lenses. A good tripod is an investment that will last many years; my first Manfrotto carbon tripod outlasted several cameras! The best combination of low weight with good rigidity comes (at a price!) in titanium or carbon fiber. Carbon-fiber tripods are made by Manfrotto and Gitzo, among others.

When shooting movies, a tripod is essential, and many tripods are designed specifically for this purpose *(see page 195)*.

› Monopods

Monopods can't equal the ultimate stability of a tripod, but are light, easy to carry, and quick to set up. They are favored by sports photographers, who have to react quickly while using hefty, long telephoto lenses.

FIREWORKS **«**
Tripods are ideal for a wide variety of subjects.
16mm, 35 sec. (tripod), f/14, ISO 400.

8

FULL OF BEANS ⌃
This home-made beanbag has served me well
since pre-digital days.

› Other camera support

There are many other solutions for camera
support, both proprietary products and
improvised alternatives. It's still hard to beat
the humble beanbag; these can be home-
made, or bought from various suppliers.
For movie-specific camera support *see
page 195.*

» PORTABLE STORAGE DEVICES

Memory cards rarely fail but it's always
worth backing up valuable images as soon
as possible, especially on long trips to
"once-in-a-lifetime" destinations.
Dedicated photo storage devices like the
Vosonic VP8870 and Epson P-7000
comprise a compact hard drive along with
a small screen. However many of us already
own something that will also store images,
in the shape of an iPod. Not all iPod
models are suitable, so investigate carefully.

The iPad is also an excellent option for
image storage: you'll need an Apple iPad
Camera Connector to transfer images.
The iPad's superb screen, especially the
Retina display of the latest models, is light-
years ahead of most alternatives for
reviewing images during long trips and
for sharing your results with travelling
companions. The one real limitation is
storage space; at a maximum 64Gb (not all
available for images) you can easily fill this
up if you shoot liberally, especially if you
shoot RAW. The HyperDrive is reputedly
the world's only iPad compatible USB hard
drive—its 1Tb capacity should be enough
for most!

» CARE

The Nikon D5200 is robust, but it's also packed with highly complex electronic and optical technology. A few simple precautions should help to keep it functioning perfectly for many years.

› Basic care

Keeping the camera clean is fundamental. Keep the camera in a case when not in use. Remove dust and dirt with a blower, then wipe with a soft, dry cloth.

There is no screen protector for the fold-out monitor and the screen will need cleaning periodically. Use a blower to

Warning!

The Nikon Reference Manual (page 300) implies that the reflex mirror can be cleaned with a cloth and cleaning fluid. This goes against all normal advice: **never touch the reflex mirror** in any way, as it is extremely delicate. Remove dust from the mirror with gentle use of an air-blower, and nothing else.

SPRAY AWAY ⌄
Deceptively beautiful: salt spray is risky for the camera. *35mm, 1/640 sec., f/13, ISO 400.*

remove loose dirt, then wipe the surface carefully with a clean, soft cloth or a swab designed for the purpose. Do not apply pressure and never use household cleaning fluids.

› Storage

If the camera will go unused for a period, remove the battery, close the battery compartment cover and and store both in a cool dry place. Avoid extremes of temperature, high humidity, and strong electromagnetic fields.

› Cleaning the sensor

Strictly speaking, it's not the sensor itself but the low-pass filter in front of it that concerns us. Specks of dust on this will appear as dark spots in the image. Prevention is better than cure, so change lenses with care, sheltering the camera from any wind. In really bad conditions (such as sandstorms) it's best not to change lenses at all. The D5200 has a self-cleaning facility, which vibrates the low-pass filter to displace dust. This can be activated manually at any time or set to run automatically when the camera is switched on and/or off; see Clean Image Sensor in the Setup menu (*page 232*).

Stubborn dust can still appear on the low-pass filter, making it necessary to clean it manually. Do this in a clean,

draught-free area with good light, preferably using a lamp which can be directed into the camera.

Ensure the battery is fully charged, or use a mains adapter. Remove the lens, switch the camera ON and select **Lock mirror up for cleaning** from the Setup menu. Press the shutter-release button to lock up the mirror. First, attempt to remove dust using a hand-blower (not compressed air or other aerosol). If this appears ineffective, consider using a sensor-cleaning swab, and carefully follow the supplied instructions. Do not use other

Warning!

Any damage to the low-pass filter from incorrect use of a cleaning swab could void your warranty. If in doubt, consult a professional dealer or camera repairer.

Tip

If, despite your best efforts, spots do appear on the image, they can always be removed using, for example, the Clone tool or Healing brush in Adobe Photoshop. In Nikon Capture NX2 this process can be automated by creating a Dust-off reference image (see page 102). Spot-removal can be applied across batches of images in Adobe Lightroom.

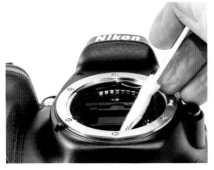

Cleaning the sensor—strictly for the confident!

brushes or cloths and never touch the low-pass filter with your finger. When finished, turn the camera OFF; the mirror will reset.

› Coping with cold

Nikon specify an operating temperature range of 32–104°F (0–40°C). When ambient temperatures fall below freezing, the camera can still be used, but aim to keep it within the specified range as far as possible. Keeping the camera in an insulated case or under outer layers of clothing between shots will help keep it warmer than the surroundings. If it does become chilled, battery life can be severely reduced (make sure you carry a spare).

COLD COMFORT　　　　　　　　　　　⊗
Winter can be great for photos, challenging for cameras and photographers. *135mm, 1/640 sec., f/11, ISO 800.*

In extreme cold, the LCD displays may become erratic or disappear completely and ultimately the camera may cease to function. If allowed to warm up gently, no permanent harm should result.

› Coping with heat and humidity

Extremes of heat and humidity (Nikon stipulate over 85%) can be even more problematic, as they are more likely to lead to long-term damage. In particular, rapid transfers from cool environments to hot and humid ones (such as from air-conditioned hotel to sultry streets) can cause internal condensation. If such transitions may occur, pack the camera and lens(es) in airtight containers with sachets of silica gel, which will absorb any moisture. Allow equipment to reach ambient temperature before unpacking, let alone using, it.

› Water protection

The D5200 does not claim to be waterproof, but brief exposure to light rain is unlikely to do permanent harm. Keep exposure to a necessary minimum, and wipe regularly with a microfiber cloth (always handy to deal with accidental splashes). Avoid using the built-in flash and keep the hotshoe cover in place. Double-check that all access covers on the camera are properly closed.

Take extra care to avoid contact with salt water. If this does occur, clean carefully and immediately with a cloth lightly dampened with fresh, preferably distilled water.

Ideally, protect the camera with a waterproof cover. A simple plastic bag will provide rudimentary protection, but purpose-made rainguards are available, such as HydroPhobia from Think Tank. True waterproof and underwater cases are generally very expensive. Aquapac's reasonably-priced DSLR case is a tight fit for the D5200, but can be used with a slimline lens.

WATERTIGHT CASE »
A waterproof SLR case from Aquapac.

› Camera cases

In all conditions, a case is highly advisable
to protect the camera when not in use.
The most practical is a simple drop-in
pouch, usually worn on a waist-belt.
Excellent examples come from makers like
Think Tank Photo, Camera Care Systems,
and LowePro.

› Card care

If a memory card is lost or damaged, your
images are lost too. Blank cards are cheap
but cards full of images can be
irreplaceable—unlike the camera itself.
SD cards are pretty robust but it's still wise
to treat them with care. Keep them in their
original plastic cases, or something more
substantial, and store carefully.

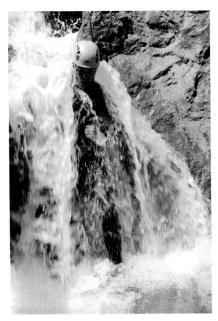

MAKING A SPLASH ⌃
Nothing less than a fully waterproof case would
do here. *18mm, 1/125 sec., f/9, ISO 200.*

> **Note:**
> There seems to be no evidence that
> modern airport X-ray machines have
> any harmful effect on either digital
> cameras or memory cards.

PADDED POUCH «
A case like this one from Think Tank Photo
combines good protection and easy access.

Chapter 9
CONNECTION

9 CONNECTION

In digital photography, connecting to external devices—especially computers—is not an optional extra: it's how you store, organize, backup, and print images. The D5200 is designed to facilitate these operations, and the main cables required are included with the camera.

» CONNECTING TO A COMPUTER

Connecting to a Mac or PC allows you to store and backup your images. It also helps you exploit more of the power of the D5200, including the ability to optimize image quality from RAW files. Some software packages allow "tethered" shooting, where images appear on the computer straight after capture; Nikon Camera Control Pro 2 (optional purchase) goes further, allowing the camera to be controlled directly from the Mac or PC.

› Computer requirements

The large file sizes produced by the D600 place extra demands on computer systems, stressing processor speed, hard disk capacity, and—above all—memory (RAM).

Connection ports on the left side of the D5200

A D5200 connected to a computer

Systems with less than 4GB of RAM may run slowly when dealing with RAW, TIFF, and even full-size JPEG images from the camera. Fortunately, adding extra RAM to most systems is relatively easy and inexpensive. Extra hard disk space can also be helpful, as the system will slow significantly when the hard disk becomes close to capacity.

A CD drive is useful but not essential for installing the supplied Nikon View NX2 software, as it can also be downloaded from the Nikon website. Nikon View NX2 requires one of the following operating systems: Windows 8 (Pro/Enterprise); Windows 7 (Service Pack 1); Windows Vista (Service Pack 2); Windows XP (Service Pack 3); Mac OS X (Version 10.6.8, 10.7.5, or 10.8.2).

› Backing up

Until they are backed up, your precious images exist solely as data on the camera's memory card. Memory cards are robust but not indestructible, and in any case you will soon wish to reformat and reuse them. However, when images are transferred to the computer and the card is reformatted, those images again exist in only one location, the computer's hard drive. If anything happens to that drive, whether fire, theft, or hardware failure, you could stand to lose thousands of irreplaceable images. The simplest form of backup is to a second hard drive. Nikon Transfer can backup automatically as images are imported.

BACKING UP »
Apple's Time Machine maintains backups automatically.

Calibration software (this is the Display Calibrator Assistant in Mac OS X)

› Color calibration

A major headache for digital camera users is that images look one way on the camera monitor, different on the computer screen, different when you email them to friends, and different again when printed. To achieve consistency across different devices, it's vital above all that your main computer screen is correctly set up and calibrated. This may seem complex and time-consuming but ultimately saves much time and frustration. Detailed advice is

beyond the scope of this book; try a search for "monitor calibration" on the web. There's more detail in the *Digital SLR Handbook* (from this author and publisher).

› Connecting the camera

This description is based on Nikon Transfer, part of the supplied View NX2 package. The procedure with other software will be similar in outline but different in detail.

1) Start the computer and let it boot up. Open the cover on the camera's left side and insert the smaller end of the supplied USB cable into the USB slot; insert the other end into a USB port on the computer (not an unpowered hub or port on the keyboard).

Note:
The supplied Hi-Speed USB cable allows direct connection to a computer. However, it's often more convenient to transfer photos by inserting the memory card into a card-reader. Many PCs have built-in SD card slots but separate card-readers are cheap and widely available. Older card-readers may not support SDHC or SDXC cards.

Nikon Transfer

2) Switch ON the camera. Nikon Transfer starts automatically (unless you have configured its Preferences not to do so).

3) The Nikon Transfer window offers various options. The following are particularly important.

4) To transfer selected images only, use the check box below each thumbnail to select/deselect as required.

5) Click the **Primary Destination** tab to choose where photos will be stored. You can create a new subfolder for each transfer, rename images as they are transferred, and so on.

6) Click the **Backup Destination** tab if you want Nikon Transfer to create backup copies automatically during transfer.

7) When transfer is complete, switch OFF the camera and disconnect the cable.

Using a card-reader
Insert the card, and when Nikon Transfer starts proceed from Step 3 above. When finished, remove the card from the system like any other external drive. In Windows, use **Safely Remove Hardware**; in Mac OS X use **Command + E** or drag the D5200 icon to the Trash.

> **Tip**
>
> *Always switch the camera OFF before connecting or disconnecting USB or other interface cables.*

Importing movies
The basic procedure for importing movies is the same as for stills. Nikon Transfer will recognize and import them, but you will probably want to store movies in a different folder than still images. Often it's better to import movies through your movie editing software (*see page 198*); this ensures that all your movie clips are stored in the same place and that the software can immediately locate them for editing purposes.

9 » CONNECTING TO AN iPAD

Unless you use Eye-Fi or a mobile adapter (*see page 245*), connecting to an iPad requires an Apple iPad Camera Connection Kit. This connects to the base of the iPad. The original iPad and iPad 2 use a 30-pin connector while newer models, including the iPad mini, use the smaller Lightning connector. The Connection Kit contains two units, allowing you either to connect the camera directly via its USB cable, or to insert a memory card.

To import, launch the Photos app (if it doesn't launch automatically). This will quickly display thumbnails of all photos on the memory card. You can then opt to **Delete All** or **Import All**; or, if you tap a photo or photos, a checkmark will appear, and you can then delete or import just these photos. Imported photos will appear under **Last Import** in the **Albums** view.

On completion, simply detach the connector.

Tip

30-pin connectors can be slightly temperamental. I've sometimes found I need to remove my iPad from its case before photos will download.

» SOFTWARE AND IMAGE PROCESSING

The D5200 is bundled with Nikon View NX2 software. This includes Nikon Transfer, a simple application which does one job competently. View NX2 itself covers most of the main processes: you can view and browse images, save them in other formats, and print. However, editing and enhancing images (including RAW files) are not very intuitive, comparing poorly with apps like iPhoto. Results might be technically superior, but getting there might try your patience. It's also weak when it comes to organizing and cataloging images.

› Using Nikon View NX2

1) From a browser view such as the thumbnail grid, click on an image to highlight it. **Image Viewer** shows the image in more detail, plus a histogram, and **Full Screen** allows you to see the image full size.

2) On the right of the screen are **Metadata** (detailed info about the image), and the **Adjustment** palette, which allows adjustments such as exposure and white balance. You can also apply Nikon Picture Controls (*see page 88*).

3) Close the image and you will be asked if you want to save any adjustments. You

do not need to export or convert the file immediately.

4) To export the file as a TIFF or JPEG which can be viewed, edited, and printed by other applications, choose **Convert Files** from the **File** menu. You can resize and rename the image if required.

5) The File Format menu in the **Convert Files** dialog offers three options (*see table*).

Nikon View NX2

› Nikon Capture NX2

Nikon Capture NX2 is a far more complete editing package than View NX2. For a full range of editing options, especially in relation to RAW files, Nikon Capture NX2 or one of its third-party rivals is essential. Unlike Adobe Photoshop, Capture NX2 cannot open RAW files from non-Nikon cameras. Capture NX2 also has a quirky interface (which some love), and you'll need another app for cataloging.

› Camera Control Pro 2

In suitable settings (e.g. studios), Camera Control Pro 2 allows the D5200 to be controlled directly from a Mac or PC. As soon as images are captured they can be checked in detail on the large, color-corrected computer screen; Live View integration allows real-time viewing. Of course, it's a professional product at a professional price.

Nikon View NX2 file format options

JPEG	Choose compression ratio: Highest Quality; High Quality; Good Balance; Good Compression Ratio; Highest Compression Ratio.	Suitable if extensive further editing is not envisaged. It's recommended to choose Highest Quality unless storage space is at a premium, or the image is specifically intended for such use as an email attachment.
TIFF (8-bit)		Creates larger file sizes than JPEG without noticeable gain in quality: 16-bit is advised for extensive retouching work.
TIFF (16-bit)		The best choice when further editing is anticipated.

› Third-party software

The undisputed monarch of image-editing software is Adobe Photoshop, the current version being Photoshop CS6. Its power is enormous and it's the subject of many dedicated books and websites. It's also about the same price as a D5200 body. (If you already own an older version of Photoshop, upgrades are cheaper.)

It is far more than many users need, and many will prefer Photoshop Elements, at a tenth of the price, which still has sophisticated editing features, including the ability to open RAW files from the D5200.

Photoshop Elements also includes something that Photoshop itself does not, namely its Organizer module, which allows photos to be sorted into "Albums" and also "tagged" in different ways. Some sort of organizer or cataloging software becomes essential as you amass thousands of images.

Mac users have another excellent choice in the form of iPhoto (latest version iPhoto 11), pre-loaded on new Macs. Like Photoshop Elements, it combines organizing and editing abilities. There's no easier imaging software to grasp, and the Adjust palette provides quick and flexible image editing too. iPhoto can open RAW files from the D5200, but—unlike Photoshop Elements—cannot edit in 16-bit depth, which is recommended for best results.

Finally, there are two one-stop solutions in the shape of Apple's Aperture (Mac only) and Adobe Lightroom (Mac and PC). These are particularly recommended if you regularly shoot RAW. Both offer powerful organizing and cataloging, seamlessly integrated with advanced image editing. Editing is "non-destructive": edit settings (any changes you make to your image, including color, cropping, and so on) are recorded alongside the original RAW (or DNG) file without creating a new

PHOTOSHOP ELEMENTS ❯❯
Adobe Photoshop Elements Organizer module.

iPHOTO ❯❯
iPhoto's Adjust options.

TIFF or JPEG file. TIFF or JPEG versions, incorporating all the edits, can be exported as and when needed.

Recent versions of Aperture and Lightroom both support tethered shooting, as do several other apps.

> **Note:**
> Older versions of Adobe Photoshop, Elements, and Lightroom will not recognize RAW files created by the D5200. These require the Camera Raw plug-in, version 7.3, which is incompatible with versions before Photoshop CS6. One workaround is to use Adobe DNG Converter (free) to convert files to the standard and widely compatible DNG format. However, this does add an extra step, possibly a time-consuming one, to your workflow. Upgrading Lightroom (v4) or Photoshop Elements (v11) is an easier, and reasonably affordable, solution.

ADOBE LIGHTROOM ⌄
Adobe Lightroom's Develop module offers a very wide spectrum of RAW adjustments.

» WIRELESS CONNECTION

› Wireless Mobile Adapter WU-1a

This adapter does not require an existing WiFi network but creates its own, so you can use it anywhere; the maximum range between camera and iOS or Android device is quoted as 49ft (15m). You also need the free Wireless Mobile Utility app on your iOS or Android device. With this, you can simply download images to the device (providing an instant backup) or preview and trigger the camera remotely. However you can't change camera settings remotely. There's a (very slight) lag in the preview image, which might be irksome in some situations, such as shooting wildlife.

› Eye-Fi

Eye-Fi looks and operates like a conventional (albeit more expensive) SD memory card, but includes an antenna so it can connect to WiFi networks, allowing wireless transfer of images to a computer.

Eye-Fi cards are supplied with a card-reader. When card and reader are plugged into any recent Mac or PC the supplied software should install automatically. There's then an automatic registration process which makes that computer the default destination for Eye-Fi upload. You can select a destination folder on your computer and you can also configure the

system to automatically upload photos to sharing sites like Flickr.

Once configuration is complete, insert the card in the camera. Use the **Eye-Fi Upload** item in the Setup menu and then the camera will automatically upload images as they are taken, as long as you remain within signal range of the network. The D5200 displays a notification when images are being uploaded.

» CONNECTING TO A GPS UNIT

Nikon's GP-1 GPS (Global Positioning System) Unit can be mounted on the hotshoe or clipped to the camera strap, and links to the camera's accessory terminal using a supplied cable. It allows information on latitude, longitude, altitude, and heading to be added to image metadata. This information is displayed by the D5200 as an extra page of photo info on playback.

When the camera has established a connection and is receiving GPS data, a GPS icon will be displayed in the Information Display. If this flashes, the GPS is searching for a signal, and data will not be recorded.

The **GPS** item under **Accessory terminal** in the Setup menu has three sections.

› Standby timer

If enabled, exposure meters turn off automatically after a set period (see Custom setting c2). This reduces battery drain. If you've enabled this, half-press the shutter release before taking shots, to "wake" the GPS, otherwise data may fail to record. If you disable this option, the meters will remain on as long as a GPS unit is attached, and GPS data will always be recorded.

› Position

Displays current location information as reported by the GPS device.

› Use GPS to set camera clock

Allows the camera clock to synchronize with time from the GPS device.

» CONNECTING TO A PRINTER

The most flexible and powerful way to print photographs from the D5200 is to transfer them to a computer. The memory card can also be inserted into a compatible printer or taken to a photo printing store. Finally, the camera can be connected to any printer that supports the PictBridge standard, allowing images to be printed directly.

› Connecting directly to a printer

1) Turn the camera OFF.

2) Turn the printer on and connect the supplied USB cable. Open the cover on the left side of the camera and insert the the smaller end of the cable into the USB slot.

3) Turn the camera ON. You should now see a welcome screen, followed by a

PictBridge playback display. There's now a choice between **Printing pictures one at a time** or **Printing multiple pictures**.

› Printing pictures one at a time

This process is very straightforward, particularly if you are already familiar with navigating the D5200's playback screens.

1) Select the photo you wish to print, then press **OK**. This brings up a menu of printing options (*see table on the next page*). Use the Multi-selector to navigate through the menu and highlight specific options; press **OK** to select.

2) When the required options have been set, select **Start printing** and press **OK**. To cancel at any time, press **OK** again.

Tip

RAW images can't be printed directly from the camera, but you can use the NEF (RAW) processing item in Retouch menu (see page 121) to create a JPEG copy for direct printing.

Printing options

Option name	Options available (may vary according to printer)	Notes
Page size	e.g. 9 x 13cm 13 x 18cm A4	Options will be limited by the maximum size the printer can print.
No of copies	1–99	Use ▲ / ▼ to choose number, then press **OK** to select.
Border	Printer default Print with border No border	If **Print with border** is selected, borders will be white (or paper base color).
Time stamp	Printer default Print time stamp No time stamp	Prints time and date when image was taken.
Crop	Crop No cropping	Prints selected area only to size selected under **Page size**. Resizing/repositioning the crop area is very similar to using Trim in the Retouch menu (see page 118).

› Printing multiple pictures

You can print several pictures at once. You can also create an index print of all JPEG images (up to a maximum of 256) currently stored on the memory card.

With the PictBridge menu displayed, press **OK**. The following options are displayed.

Print Select	Use the Multi-selector to navigate pictures on the memory card (displayed as six thumbnails at a time). To see an image full-screen, press ⊞. To choose the currently selected image for printing, hold [⚬⤙] and press ▲. The picture is marked with **PRINT** and the number of prints set to one. Keep ⊞ depressed and use ▲ to change the number of prints.

Repeat to select further images and choose the number of prints required from each. Finally, press **OK** to display the PictBridge menu and select printing options, as in the table *on the previous page, 248*. (Only **Page size**, **Border**, and **Time stamp** will be available.) Select **Start printing** and press **OK**. |
Select date	Prints one copy of each image taken on a selected date.
Print (DPOF)	Prints images already selected using the **Print set (DPOF)** option in the Playback menu *(see page 99)*.
Index Print	Prints all JPEG images (up to a maximum of 256) on the memory card. If more than 256 images exist, only the first 256 will be printed. Options for **Page size**, **Border**, and **Time stamp** can be set as already described.

» CONNECTING TO A TV

The supplied EG-CP14 cable is used to connect the camera to a normal TV or VCR. You can also connect the camera to an HDMI (High Definition Multimedia Interface) TV but you'll need an HDMI cable (not supplied). In other respects the process is the same.

1) Check that the camera is set to the correct mode in the Setup menu (NTSC or PAL for standard TVs and VCRs or HDMI).

2) Turn the camera OFF. (Important: always do this before connecting or disconnecting the cable.)

3) Open the cover on the left side of the camera and insert the cable into the appropriate slot (A/V-out or HDMI). Connect the other end to the TV.

4) Tune the TV to a Video or HDMI channel.

5) Turn the camera ON and press the playback button. Images remain visible on the camera monitor as well as on the TV and you navigate using the Multi-selector in the usual way. The Slide show item in the Playback menu *(page 98)* can be used to automate playback.

8-bit, **12-bit**, **16-bit** *See* Bit depth.

Aperture The lens opening which admits light. Relative aperture sizes are expressed in f-numbers. *See* f-number.

Artefact Occurs when data or data produced by the sensor are interpreted incorrectly, resulting in visible flaws in the image.

Bit depth The amount of information recorded for each color channel. 8-bit, for example, means that the data distinguishes 2^8 or 256 levels of brightness for each channel. 16-bit images recognize over 65,000 levels per channel, which allows greater freedom in editing. The D5200 records RAW images in 12-bit depth and they are converted to 16-bit on import to the computer.

Bracketing Taking a number of otherwise identical shots in which just one parameter (e.g. exposure) is varied.

Buffer On-board memory that holds images until they can be written to the memory card.

Burst A number of frames shot in quick succession; the maximum burst size is limited by buffer capacity.

Channel The D5200, like other digital devices, records data for three separate color channels (see RGB).

Chimping Checking images on the screen after shooting.

CCD (charge-coupled device) A type of image sensor used in many digital cameras.

Clipping Complete loss of detail in highlight or shadow areas of the image (sometimes both), leaving them as blank white or black.

CMOS (Complementary Metal Oxide Semiconductor) A type of image sensor used in many digital cameras, including the Nikon D5200.

Color temperature The color of light, expressed in degrees Kelvin (K). Confusingly, "cool" (bluer) light has a higher color temperature than "warm" (red) light.

CPU (central processing unit) Really a small computer in the camera, and in many lenses, which controls most or all of the unit's functions.

Crop factor *See* Focal length multiplication factor.

Diopter Unit expressing the power of a lens.

dpi (dots per inch) A measure of resolution. Should strictly be applied only to printers. *See also* ppi.

Dynamic range The range of brightness from shadows to highlights within which the camera can record detail.

Exposure Used in several senses. For instance, "an exposure" is virtually synonymous with "a photo": to make an exposure is to take a picture. Exposure also refers to the amount of light hitting the image sensor, and to systems of measuring this. *See also* Overexposure, Underexposure.

Ev (exposure value) A standardized unit of exposure. 1 Ev is equivalent to 1 "stop" in traditional photographic parlance.

Extension rings/extension tubes Hollow tubes which fit between the camera tube and lens, used to allow greater magnifications.

f-number Lens aperture expressed as a fraction of focal length; f/2 is a wide aperture and f/16 is narrow.

Fast (lens) Lens with a wide maximum aperture, e.g. f/1.8. f/4 might be considered relatively fast for long telephotos.

Fill-in flash Flash used in combination with daylight. Used with naturally backlit or harshly side-lit subjects to prevent dark shadows.

Filter A piece of glass or plastic placed in front of, within, or behind the lens to modify light.

Firmware Software which controls the camera. Upgrades are issued by Nikon from time to time and can be transferred to the camera via a memory card.

Focal length The distance (in mm) from the optical center of a lens to the point at which light is focused.

Focal length multiplication factor Because the D5200's sensor is smaller than a frame of 35mm film, the effective focal length of all lenses is multiplied by a factor of 1.5.

fps (frames per second) The number of exposures (photographs) that can be taken in a second. The D5200's maximum rate is 4.5fps.

Highlights The brightest areas of the scene and/or the image.

Histogram A graph representing the distribution of tones in an image, ranging from pure black to pure white.

Incident light metering Measuring the light falling on to a subject, usually with a separate meter. An alternative to the in-camera meter, which measures reflected light.

ISO (International Standards Organization) ISO ratings express film speed and the sensitivity of digital sensors is quoted as ISO-equivalent.

JPEG (Joint Photographic Experts Group) A compressed image file standard. High levels of JPEG compression can reduce files to about 5% of their original size, but there may be some loss of quality.

LCD (liquid crystal display) A flat screen such as the D5200's rear monitor.

Macro A term used to describe close focusing and close-focusing ability of a lens. A true macro lens has a reproduction ratio of 1:1 or better.

Megapixel See pixel.

Memory card A removable storage device for digital cameras.

Noise Image interference manifested as random variations in pixel brightness and/or color.

Overexposure When too much light reaches the sensor, resulting in a too-bright image, often with clipped highlights.

Pixel (picture element) The individual colored dots (usually square) which make up a digital image. One million pixels = 1 megapixel.

ppi (pixels per inch) Should be applied to digital files rather than the commonly used dpi.

Reproduction ratio The ratio between the real size of an object and the size of its image on the sensor.

Resolution The number of pixels for a given dimension, for example 300 pixels per inch. Resolution is often confused with image size. The native size of an image from the D5200 is 6000 x 4000 pixels; this could make a large but coarse print at 100 dpi or a smaller but finer one at 300 dpi.

RGB (red green blue) Digital devices, including the D5200, record color in terms of brightness levels of the three primary colors.

Sensor The light-sensitive chip at the heart of every digital camera.

Shutter The mechanism which controls the amount of light reaching the sensor by opening and closing to expose the sensor when the shutter-release is pushed.

Spot metering A metering system which takes its reading from the light reflected by a small portion of the scene.

Telephoto lens A lens with a large focal length and a narrow angle of view.

TIFF (Tagged Image File Format) A universal file format supported by virtually all image-editing applications.

TTL (through the lens) The viewing and metering systems of SLR cameras like the D5200.

Underexposure When insufficient light reaches the sensor, resulting in a too-dark image, often with clipped shadows.

USB (Universal Serial Bus) A data transfer standard, used to connect to a computer.

Viewfinder An optical system used for framing the image; on an SLR camera such as the D5200 it shows the view as seen through the lens.

White balance A function which compensates for different color temperatures so that images may be recorded with correct color balance.

Wideangle lens A lens with a short focal length and a wide angle of view.

Zoom A lens with variable focal length, giving a range of viewing angles. To zoom in is to change focal length to give a narrower view and zoom out is the converse. Optical zoom refers to the genuine zoom ability of a lens; digital zoom is the cropping of part of an image to produce an illusion of the same effect.

» USEFUL WEB SITES

NIKON-RELATED SITES

Nikon Worldwide
Home page for the Nikon Corporation
www.nikon.com

Nikon USA
Home page for Nikon USA
www.nikonusa.com

Nikon UK
Home page for Nikon UK
www.nikon.co.uk

Nikon User Support
European Technical Support Gateway
www.europe-nikon.com

Nikon Historical Society
Worldwide site for study of Nikon products
www.nikonhs.org

Nikon Rumors
What's next from Nikon?
http://nikonrumors.com/

Grays of Westminster
Revered Nikon-only London dealer
www.graysofwestminster.co.uk

GENERAL SITES

Digital Photography Review
Independent news and reviews
www.dpreview.com

Thom Hogan
Real-world reviews and advice
www.bythom.com

Jon Sparks
Landscape and outdoor pursuits
photography
www.jon-sparks.co.uk

SOFTWARE AND EQUIPMENT

Adobe
Photoshop, Photoshop Elements, Lightroom
www.adobe.com

Apple
Aperture and iPhoto
www.apple.com

Aquapac
Waterproof cases
www.aquapac.net

Think Tank Photo
Backpacks, camera cases
www.thinktankphoto.com

Sigma
Independent lenses and flash units
www.sigma-imaging-uk.com /
www.sigmaphoto.com

PHOTOGRAPHY PUBLICATIONS

Photography books
www.ammonitepress.com/camera-guides.
html

***Black & White Photography* magazine,
Outdoor Photography magazine**
www.thegmcgroup.com

» INDEX